IMAGES
of America

SOUTHERN HIGHLAND
CRAFT GUILD

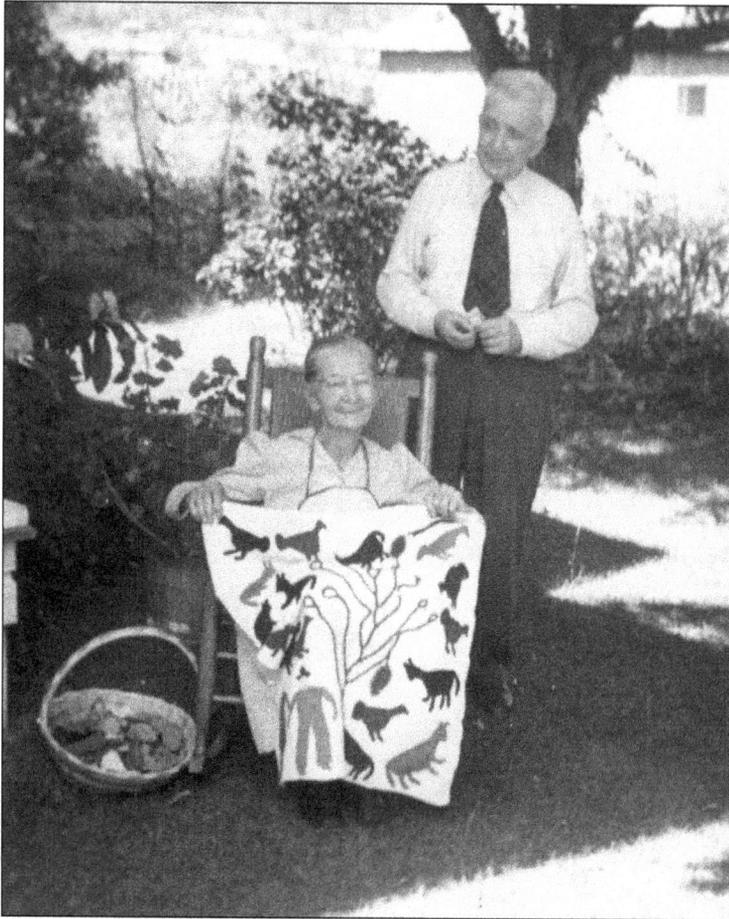

Allen Eaton played a large role in the formation of the Southern Highland Craft Guild. His efforts included traveling into rural communities to find craftspeople who would benefit from the marketing of their work. "Granny" Kate Donaldson worked with homespun yarn in natural dyed colors to crochet figures, which she then applied to baby blankets. (Archives of the Southern Highland Craft Guild.)

ON THE COVER: This is a view of the Allanstand Shop on College Street in Asheville, North Carolina. It is the oldest craft shop in the country, although it has relocated several times. Pictured here are, from left to right, William Bader, Wade Martin, Gertrude Bader, and shop manager Margaret Roberts. William Bader and Martin were Southern Highland Craft Guild members who worked with wood. Bader did marquetry, which he learned in Germany. Martin was a Swannanoa native who carved detailed figures. (Archives of the Southern Highland Craft Guild.)

IMAGES
of America

SOUTHERN HIGHLAND
CRAFT GUILD

Deb Schillo & Barbara Miller

ARCADIA
PUBLISHING

Published by Arcadia Publishing
Charleston, South Carolina

Library of Congress Control Number: 2020949126

For all general information, please contact Arcadia Publishing:
Telephone 843-853-2070
Fax 843-853-0044
E-mail sales@arcadiapublishing.com
For customer service and orders:
Toll-Free 1-888-313-2665

Visit us on the Internet at www.arcadiapublishing.com

*Dedicated to Southern Highland Craft Guild
members past, present, and future*

CONTENTS

ACKNOWLEDGMENTS

The authors wish to acknowledge and thank all the people who have contributed to the photographs that document the Southern Highland Craft Guild. Frances Goodrich captured the earliest images of people living in Western North Carolina while establishing her church schools and women's circles. Edward DuPuy, a guild member and craftsman who made furniture, was also a gifted photographer and, for 20 years, took photographs of members and visitors at the various fairs. At various times, the guild hired professional photographers, most notably Robert Amburg, Tim Barnwell, and Steve Stokes. And from old times to new days, staff members, artists, and volunteers have contributed their images. The Southern Highland Craft Guild's archives contain thousands of photographs, slides, and DVDs of people and artwork. The guild's archive is a treasure trove only being glimpsed in this book.

Unless otherwise noted, all photographs appear courtesy of the archives of the Southern Highland Craft Guild (SHCG).

INTRODUCTION

December 27, 1928, brought the first snowfall of the year to the settlement of Penland, North Carolina. It also became the heaviest snowfall that winter.

In the midst of this storm, seven people departed the train at the small station in Penland. Waiting to transport them up the mountain to the Penland school was Lucy Morgan in her newly acquired automobile. A passable road to the school had meant that the usual mode of transportation, a horse and wagon, remained in the barn. Not only was this the day for a new way of traveling, but these people had also come together to prepare a new way of thinking about arts and crafts that would change the future as well as the economics of the southern mountains.

In the years leading up to 1928, the southern mountain region had undergone great change. Isolated communities were becoming accessible as new roads were being built, trains came into the towns and villages, and a renaissance of mountain arts and crafts was occurring. In the 1870s and 1880s, teachers, missionaries, and social workers had arrived in the very poor, isolated mountain communities to establish settlement schools and medical clinics and to improve communication. The progress made in education and transportation during those years was leading them to think more about the economics of the arts and crafts community.

Frances L. Goodrich was one of these social workers. She left a life of wealth and culture to work among the people of the North Carolina mountains who had little opportunity for education or social enrichment. Like many of the other workers, she grew to love and respect her neighbors who worked so hard for so little. In her work for the Presbyterian Church Home Mission Board, she helped establish schools, churches, and a hospital.

Goodrich was not satisfied with her work for the mission board because she wanted to do more for the women of the community. Seeing how limited their lives were, she started weekday "mothers" meetings where they would have Bible lessons, health-care instruction, and sewing and cooking lessons. It was at one of these meetings that Mrs. William Davis brought Goodrich a "gift of pure neighborliness." It was a double bow-knot coverlet. Handwoven and dyed with the bark of the chestnut oak to a golden brown, the coverlet was the answer to Goodrich's quest to help the people with whom she lived and worked.

The geography of the mountains had made the people who lived there adept at making—or crafting, as we would say today—things used in everyday life. In many cases, this had been taken to the level of an art form. Could these old crafts be the answer to a better life for the people? Could the making and selling of crafts fulfill Goodrich's desire to promote the happiness of the women of the mountains? The question regarding the revival of the old crafts would start with weaving. Could coverlets be produced at a moderate cost by the women? Could a market be found that would pay a good price for them?

Goodrich began to seek answers among the women. Weavers were found, materials were located and prepared, and the project was started. When the coverlets were complete, Goodrich soon found buyers among her friends in the North. As the enterprise developed, it was not long

before other items—rugs, tufted bedspreads, quilts, baskets of all descriptions, wood carvings, and pottery—were being brought to the Allanstand home of Goodrich.

Allanstand Cottage Industries (named for Allan's Old Stand, a livestock stopover for drovers taking animals from Tennessee to market in South Carolina) was formed as the marketing arm for these products. Goodrich set three purposes for the cottage industry to achieve: saving the old arts from extinction, giving paying work to women too far from a market to find it for themselves, and, most importantly, bringing interest into their lives. The joy of making useful and beautiful things cannot be measured. By 1908, Goodrich had opened an Allanstand Cottage Industries shop in downtown Asheville, North Carolina, where there was a busy stream of tourists coming for the mountain air.

As the business thrived, more people from the mountain communities became interested in making products for sale in the shop. Goodrich wrote in her annual report to the Home Mission Board, "Monies made from the sale of their crafts have put a cow in the barn, shingles on the roof, and shoes on their children so they could go to school in winter."

Almost every area of the southern mountains had a settlement school or mission station that was leading the communities to develop their own resources. Handcrafts were the common thread among them. The workers stayed in touch with one another, often traveling from one area to another depending on where their expertise was needed. Under the leadership of John C. Campbell and the Russell Sage Foundation, an annual conference of Southern Mountain Workers was held in Knoxville, Tennessee. Here, people could share their plans, accomplishments, and dreams for the future. Much conversation was held about the occurring extinction of the arts and crafts among the mountain people. It became apparent that efforts like Allanstand Cottage Industries and others would be more powerful in the market if they joined together in some kind of cooperative effort.

This led to the meeting at Penland, North Carolina, in 1928. Olive Dame Campbell, the widow of John C. Campbell, had begun the discussion about coordinating the preservation, marketing, and training efforts of Berea College, John C. Campbell Folk School, the Spinning Wheel of Asheville, Tryon Toy Makers and Wood Carvers, Crossnore School, Allanstand Cottage Industries, Penland Weavers & Potters, Arrowcraft, and others. At Penland, during those snowy days in December, people representing these groups talked over the mountain handicraft situation, their hopes and fears, and practical problems. The Russell Sage Foundation had sent Allen Eaton, at the group's request, to offer guidance in the formation of an organization. Quality, marketing, and preservation of the mountain culture were the cornerstones of the new cooperative that was soon called a guild.

The next year, during a meeting held at the Spinning Wheel in Asheville, North Carolina, a membership structure was agreed upon. People who lived in the region defined by John C. Campbell as the Southern Highlands, which encompassed parts of nine states, would be eligible for membership. Members would pay yearly dues, and centers would have one vote and elect their voting member. All applicants would be required to be approved by the admissions committee and voted on by the entire guild membership. There have been only minor changes to this basic membership format over the years—a tribute to those forward-thinking founders who assembled the guild so many years ago. Final approval of the organization took place in 1930 at the Knoxville, Tennessee, meeting of the Southern Mountain Workers conference. By the spring of 1932, the guild had 25 members.

The biggest boost to the new organization occurred at the Asheville, North Carolina, meeting in 1929. Goodrich announced, through Clementine Douglas, that she was giving all rights to Allanstand Cottage Industries, the shop, and its contents to the newly formed guild. This immediately gave the guild a permanent home.

Today, a guild membership totaling nearly 1,000 stands on the shoulders of these women and men. This is our story of 90 years.

"Mission: Bringing together the crafts and craftspeople of the Southern Highlands for the benefit of shared resources, education, marketing, and conservation.

The Southern Highland Craft Guild (SHCG) is an educational, non-profit organization incorporated under the laws of the State of North Carolina to conserve and perpetuate the living arts and practices of hand craftsmanship of the Southern Mountains. The active membership of over 700 individuals and centers is from the counties within the Appalachian mountain regions of Kentucky, Tennessee, Virginia, West Virginia, North Carolina, South Carolina, Georgia, Maryland, and Alabama. The Guild is governed by a Board of Trustees elected from and by the membership.

Since 1930, the Guild has worked to instill and maintain standards of excellence in the design and workmanship of crafts taught, produced, and sold in the area. Workshops and demonstrations aid local groups in rural and urban locations throughout the mountains. Scholarships provide aid for craft research and training, and a library of books and slides gives valuable information to craft students for research as well.

Membership in the Southern Highland Craft Guild provides the well-earned tangible and intangible benefits associated with a long-standing, well-established and highly respected craft community in all levels of the crafts field. The significant national, regional, and local prestige of the Guild enhances each member's craft skill credentials through the high standards of craft technique, design, and execution required for membership.

The educational mission of the Southern Highland Craft Guild is to discover, preserve, and promote knowledge and appreciation of traditional and contemporary crafts of the Appalachian region. Educational programs include exhibitions, demonstrations, collections, and special events which are produced for craftspeople, students, and general public."

—From the Southern Highland Craft Guild members' handbook, revised April 2003

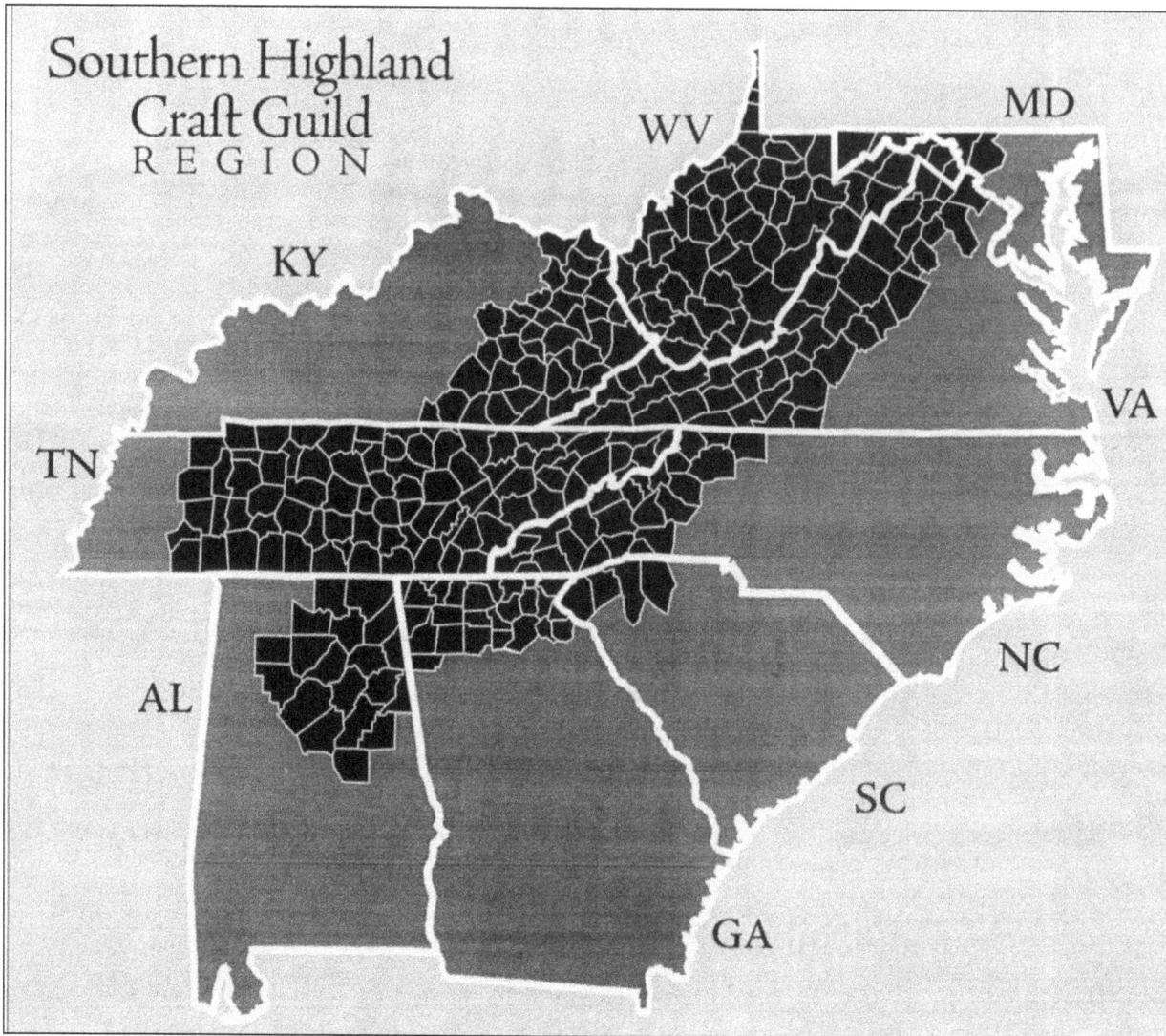

Southern Highland Craft Guild Region

KY

WV

MD

TN

VA

AL

NC

SC

GA

The Southern Highlands region was first delineated by John C. Campbell in his 1921 book *The Southern Highlander and His Homeland.* This region was used as a guide when Olive Campbell and members of the Conference of Southern Mountain Workers came together to discuss forming a cooperative. In 1950, a larger section of Tennessee was added to the map when the Southern Highlanders, a group created in the Tennessee Valley Authority (TVA) region, merged with the Southern Highland Craft Guild (SHCG).

One

THE EARLY YEARS
SOUTHERN MOUNTAIN WORKERS

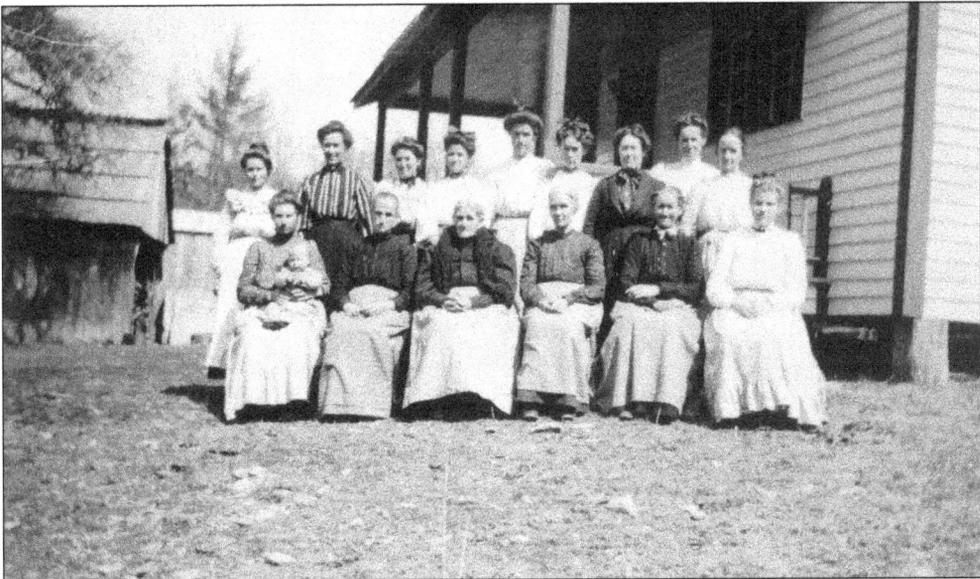

In 1890, the Appalachian Mountains were home to small communities and isolated farms. Traditionally, men had the mobility to trade and hunt, while women were tied to the farm by children and daily chores. Missionaries who came to the region, like Frances Goodrich, were struck by the conditions they found and worked to bring women into contact with the larger community. This photograph of the mothers' group at Allanstand, North Carolina, was taken by Goodrich after her arrival in the community in 1897.

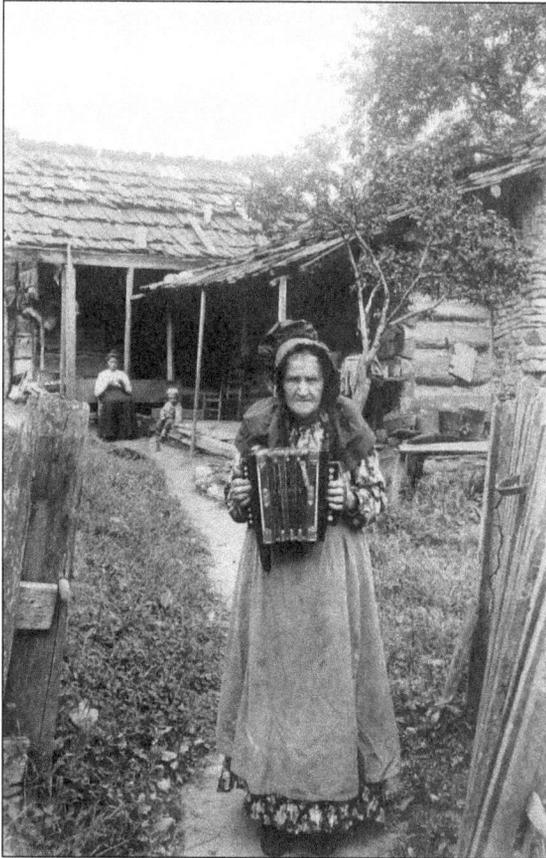

"Granny" Ealy Banks was one of the women with whom Frances Goodrich established a relationship. Granny Banks shared this cabin with her son and his wife and son. They were part of the community at White Rock, North Carolina. Goodrich also took photographs of Granny Banks with her flax tools to document that the old items were still in use. Granny Banks is shown holding a concertina.

Elmeda Walker was another woman who helped Frances Goodrich in continuing older traditions. Walker lived with her sisters in the mountains of Tennessee and had been involved in weaving for the Woodrow Wilson White House. She worked on a great (or walking) wheel, which was traditionally used by Scots-Irish immigrants. The text below the image was handwritten by Goodrich and notes that Walker was "a master hand."

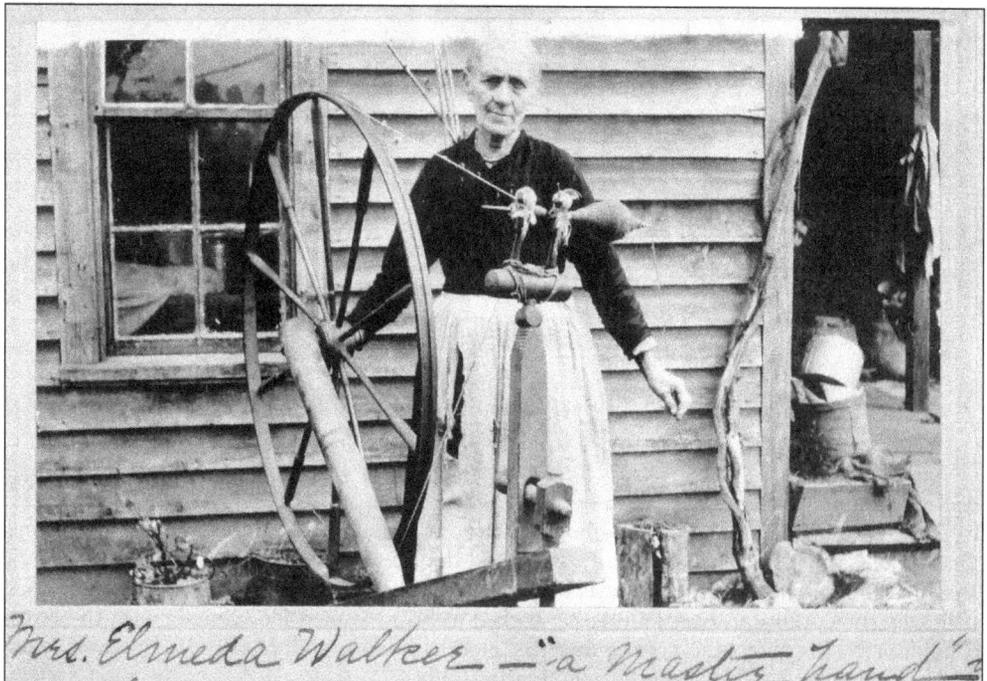

Mrs. Elmeda Walker — "a master hand"

People in this crowd around long picnic tables are well-dressed, with men in suits and ladies in fancy hats. The timber industry brought roads and resources to the mountains, while it also clear-cut most of the area. The craftspeople of Western North Carolina appreciated the educational and marketing opportunities that outsiders could provide. Sending mountain-crafted objects into a wider market provided a needed cash income to artisans.

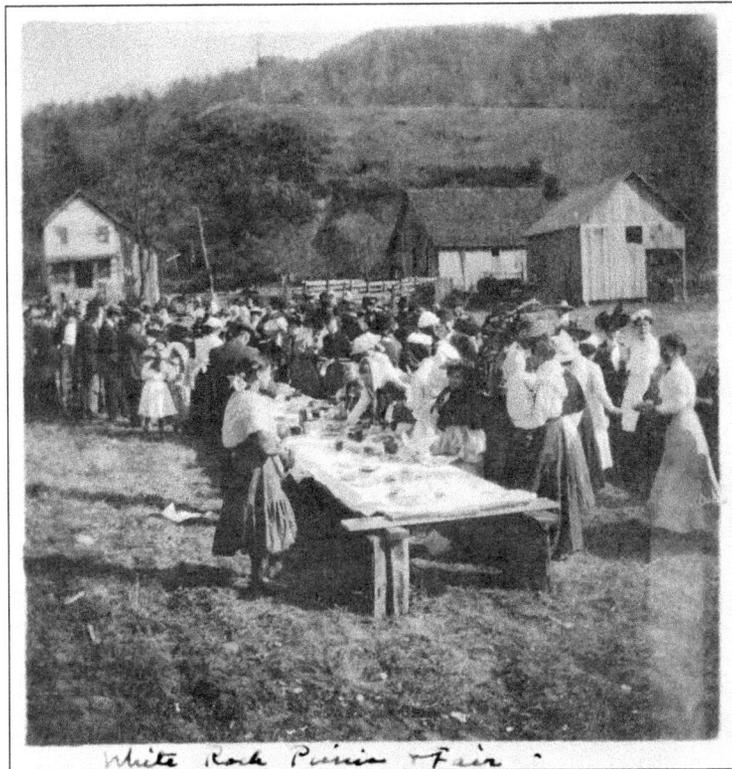

White Rock Picnic + Fair .

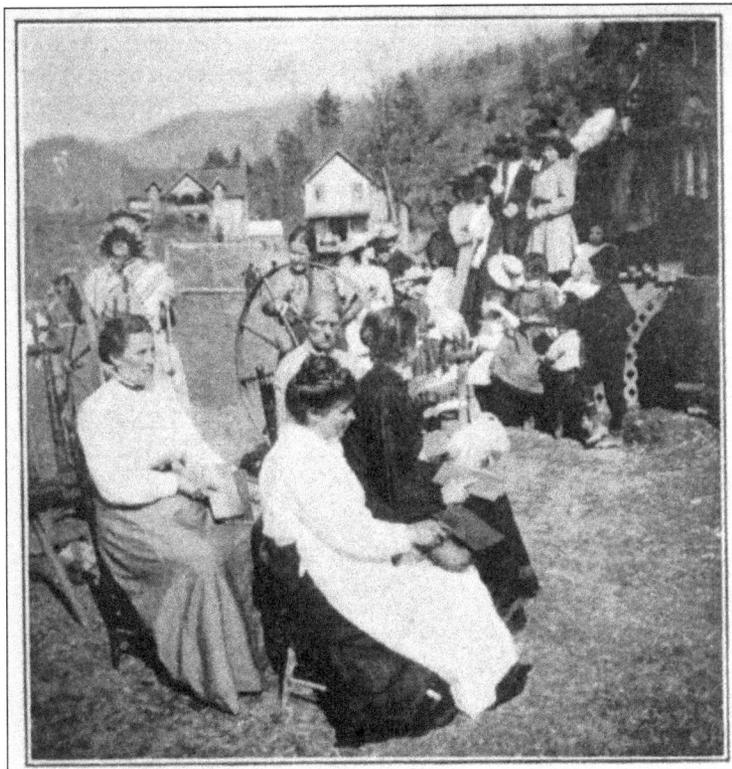

This postcard from the White Rock Fair shows a contest underway. The four women in the foreground are carding wool, which will be handed off to the two spinners working behind them at great wheels. Weavings in the mountains were often linsey-woolsey fabric, with wool forming the weft on a linen or cotton warp. Frances Goodrich focused each woman's energies on the job that she did best.

13

Frances Louisa Goodrich was born in 1856 and came to the mountains when she was 31. She stayed active in the community and guild until her death in 1944. She studied art at Yale College and received a "Recognition of Attendance" for her years of study since women could not earn a degree. She had traveled through Europe (probably in the 1870s) and lived in New York City before coming to Asheville, North Carolina. She is especially remembered for the number of mountain weaving drafts that she collected and preserved. Although she was not a weaver, she learned to read the draft strip and could interpret each formula into a diagram of how the weaving would look. In the example below, "Leaf and Snowballs," the strip of numbers on the left provides the information to create the pattern drawn on the right.

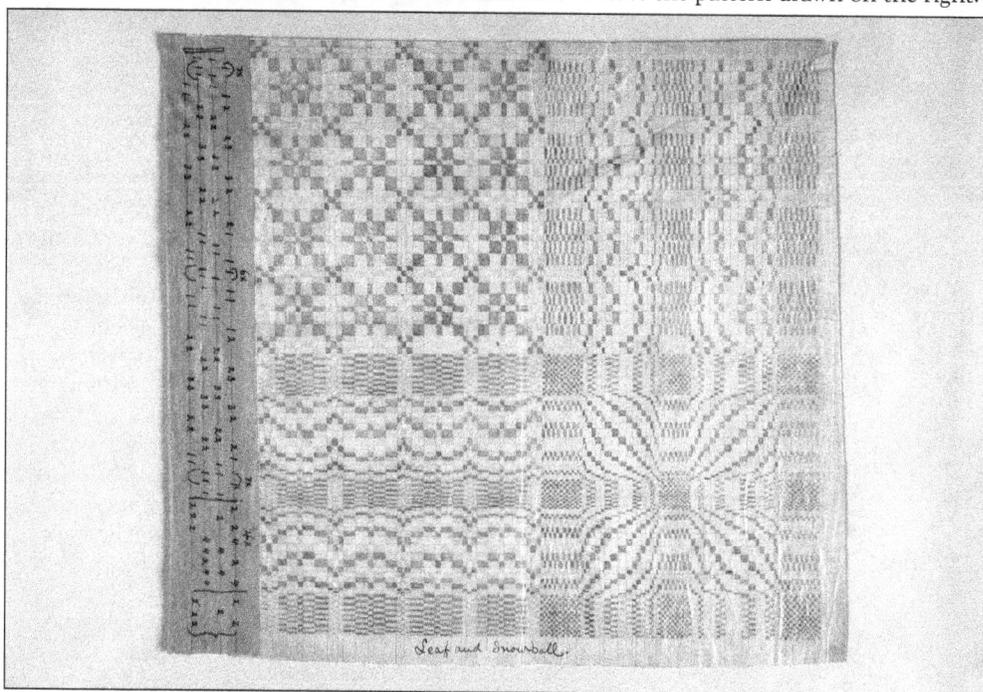

Leaf and Snowball.

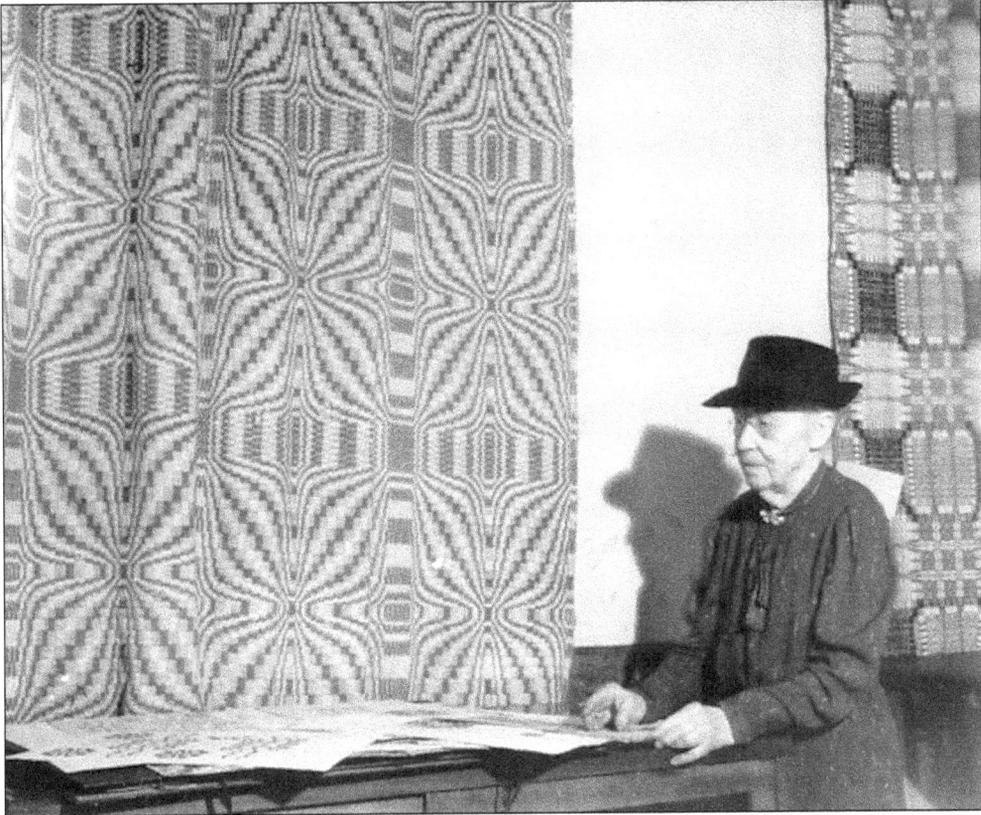

Frances Goodrich often credited the gift of an old brown coverlet (shown above with Goodrich) as the inspiration for her cottage industry. "Cottage industry" was an English phrase used during the Arts & Crafts period of art history in response to the early industrial age that flooded the economy with machine-made fabrics and household items, putting small home businesses out of work. The home businesses were also known as fireside industries. In the 1900s, Goodrich collected people's work and sent it to Asheville, North Carolina, from where it was shipped to shops and friends of hers in the north. In the below photograph, Goodrich stands with her hand on the cart. Most of her work was done on horseback as she visited weavers, spinners, and dyers.

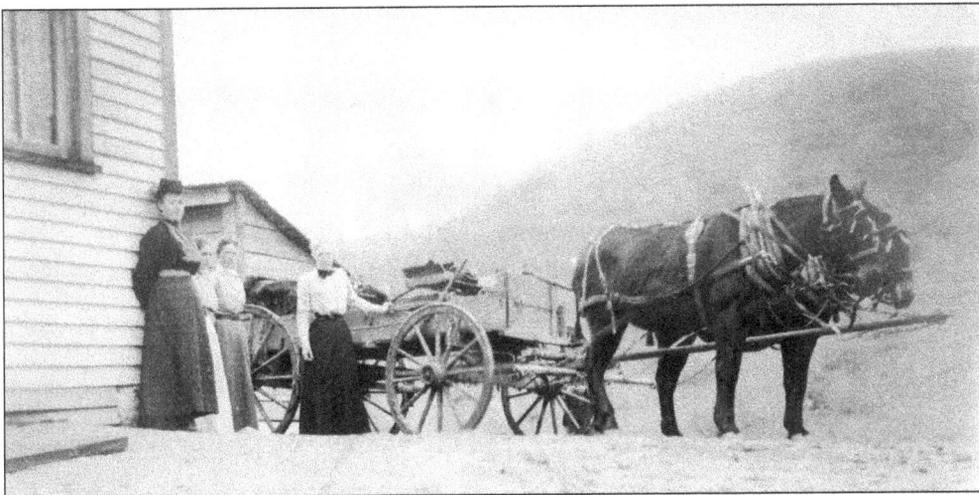

Allanstand
Cottage Industries

EXCHANGE FOR
MOUNTAIN HANDICRAFT
6 GOVERNMENT ST.
ASHEVILLE, N. C.

In 1902, Frances Goodrich opened Allanstand Cottage Industries as a roadside shop. The building was made from the logs of the original Allen's Old Stand, an inn for drovers moving herds of pigs and turkeys through the mountains to market. She sold shares in her new endeavor with the understanding that investors would not receive dividends. All funds would be returned to the people and communities she served. As new roads were created, traffic was diverted away from the Allanstand Shop, so Goodrich made the decision to move the shop to Asheville, North Carolina, around 1908. The city was entering a period of growth with the completion of the Biltmore Estate and the Grove Park Inn. Tourists were coming to the mountains for scenery and healthy air. Goodrich's Allanstand Cottage Industries logo is reflected in today's Southern Highland Craft Guild logo (pictured on page 9).

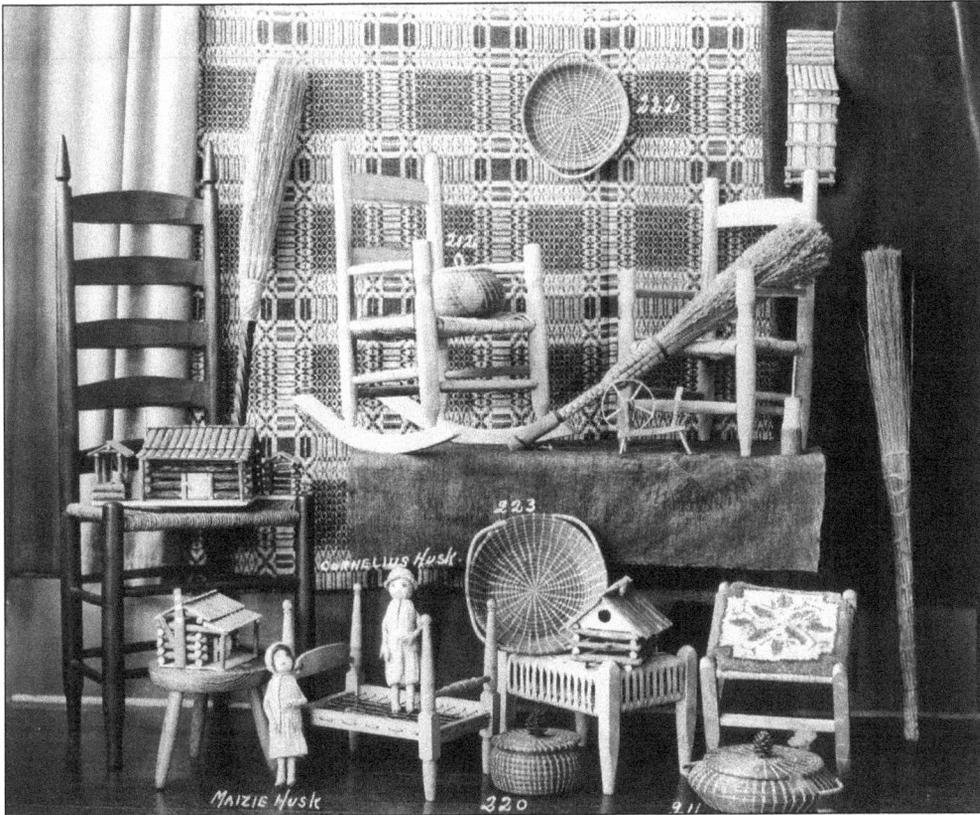

The display pictured above was used in a brochure for Allanstand Cottage Industries. Pine-needle baskets and brooms have pride of place in the arrangement, with a woven coverlet as the backdrop. A small sample of hooked rug work is displayed on a footstool. The ladder-back chair is finished with "mule ears," and several children's toys are displayed. The "Husk Family" of corn-shuck dolls was a patented design, with the royalties going to benefit Allanstand Cottage Industries. The dolls came in sizes ranging from three feet tall to pocket-sized. The shop also sold metalwork, wood carvings, quilts, and split-oak baskets.

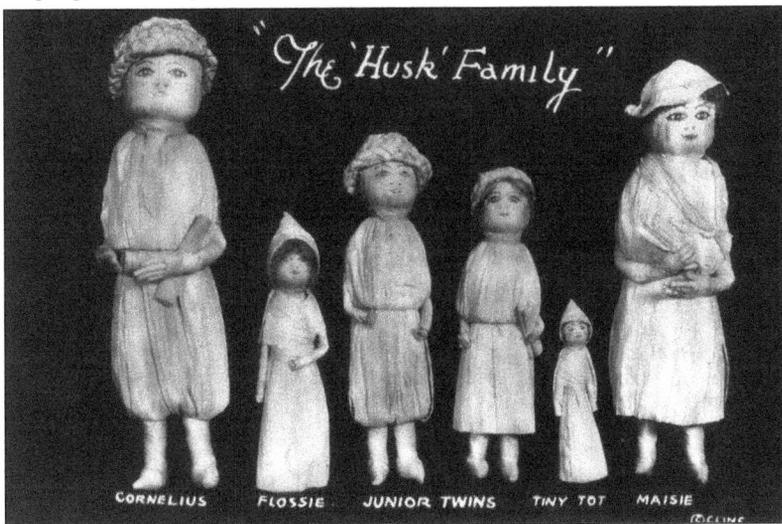

Olive Dame Campbell (1882–1954) was another avid supporter of mountain crafts. She came to the mountains in 1909 with her husband, John C. Campbell, who was an educator sponsored by the Russell Sage Foundation to survey the needs of Southern Appalachian communities. They organized the Southern Mountain Workers Conference, which met once a year in Knoxville, Tennessee, so people and organizations in the region could share information and give support to each other. After John's death in 1919, Olive took a more active role in the Russell Sage Foundation program and worked with Alan Eaton. It was her vision to bring the crafting community together for greater impact and further education. She founded the John C. Campbell Folk School in 1925 to educate farmers and support home industries.

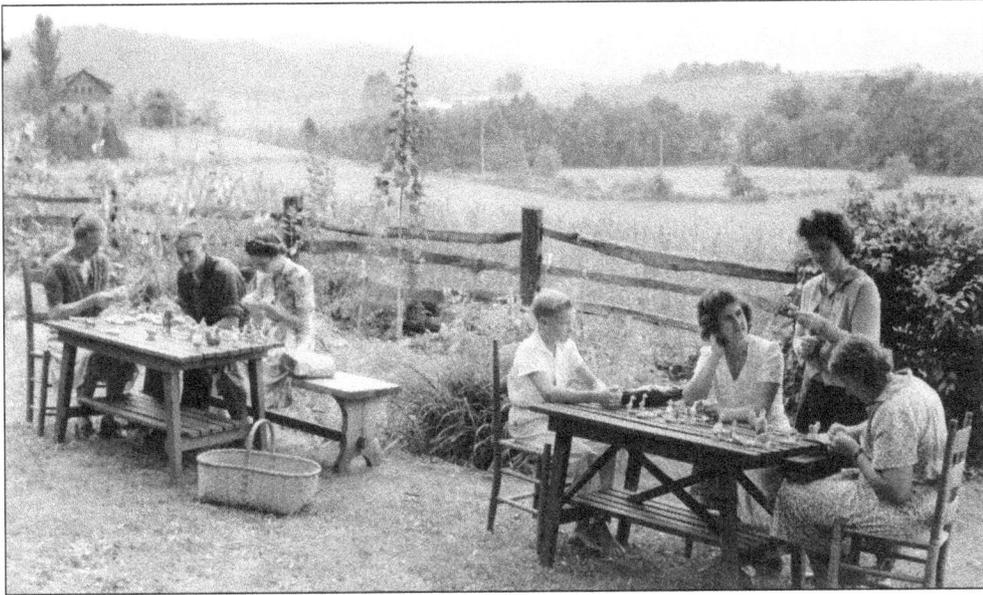

Wood carving was a popular pastime in the mountains. Men gathering to talk would whittle away at whatever was at hand, including the old bench at the general store. Seeing this, Olive Campbell decided to focus on refining their techniques and creating a market. Some of the early carvers are shown here at tables set up at the John C. Campbell Folk School. (Photograph by Hemmer Photography.)

An informal group that became the Brasstown Carvers filled a social and economic need in the rural community. This photograph of a display from the 1950 Craftsman's Fair shows a sample of their carvings. The group continues today and is a consistent source of revenue for the John C. Campbell Folk School, where wood carving and other crafts are taught.

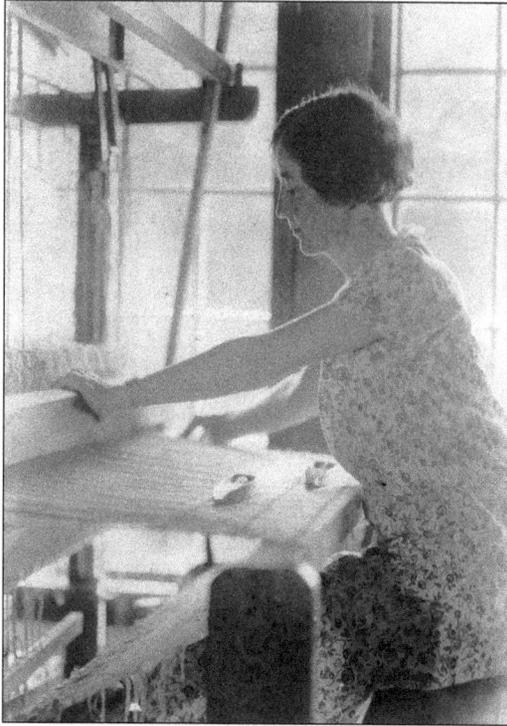

Lucy Morgan (1889–1981) was born in the Western North Carolina mountains. Through her work at the Appalachian School, a church-sponsored boarding school in Penland, North Carolina, she became aware of the many weavers in the region. She traveled to Berea College in Berea, Kentucky, to learn to weave and returned with knowledge and a better loom design. She established a system where weavers could come to the school for the fibers they needed and later sell the items they had created. When a workplace/weaving cabin (pictured below) was required, people in the community brought the supplies to construct a weaving house where Morgan could distribute supplies and assist weavers. Once the Appalachian School closed, Penland Weavers and Potters became the focus of teaching. Soon, a larger weaving hall was needed. As the campus grew, it became a destination for craft artisans.

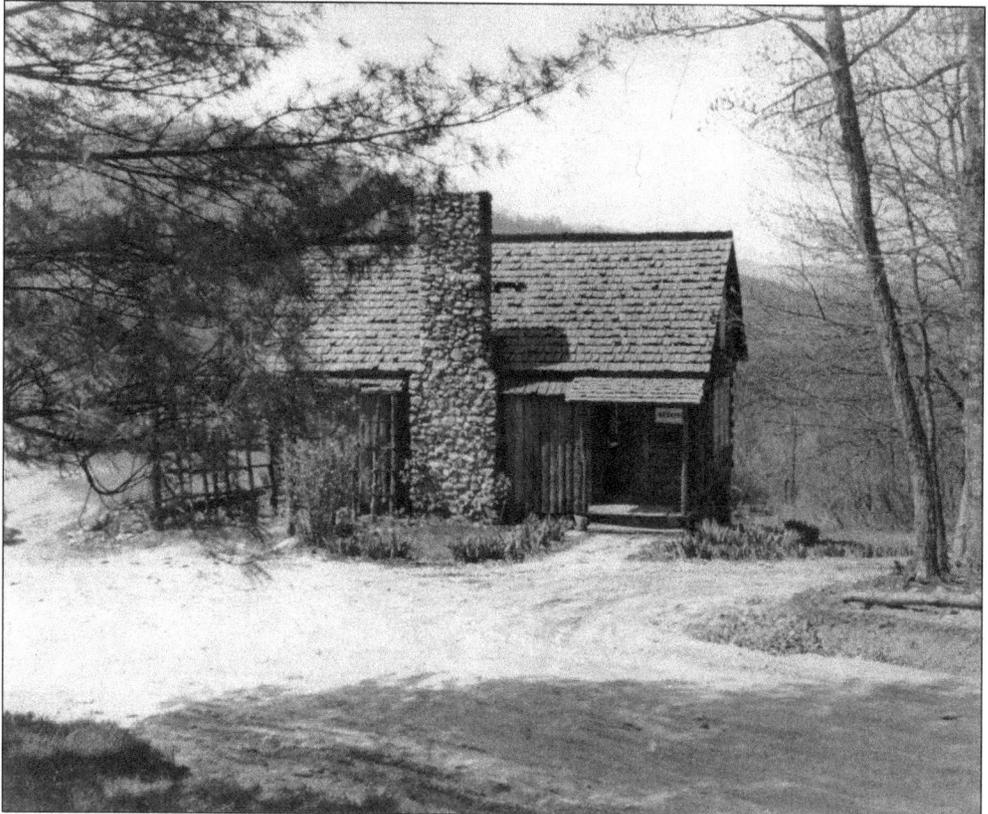

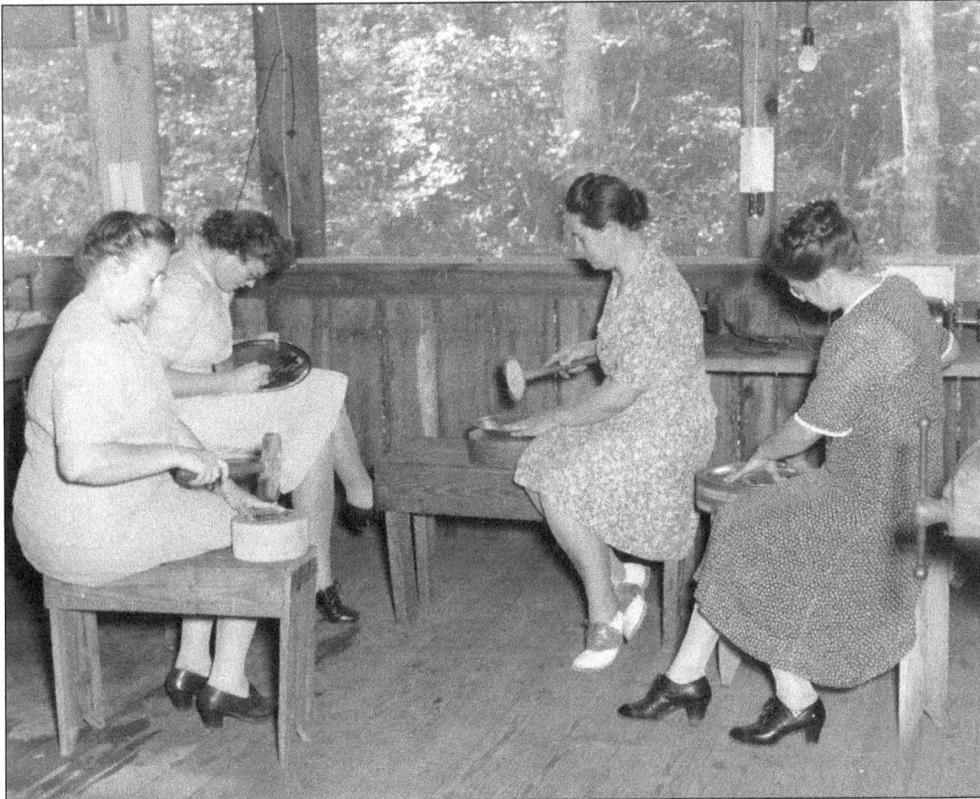

Throughout the 1920s, Penland Weavers and Potters taught craft classes and summer art programs. Weaving, pottery, and pewter work were among the classes offered. Pewter work was a popular craft for the rehabilitation of World War I veterans and was taught as physical therapy at the Veterans Hospital in Oteen, North Carolina.

Rufus Wyatt was one of the Penland Potters. He was photographed in the 1930s by Bayard Wootton, who built a reputation on pictures she took around the Appalachian region. Wootton was a cousin of Lucy Morgan and took several excellent photographs of the early Penland campus. (North Carolina Collection, University of North Carolina Library at Chapel Hill.)

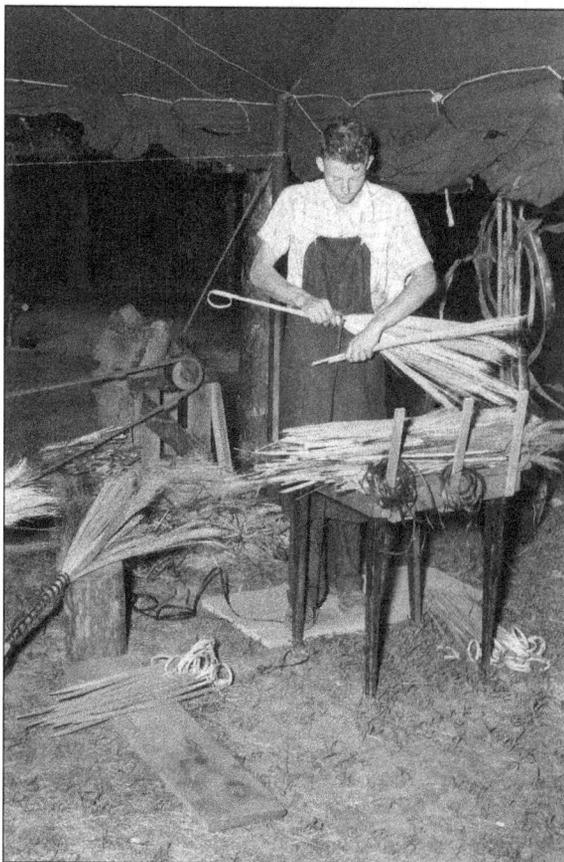

Berea College in Berea, Kentucky, became an early promoter of regional crafts. In 1904, Berea College was prohibited from following its mandate to be an integrated institution of higher learning; therefore, Berea College president William Goodell Frost turned his attention to helping the mountain communities. He focused on crafts as a source of income both to help students pay tuition and to assist the families associated with the school. Berea College Student Industries provided training and revenue for college students, while the Berea Fireside Industries provided a marketplace for local work. Broom-making was a popular demonstration for Berea College students, as shown in the photograph at left from the 1948 Craftsman's Fair. Skilled craftspeople taught weaving and furniture-making as well. The Berea craft fair became an annual event at the college.

The Pi Beta Phi women's fraternity established a school in Gatlinburg, Tennessee, and also found a community of weavers. Their Arrowcraft Shop was used as an educational and marketing center for weavers, who could pick up fiber materials and new designs while selling finished work. Many of the pieces were sold to fraternity members to raise funds for the school and health center. "Aunt" Lizzie Regan is shown below spinning on a great wheel. Note the rolls of fiber ready to hand. When a public school replaced the Pi Beta Phi Settlement School, the campus turned its focus to craftwork and expanded the programs offered. The Arrowmont School of Arts and Crafts continues to serve a varied community of people interested in weaving, woodcraft, and pottery. (Below, Arrowmont School of Arts and Crafts Collection and Betsey B. Creekmore Special Collections and University Archives.)

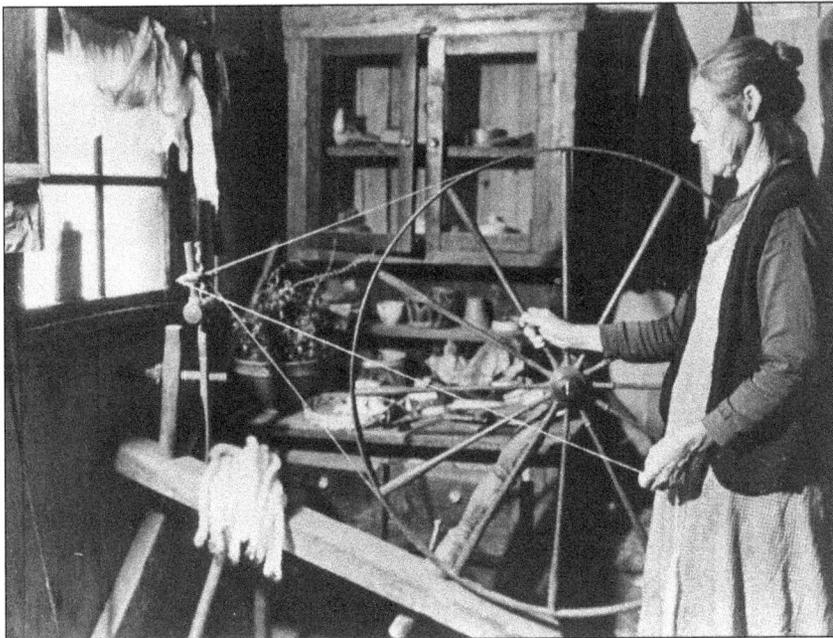

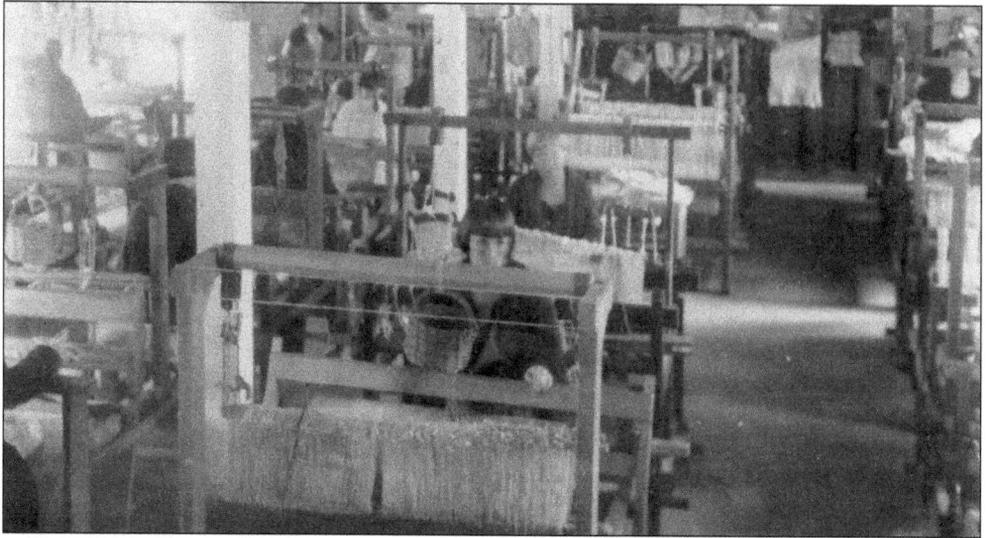

Crossnore School was established in 1913 by Drs. Eustace and Mary Martin Sloop as a boarding school for mountain children. It also became a focus for weavers as community involvement and the need for funds found a familiar Appalachian solution. This photograph from an early brochure shows the inside of the loom house. Many of the women were experienced weavers willing to share their expertise.

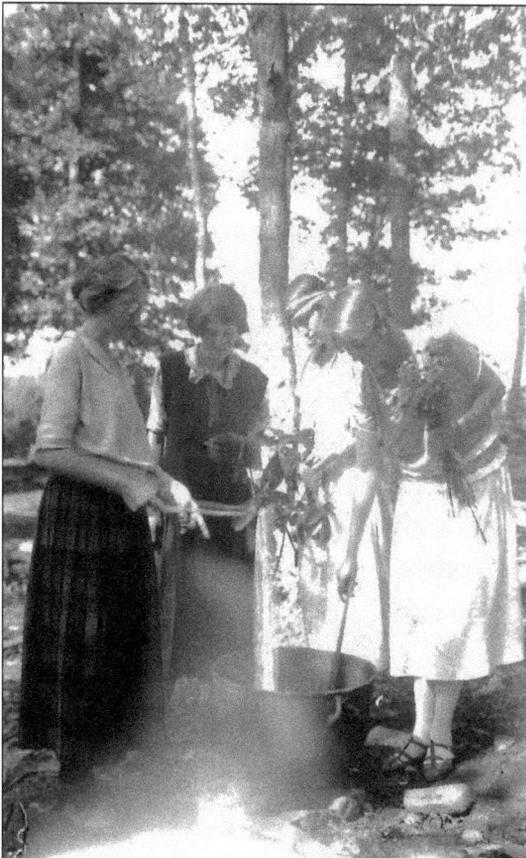

Crossnore School weavers were taught to spin and dye as well as weave. Here, a group gathers around a dye-pot, where they are being instructed by "Aunt Newbie" (Newbern Johnson), who managed the shop and taught at the school as well as raising her own family. As times changed, she helped Crossnore transform into the present boarding school for children with special needs.

One other name is included with the guild founders: Clementine Douglas (1893–1967), who spent summers during her college years working at mountain settlement schools in Kentucky. In 1925, Douglas settled in Asheville, North Carolina, where she repurposed an abandoned log cabin to serve as a loom house and shop. She taught young women to weave and operated a successful tourist shop on the outskirts of town. She continued to be very active with the guild and the Southern Highlanders. Many of the weavings for sale at her shop included a laid-in design of dogwood or scenes of mountain life. The women were encouraged to create their own unique patterns. The covered wagon shown below was designed and executed by Mae Etta Howard Deweese.

Allen Eaton (1878–1962) was very involved in the early years of the guild. After the death of John C. Campbell, he came to the mountains as a representative of the Russell Sage Foundation to continue creating opportunities for development and education. Eaton was especially instrumental in arranging exhibitions and making contacts with the US National Park Service (NPS) in Washington, DC. His interest in crafts took him to numerous locations, including New Hampshire, where he worked with the state government to form a guild there, and to India. He returned from his travels with items that he used in lectures to raise awareness of the role crafting plays in cultures around the world.

Two

THE 1930S

GUILD FORMATION

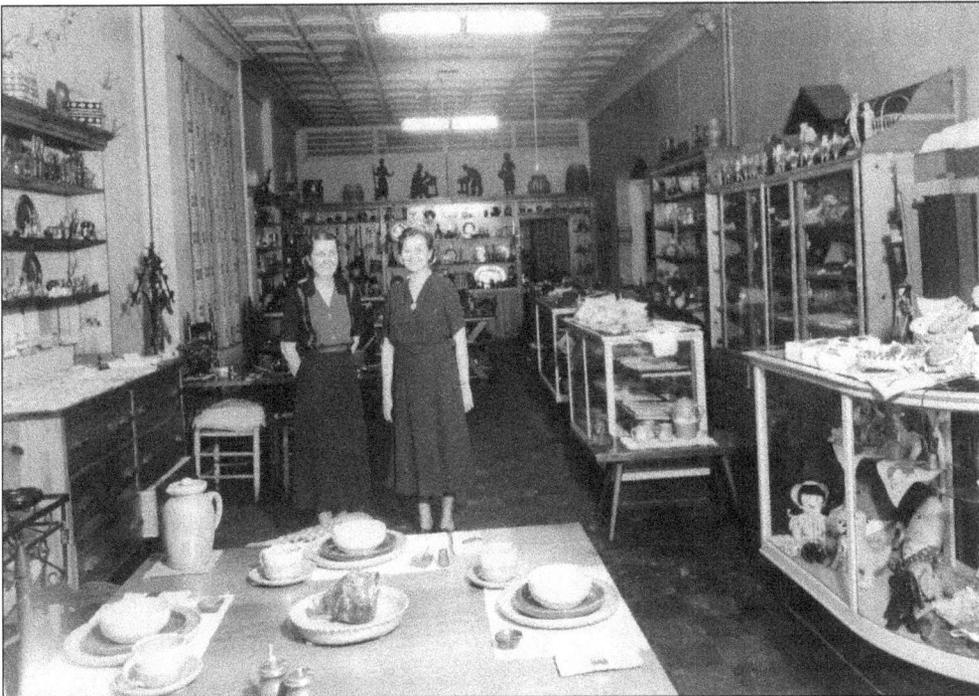

In 1930, the Southern Mountain Handicraft Guild (later the Southern Highland Craft Guild) was officially launched at the Southern Mountain Workers Conference. It was the beginning of the Great Depression, and the timing could not have been better for mountain communities. Frances Goodrich generously turned over her Allanstand Cottage Industries shop in downtown Asheville, North Carolina, to guild management. This gave guild members immediate access to an established market.

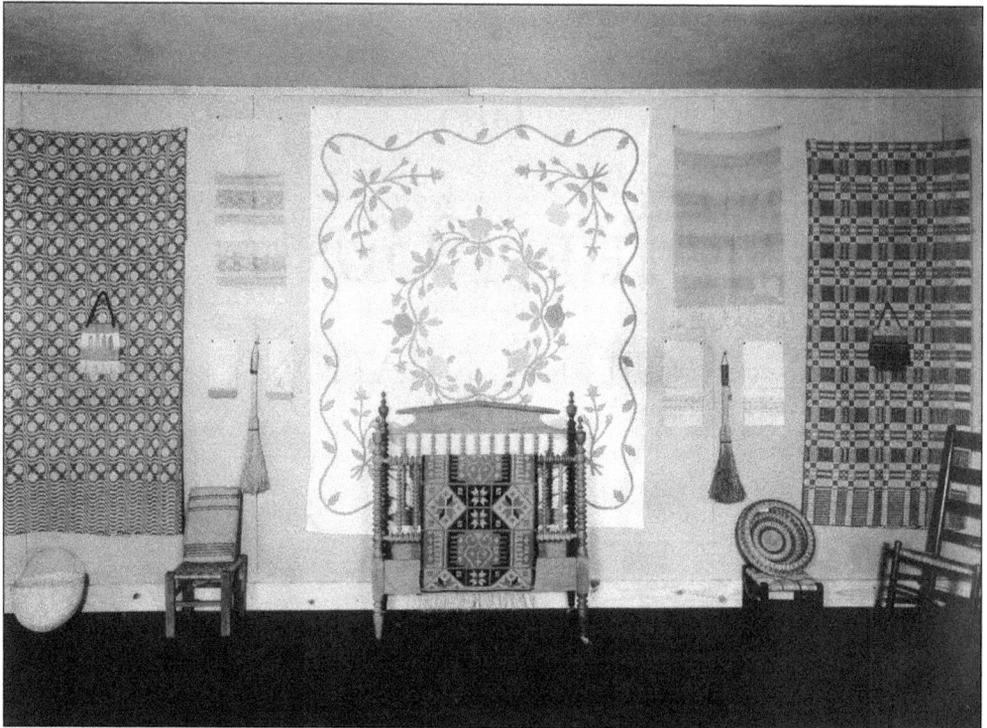

An inaugural guild exhibition was designed, with direction from Allen Eaton, for the Southern Mountain Workers Conference in 1930. Reports vary about the number of participants—between 14 and 32 guild center members—but certainly, many works came from Allanstand, Penland Weavers and Potters, Berea College Student Industries, and Arrowcraft. Hooked and woven rugs, coverlets, and quilts have pride of place on the sectional divides. Small rooms were created and decorated to show how crafts could be used in everyday living. The tables would have displayed clay and pewter works as well as Brasstown carvings. This successful first exhibition was repeated at the conferences in 1931 and 1932. (Both, Tennessee Conservation Department.)

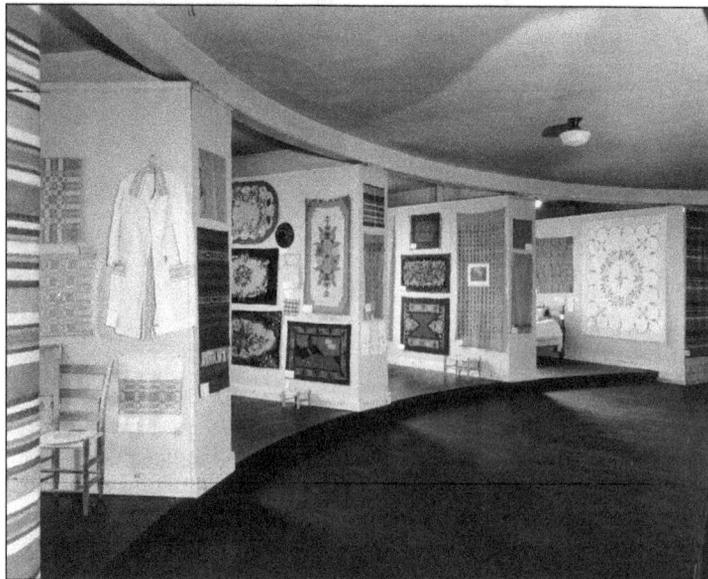

Allen Eaton and Lucinda Crile curated an exhibition in Washington, DC, for the US Department of Agriculture. This exhibition, *Rural Handicrafts in the United States*, included works from nearly every state in the nation. Because of Eaton's close ties to the guild, there were many items from the Appalachian states. The Spinning Wheel's covered wagon and Granny Donaldson's crocheted figures are visible on the right side of the below photograph. The large black-and-white panels are from photographs by Doris Ulmann, who did a series of Appalachian portraits that Eaton used in his book *Handicrafts of the Southern Highlands*. Ulmann met with guild leaders and visited several homes and workshops, often staging scenes to create a more rustic setting. (Both, Horydczak Photography.)

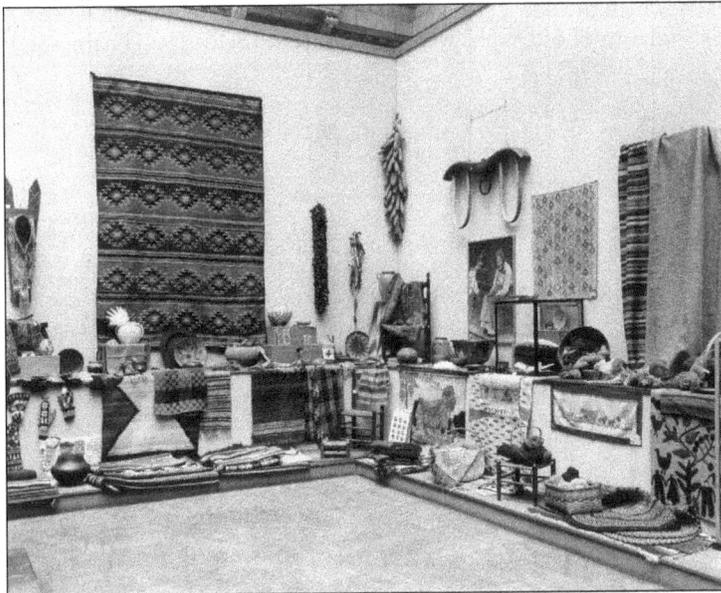

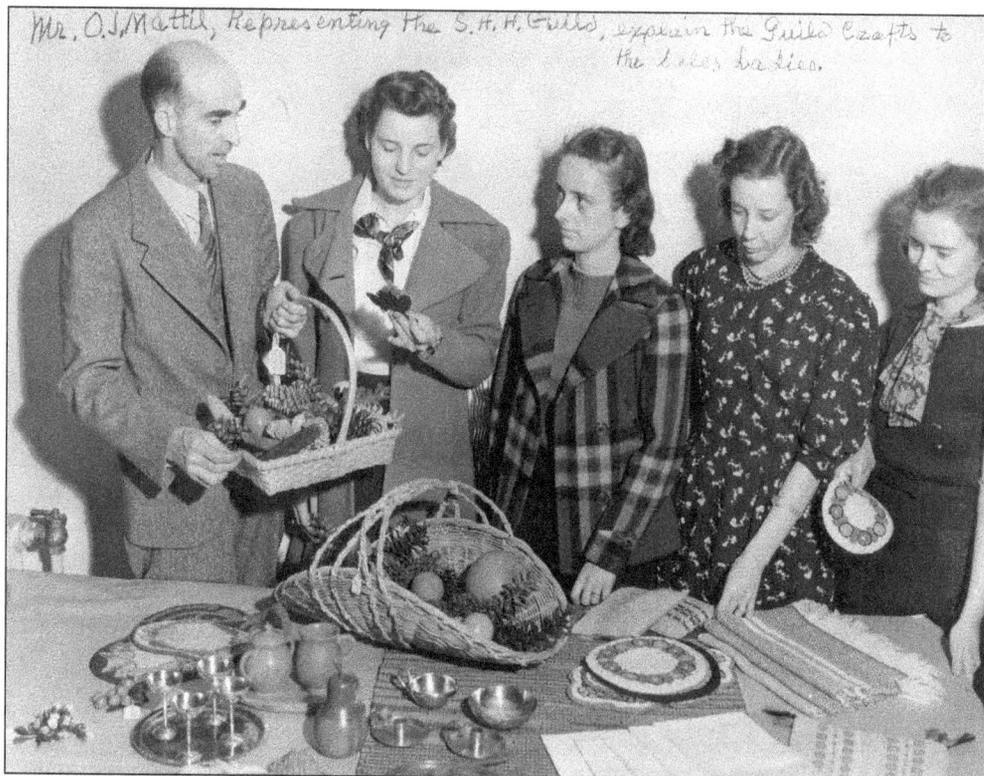

Mr. O.J. Mattil, Representing the S.H.H. Guild, explain the Guild Crafts to the Sales Ladies.

The note on the above image reads, "Mr. O.J. Mattil, Representing the S.H.H. Guild, explain the Guild Crafts to the Sales Ladies." Mattil did woodwork and taught at Berea College. He is shown working with the Tennessee Extension Service to organize an exhibition and sale in 1935. Arranged on the table are hooked mats, pewter work, pottery, baskets, and woven items. The woman next to Mattil is admiring a corsage made of natural materials and designed to be worn on the wide lapels that were popular at the time. The below photograph shows some of the items in the exhibition, which include a great wheel, a coverlet, and a hexagonal skein winder. Small copies of Doris Ulmann's photographs were also on view. (Below, Jim Thampson.)

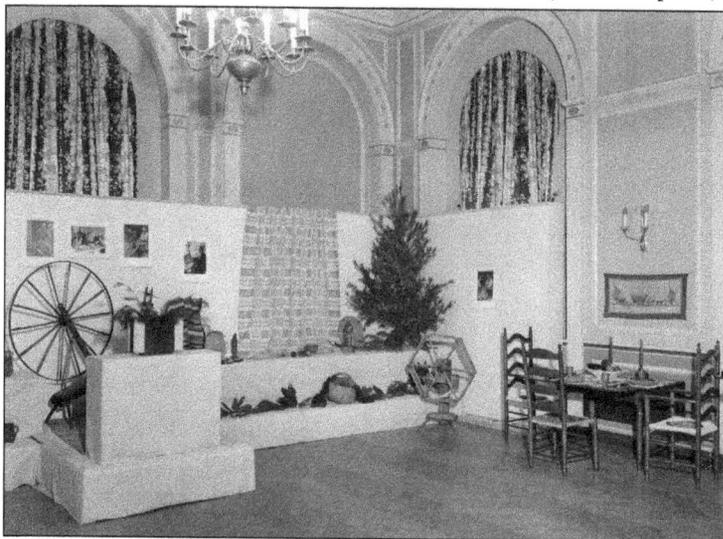

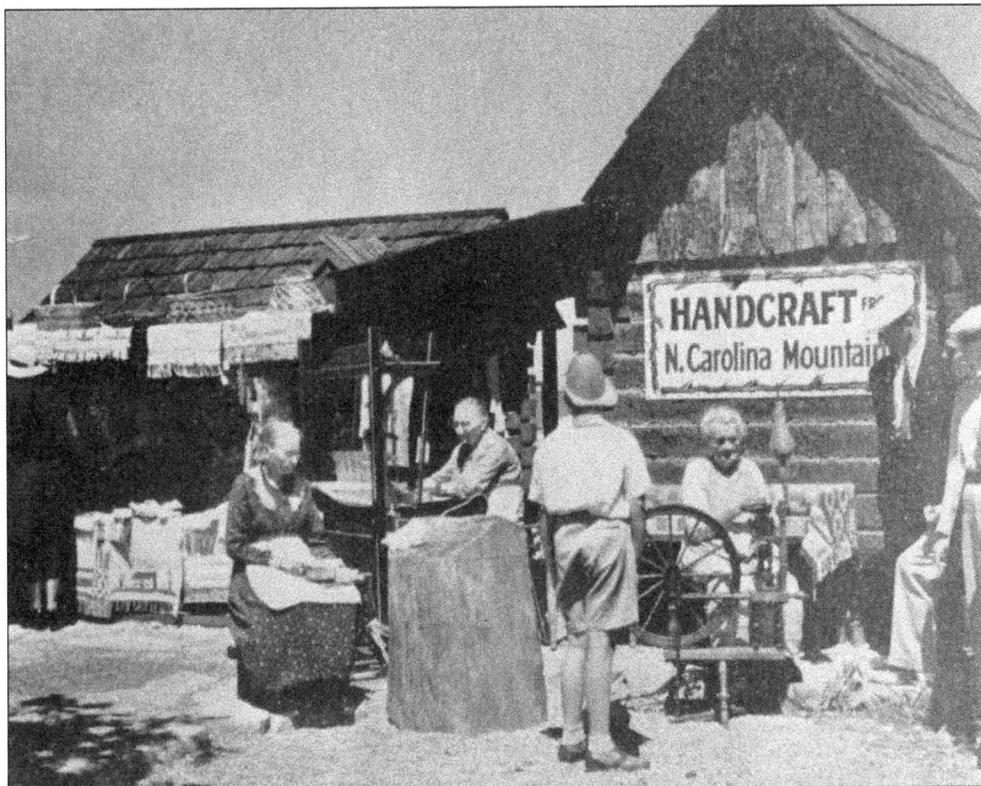

Lucy Morgan organized a group from Penland to represent Appalachian crafts at the 1933 Chicago World's Fair. In the above photograph, women prepare flax for weaving. The figure at left is carding the fiber. She would pound the stalks of the plant on the stump in front of her in order to break up the stems. On the right, a woman is spinning flax. Her spinning wheel has a distaff that is wrapped with fiber. In the center, a weaver sits at her loom weaving linen. (Arrowmont School of Arts and Crafts Collection and Betsey B. Creekmore Special Collections and University Archives.)

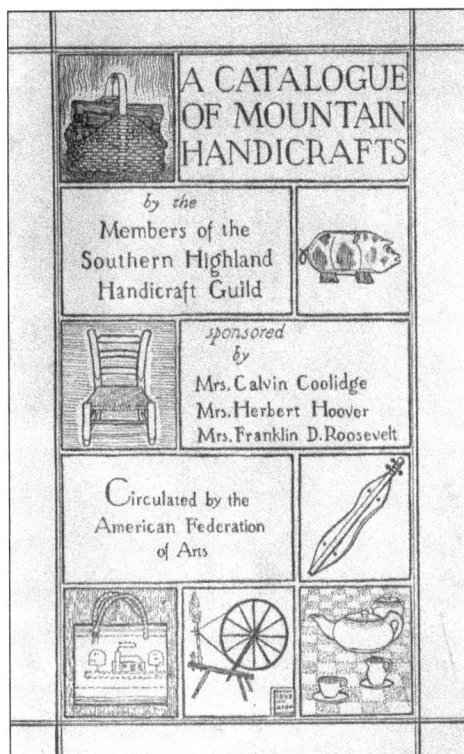

A CATALOGUE OF MOUNTAIN HANDICRAFTS

by the Members of the Southern Highland Handicraft Guild

sponsored by
Mrs. Calvin Coolidge
Mrs. Herbert Hoover
Mrs. Franklin D. Roosevelt

Circulated by the American Federation of Arts

The American Federation of Arts and the American Country Life Association hosted an exhibition of SHCG members' work for a 1933 conference in Blacksburg, Virginia. After the conference, the show traveled to 10 cities around the country. Visitors could place orders for items in the show. These requests were returned to the guild centers to be filled. The tour lasted from 1933 through 1935.

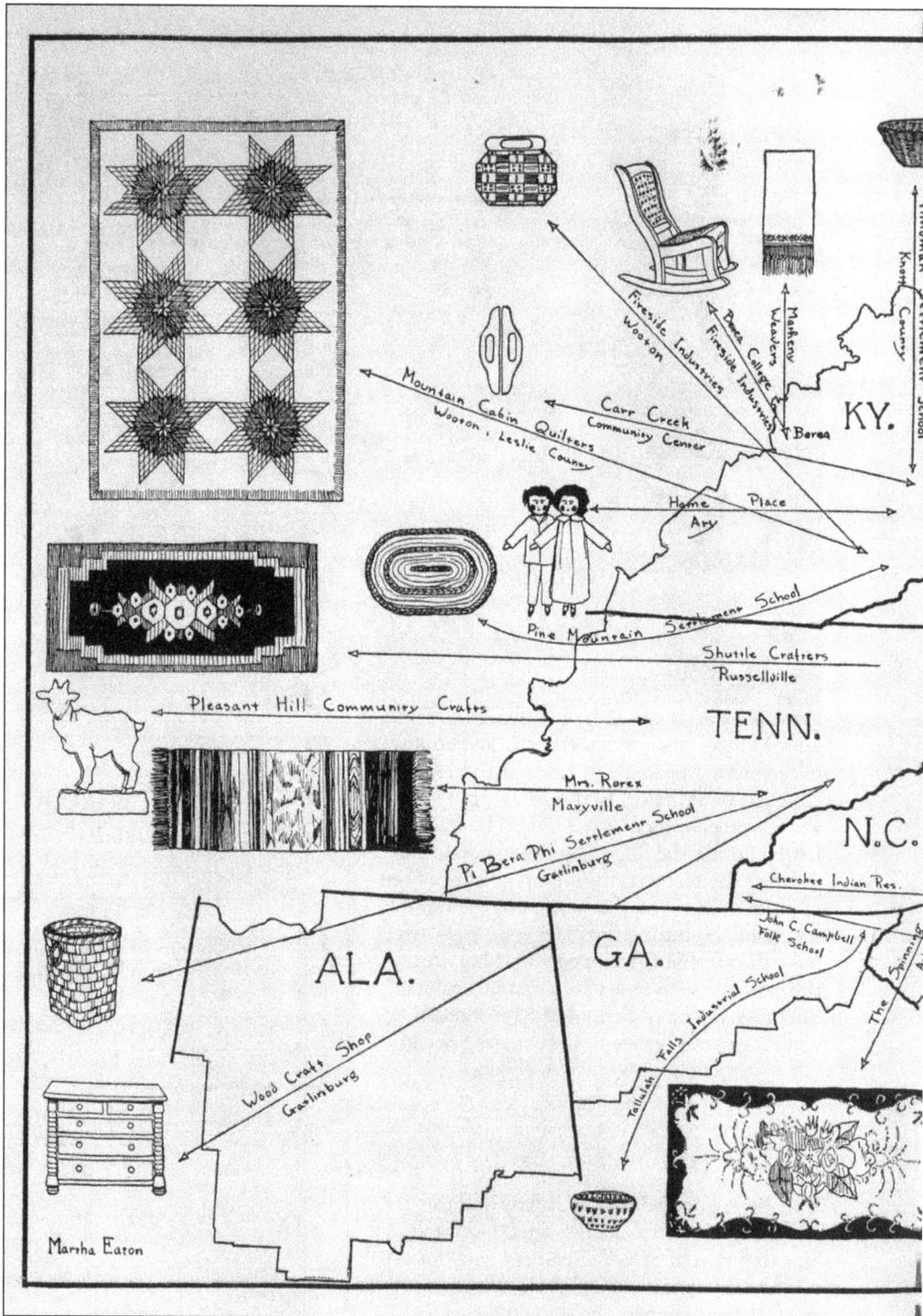

The map labels, as they appear:

- Dingman Settlement School
- Knott County
- KY.
- Berea
- Bera College
- Fireside Industries
- Fireside Industries
- Wooton
- Marvey Weavers
- Mountain Cabin Quilters
- Wooton, Leslie County
- Carr Creek Community Center
- Home Place
- Ary
- Pine Mountain Settlement School
- Shuttle Crafters
- Russelville
- Pleasant Hill Community Crafts
- TENN.
- Mrs. Rorex
- Mayville
- Pi Beta Phi Settlement School
- Gatlinburg
- N.C.
- Cherokee Indian Res.
- John C. Campbell Folk School
- The Spinning
- ALA.
- GA.
- Wood Craft Shop
- Gatlinburg
- Tallulah Falls Industrial School
- Martha Eaton

This map is taken from the American Federation of Arts catalog for the guild's first traveling exhibition. It shows the variety of places and items that were part of the display. According to a magazine account of the exhibition, the show featured 586 craft works from 33 centers. The second stop for the exhibition was in Washington, DC. There, it was visited by Pres. Franklin D. Roosevelt

32

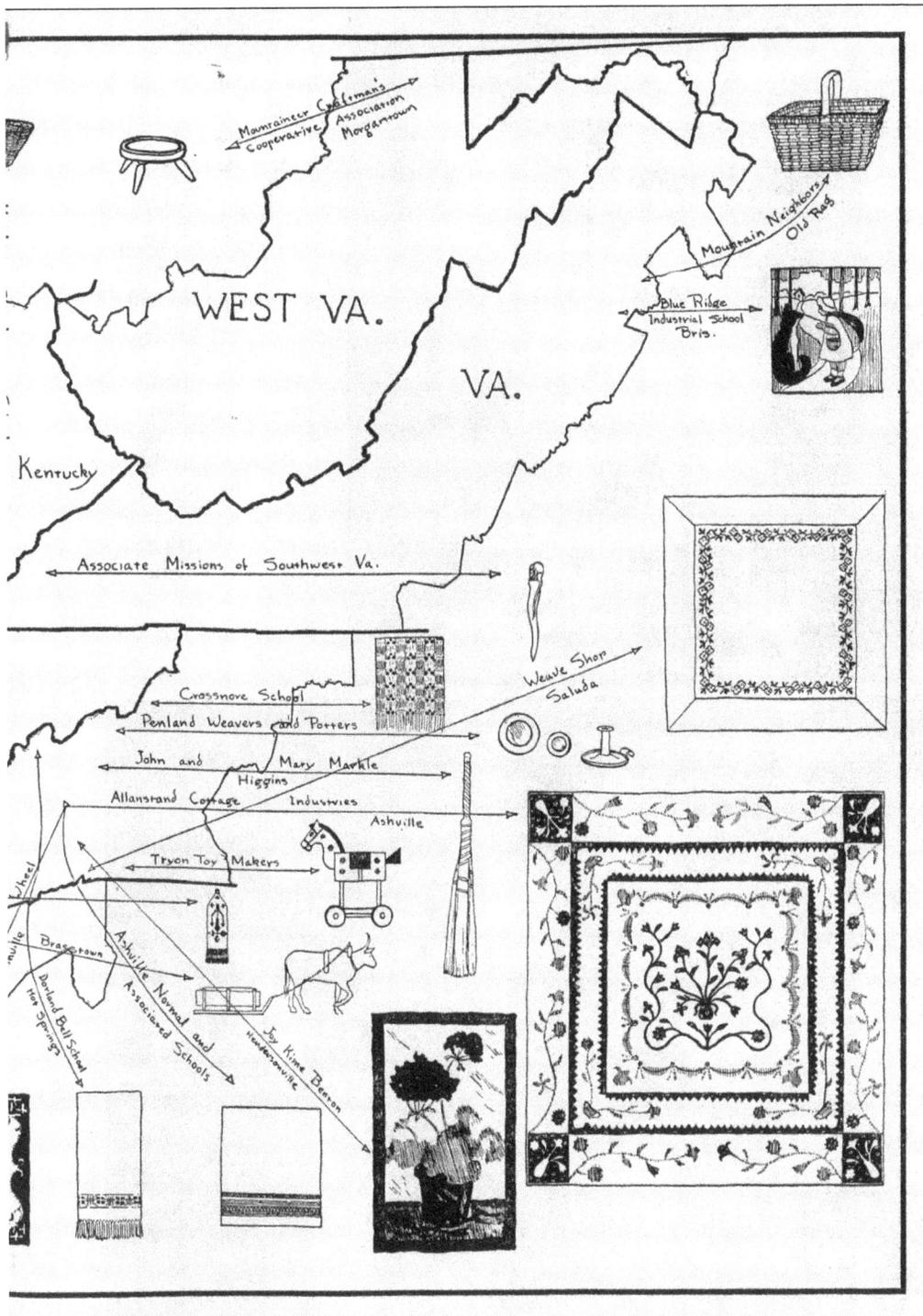

Mountaineer Craftsmans Cooperative Association Morgantown

WEST VA.

VA.

Kentucky

Mountain Neighbors Old Rag

Blue Ridge Industrial School Bris.

Associate Missions of Southwest Va.

Weave Shop Saluda

Crossnore School

Penland Weavers and Potters

John and Mary Markle Higgins

Allanstand Cottage Industries

Ashville

Tryon Toy Makers

Joy Kime Benson Hendersonville

Ashville Normal and Associated Schools

Brasstown

Penland Bell School Hot Springs

and First Lady Eleanor Roosevelt. The exhibition then traveled to Brooklyn, New York; Decatur, Illinois; Omaha, Nebraska; St. Louis, Missouri; Scranton, Pennsylvania; Milwaukee, Wisconsin; Norfolk, Virginia; and finally, Berea, Kentucky. Martha Eaton did the drawings shown here.

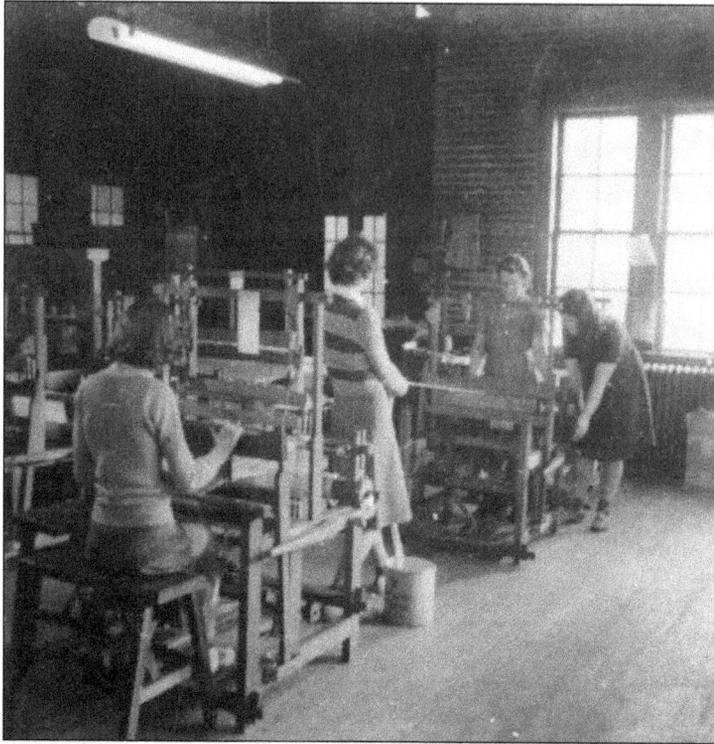

The guild leaders continued to locate more mountain craft groups. They sought out schools and centers in order to facilitate teaching and quality control. This photograph was taken in the weaving studio at Asheville Normal School, a boarding school for women. Frances Goodrich was involved there during her first visits to the region in the 1880s. The program was managed for many years by Alice Pratt (second from right).

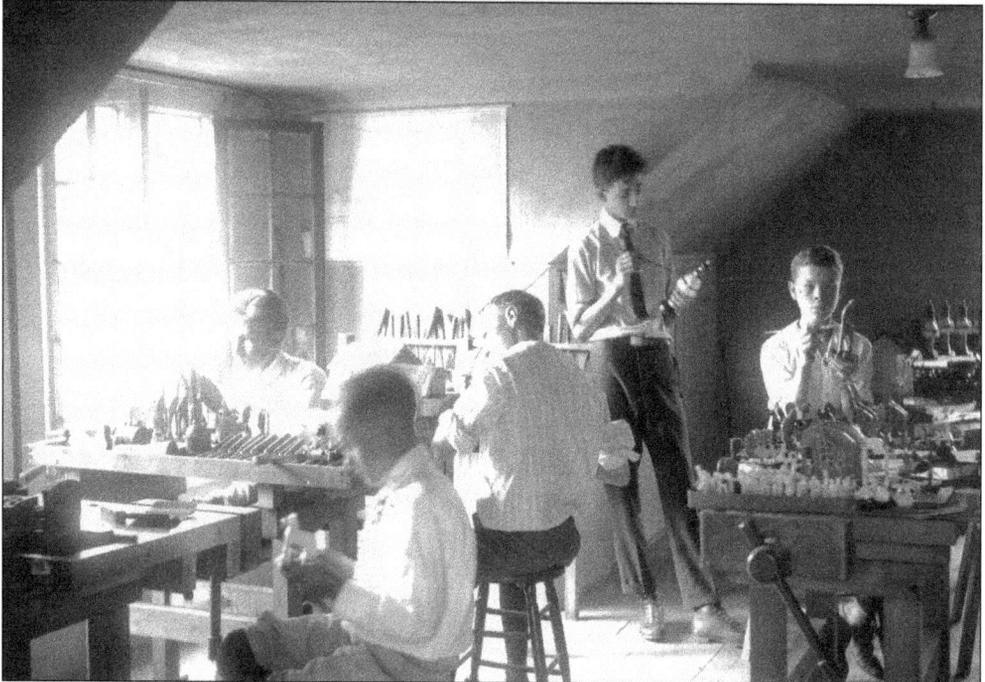

Tryon Toy Shop was another established school. It originated on the Biltmore Estate with Charlotte Yale and Eleanor Vance, who taught Arts and Crafts–style wood carving to boys whose families worked on the estate. In 1915, the women moved their studio to Tryon, North Carolina, an area home to a popular summer art colony.

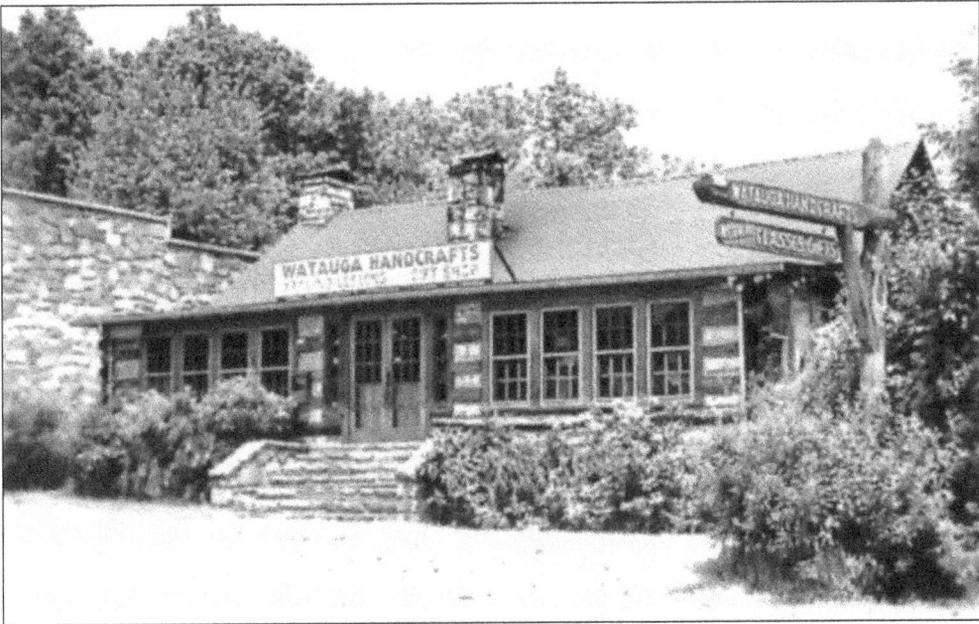

Watauga Handcrafts was a shop and learning center that opened in 1938 in Boone, North Carolina. The center provided a school for weaving and was supported by the state department of trades and industrial education. Elizabeth Lord supervised the weaving being done by community women, many of whom were already proficient. The shop also supported artisans who worked in rug hooking and carving and boasted of a 90-year-old maker of corn-shuck dolls. Today, the Western Watauga Community Center, which is housed in a new building, continues to teach arts and crafts with a focus on weaving.

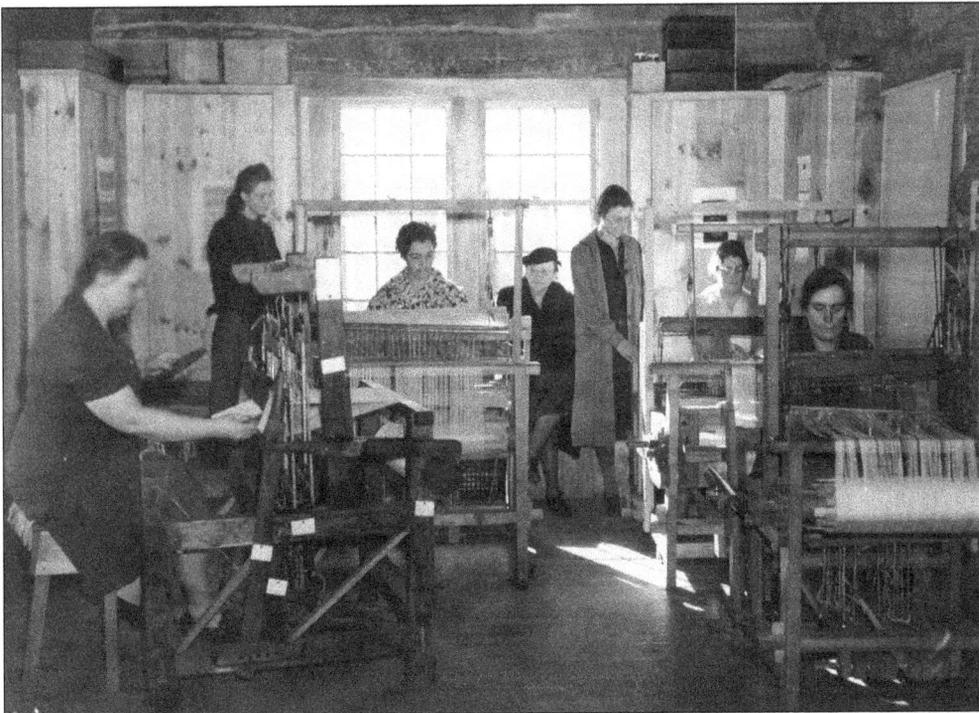

Pleasant Hill Academy in Pleasant Hill, Tennessee, followed the pattern of other community schools. In 1922, Margaret B. Campbell was hired to teach art. She worked with Earl Clark to encourage promising weavers and woodworkers already in the community. The distinctive curl of this loom's beater bar shows that it was a Berea College loom design.

A student of special interest at Pleasant Hill Academy was a wood-carver named Tom Brown. The popularity of his carvings led to opportunities for him to study at various schools, including the Sorbonne in Paris, France. The experience proved to be too overwhelming for the young man, and he returned to the mountains before moving to Baltimore, Maryland. His carvings continue to be highly valued.

36

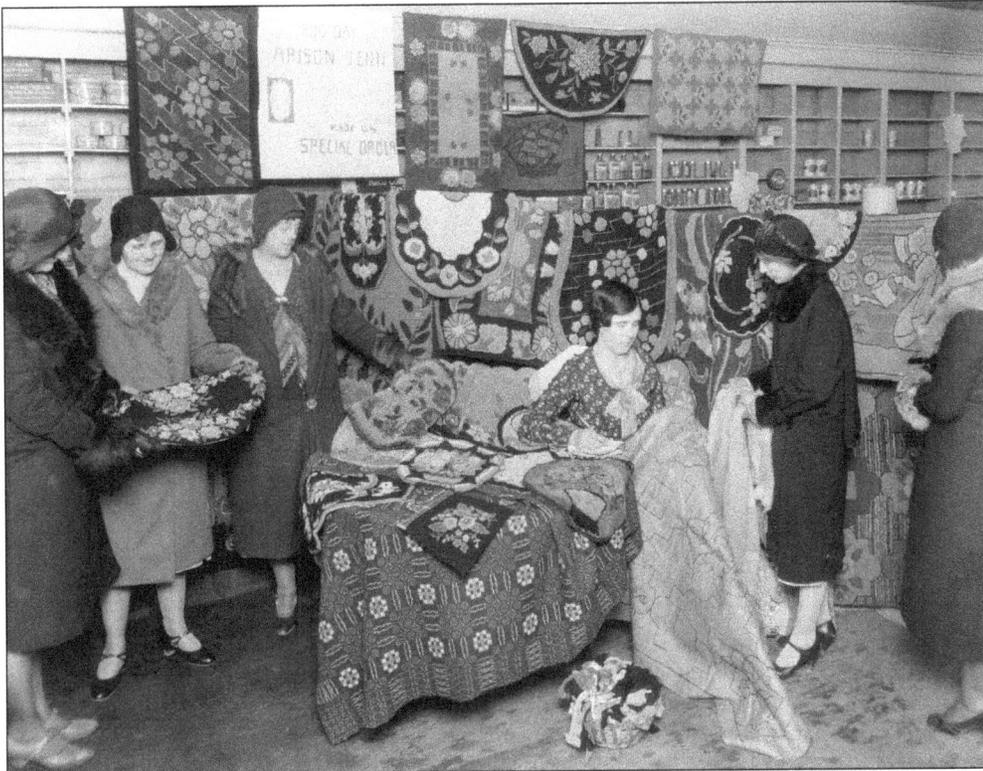

The Tennessee Extension Service was an excellent source of artisans. Isadora Williams had the opportunity to make many connections in her role as an assistant extension economist specializing in marketing. She encouraged people to join the SHCG. The Apison Handicraft Center in Apison, Tennessee, promoted rug hooking in 1934. Above, the seated woman is holding a burlap piece with the outlines of a project ready to be worked. Below, the women are busy filling the design outlines on their burlap canvas. They are using rug hooks to pull the fabric loops up from beneath the design. Many rug hookers received leftover fiber from hosiery mills in Georgia. This material was cut and dyed for a variety of crafts, including weaving. During World War II, production at the mill changed to meet military needs, and the Apison Handicraft Center closed.

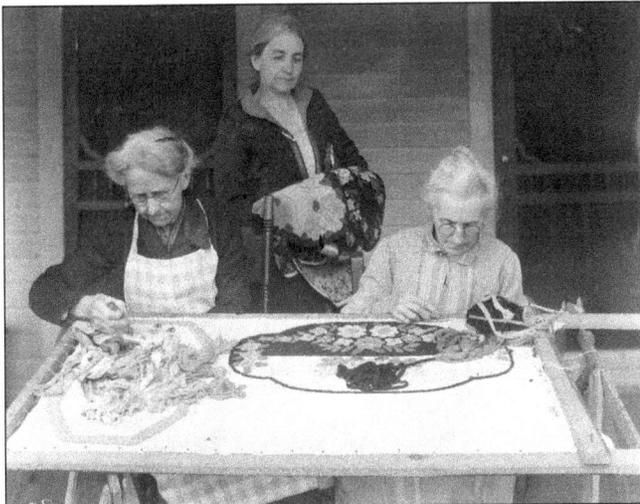

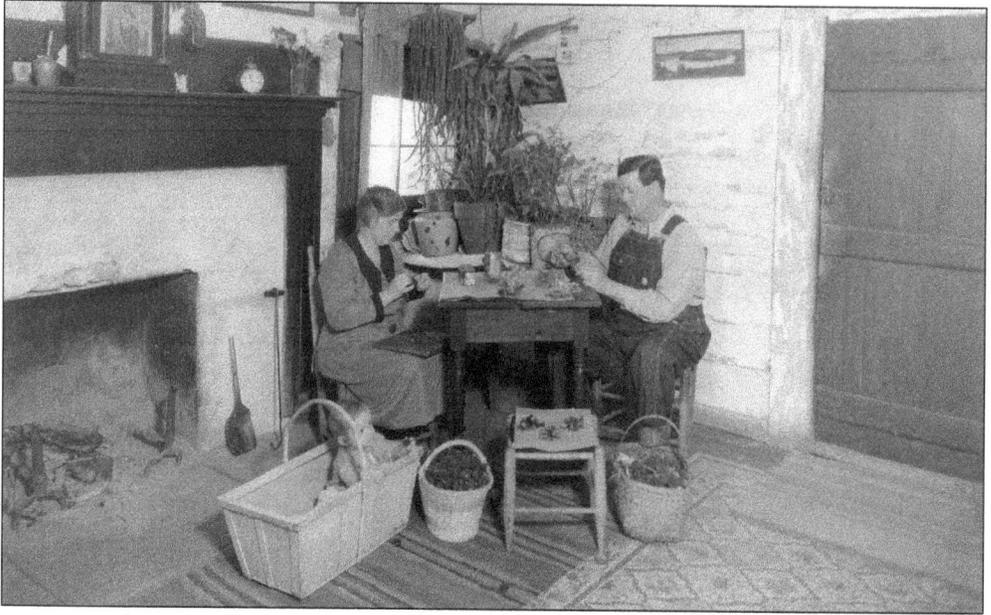

Along with arts and crafts centers joining the guild, talented individuals began applying for SHCG membership. Isadora Williams brought several people who worked with natural resources into the guild. The "natural resources" category included items created from corn husks, pinecones, nuts, and other materials that grew in the region. Small corsages made from tiny pinecones and seedpods were especially popular. Above, Mr. and Mrs. Herbert Payne (and son—in the basket) are shown assembling and painting pinecone and nut clusters. Below, Grace Rogers is attaching them to buckeye-splint hats while her husband, Ernest, cuts the thin wood splints used to weave the hats. Several guild members were employed to supply department stores, which placed orders for corsages of specific colors and designs.

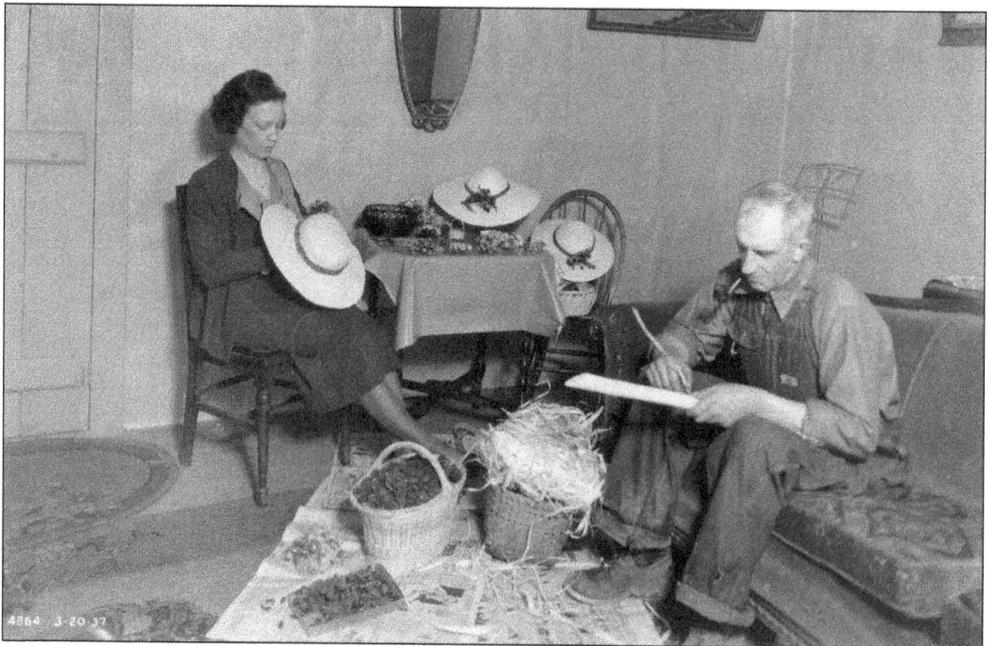

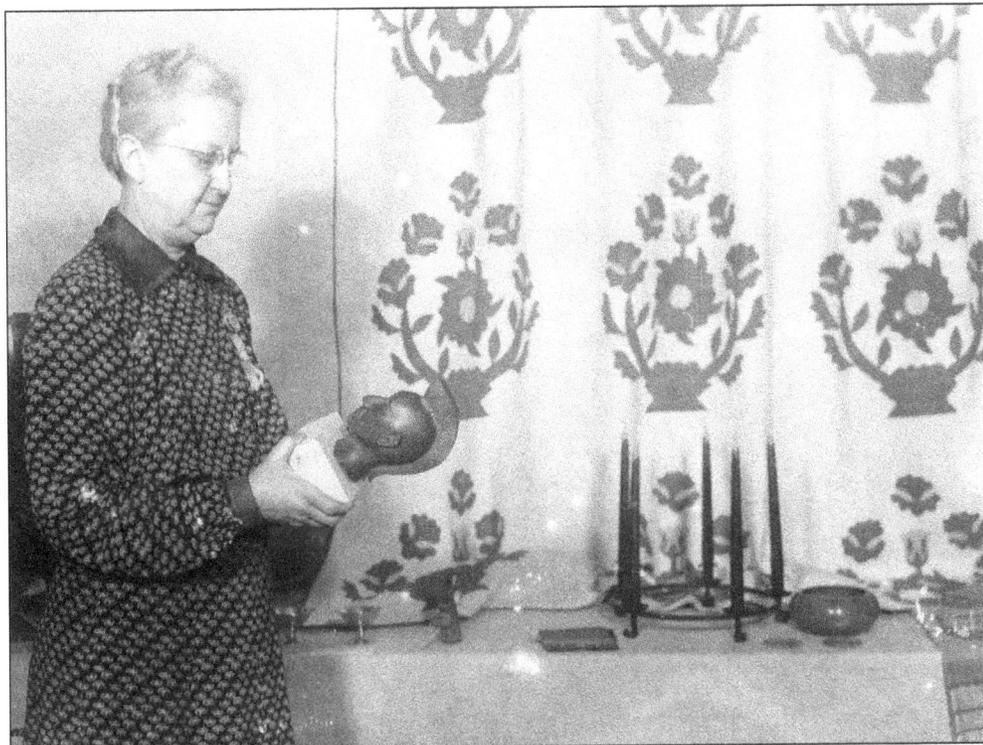

Isadora Williams (1884–1976) was born in South Carolina. As an economist with the Tennessee Extension Service, she managed curbside markets and encouraged craftwork for rural people looking to earn extra cash. She joined the guild in 1935, specializing in dyeing and natural materials—two subjects that she taught as an extension agent. She was active in the guild and served on the board of trustees.

Daniel Boone VI and his brother, Lawrence, were the sixth generation of metalworkers in their family. Daniel operated a forge and salesroom in Burnsville, North Carolina. They were involved in several large projects that included metal gates at Yale University and the National Cathedral in Washington, DC. (North Carolina Collection, University of North Carolina Library at Chapel Hill; photograph by Bayard Wootton.)

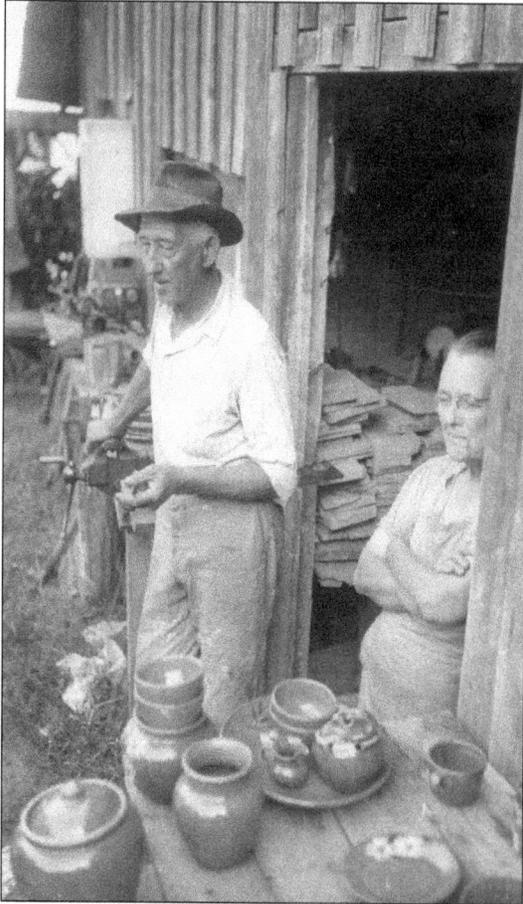

Hilton Pottery of Catawba Valley was a family business that made practical ware as well as decorative pieces for the growing number of tourists to the region. A natural deposit of clay on the family land allowed the potters to create their own unique stoneware. A.E. Hilton worked the clay, and his wife, Clara Maude, painted designs with regional themes. After A.E. Hilton died, his wife and daughters continued to produce work, but the focus shifted from household pieces, which were rapidly being replaced with mass-produced materials, to dolls and figurines. Clara Hilton was known for an antique-style doll with a porcelain head and arms.

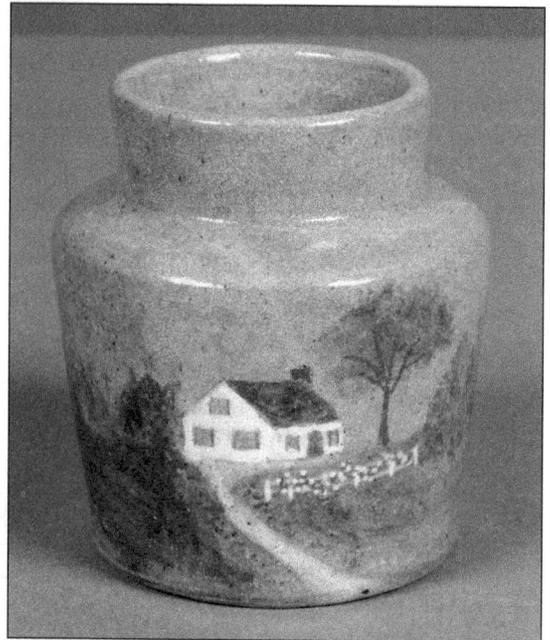

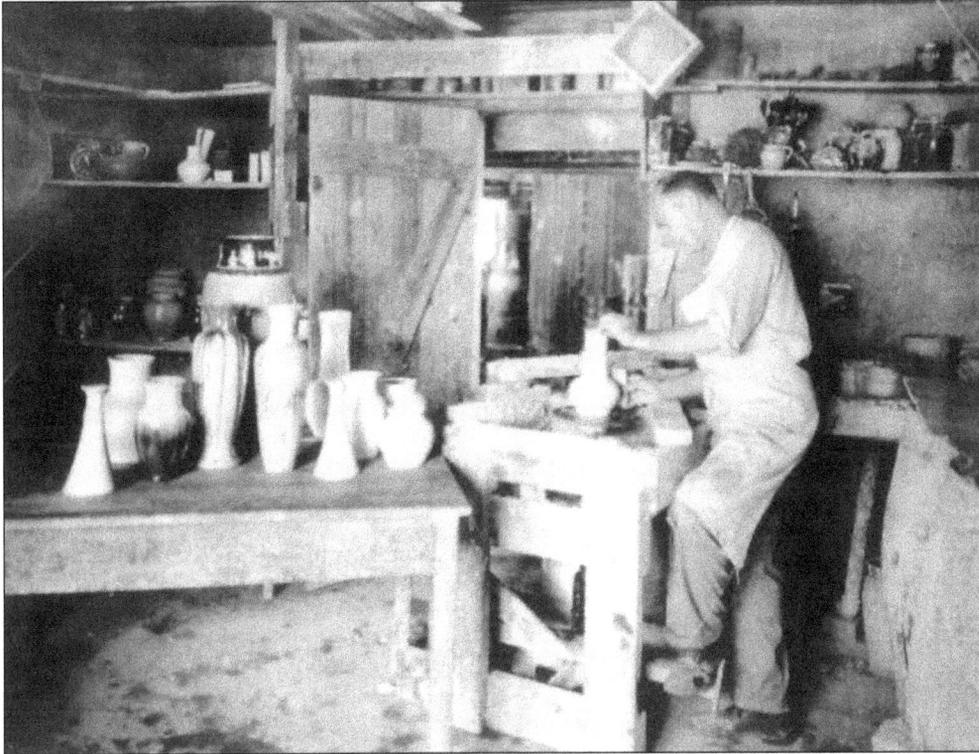

Pisgah Forest Pottery was founded in 1926 after Walter Stephen returned to the mountains after the family's attempt to settle in Nebraska. Stephen (pictured in both images) was able to dig his own clay and created varied works with distinctive turquoise and purple glazes. He also experimented with decorative techniques such as crystalized-mineral glazes and a Wedgewood type of decoration. While the English company used molds for their varied classical designs, Stephen painted layers of porcelain slip on the pottery. His design choices were related to familiar farm scenes and western themes from his youth. Pisgah Forest Pottery was passed on to Stephen's step-grandson, Thomas Case, and continued to produce pottery until Case's death in 2014.

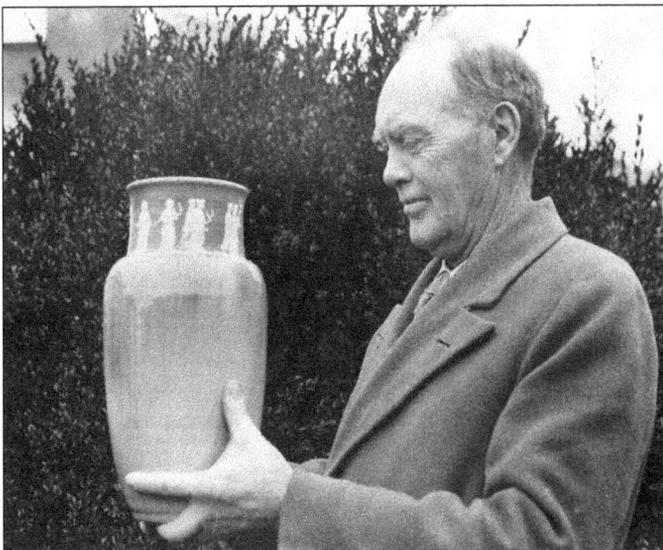

Mountain
Cabin
Quilters

Cashiers, North Carolina

Wooton, where the quilts are made, lies in a gap — not a valley — and in every direction the Appalachians surround it — and to the very tip top they are covered with oaks, chestnuts, maples, laurel, rhododendron and dogwood. Through these

Blazing Star

Mountain Cabin Quilters was a cottage industry group founded in 1933 in Wooton, North Carolina. The women coordinated their efforts to fill orders placed at Allanstand Cottage Industries for specific designs and colors. Minnie Klar managed the quilters and made color and design choices based on sales and requests. The pattern-cutting and sewing jobs were divided among the local women and included sheep farmers, who supplied wool for the batting, which had to be washed and combed. In the 1930s, a hand-quilted double-bed quilt sold for $20. It was a dollar more for the extra stitching of difficult designs. The quilt shown below features a "Swallows in the Window" pattern.

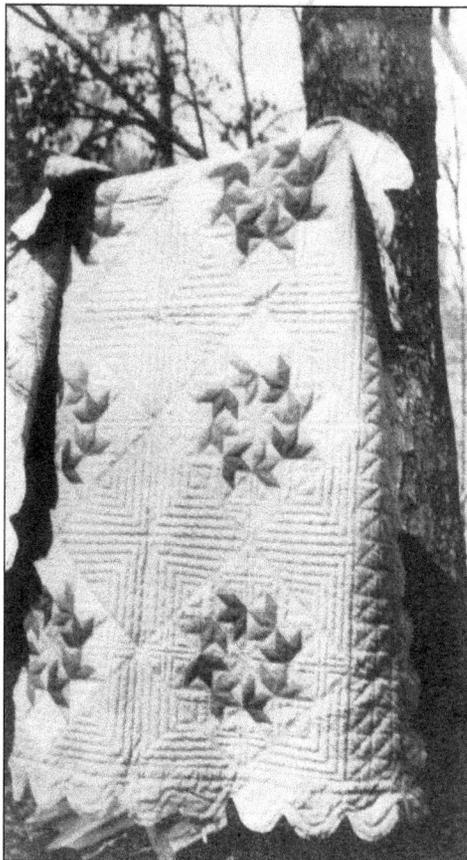

From The Looms
of The
Shuttle Crafters

DOOR-WAY OF LOOM HOUSE WHERE WE
PRACTICE THE ARTS OF OUR GRANDMOTHERS
Russellville, Tennessee

SARAH DOUGHERTY ELLA DOUGHERTY WALL

(Summer Shop. Gatlinburg)

Shuttle Crafters of Russellville, Tennessee, was managed by Sarah Dougherty and her sister, Ella Dougherty Wall. The Doughertys were proud of a long Scots-Irish heritage and worked from a loom house that was built on their property in 1799. Sarah and Ella were sixth-generation weavers. Many of the looms and spinning wheels that they used for teaching were found in attics and on the grounds of old Russellville homes. The connection to history was important and played a large role in the choosing of the patterns and colors. Hand-spun yarns were dyed with natural dyes. The below photograph features a similar type of handwoven coverlet on display at a Kentucky home.

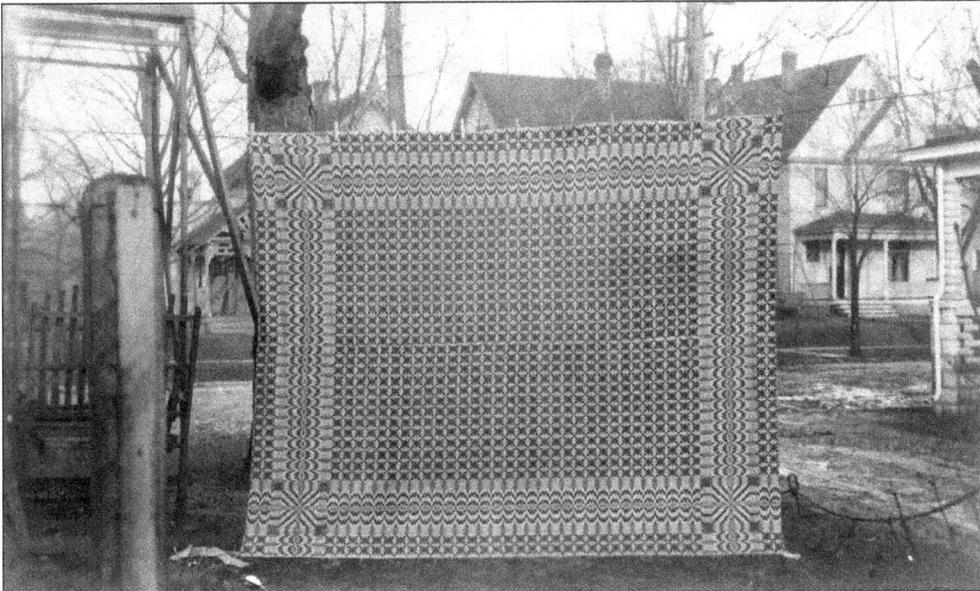

The Cherokee School was opened in Cherokee, North Carolina, in 1932. Many of the school's programs were overseen by non–Native Americans sent by the US Department of the Interior to supervise education; however, traditional crafts received strong support. The school became a member of the guild, selling at Allanstand and other guild venues under the supervision of Gertrude Flanagan. In 1946, a Native American–run cooperative was formed, which developed into Qualla Arts and Crafts Mutual. The organization works closely with artisans to support traditions and help the community. The name badge this woman is wearing says "Cherokee School Pottery."

This is an example of Cherokee pottery that was handmade and fired directly in flames.

Three

THE 1940S

GROWTH AND FIRST FAIRS IN GATLINBURG, TENNESSEE

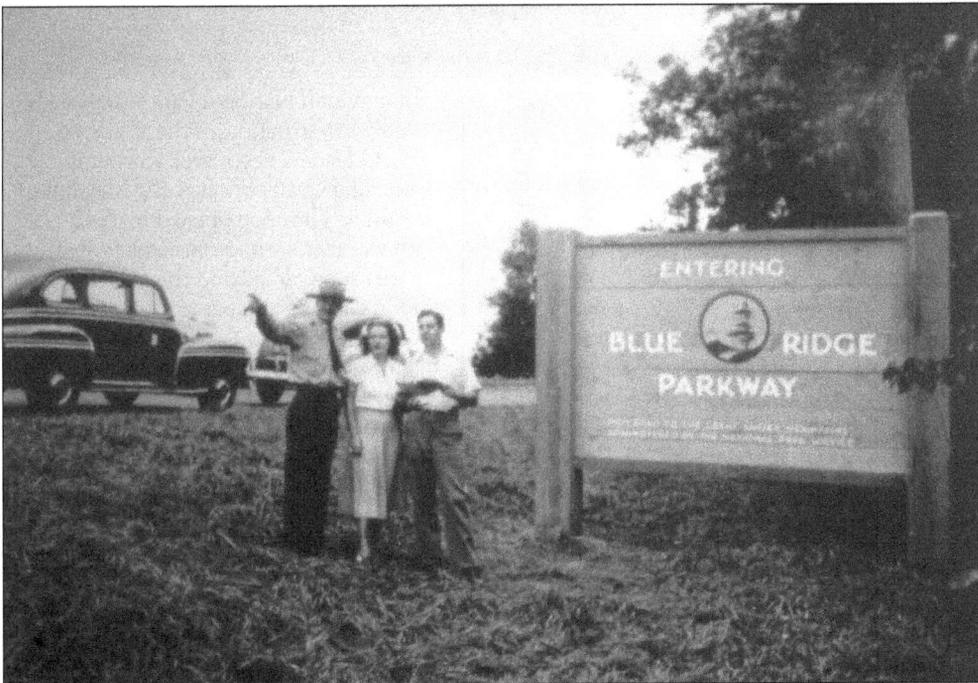

In the 1930s, work began on the Great Smoky Mountains National Park and the Blue Ridge Parkway. Guild organizers were anxious to see mountain crafters become a part of the development process, since they were most affected as farmland was changed into parkland. In the tourist shops, SHCG leaders hoped to have local craftwork for sale instead of cheaply made items from overseas. (National Park Service, Blue Ridge Parkway.)

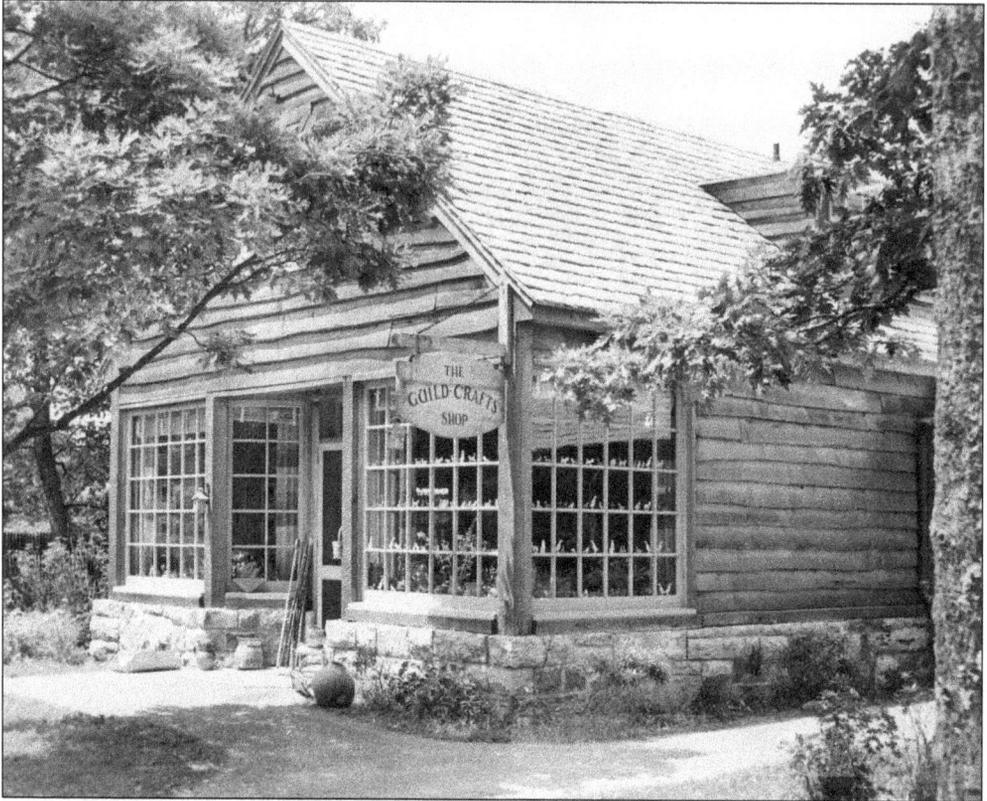

Shenandoah National Park was already a tourist destination in the 1940s, so SHCG leaders negotiated to operate the Guild Crafts Shop at Big Meadows, Virginia. The shop opened in 1942 and was met with resentment from a tourist shop already on the site. The Guild Crafts Shop persevered by hosting demonstrations and encouraging members to supply low-cost items. However, the skill and time it takes to create even a small carving meant that local crafters could not compete in the market with swiftly mass-produced items. In the photograph at left, carved wooden figures are framed in the windows. In 1944, the Guild Crafts Shop was closed due to shortages of gasoline and tires, which led to the prohibition of unnecessary travel. It reopened in the 1950s after the guild's merger with Southern Highlanders. (Both, *Richmond Times-Dispatch*.)

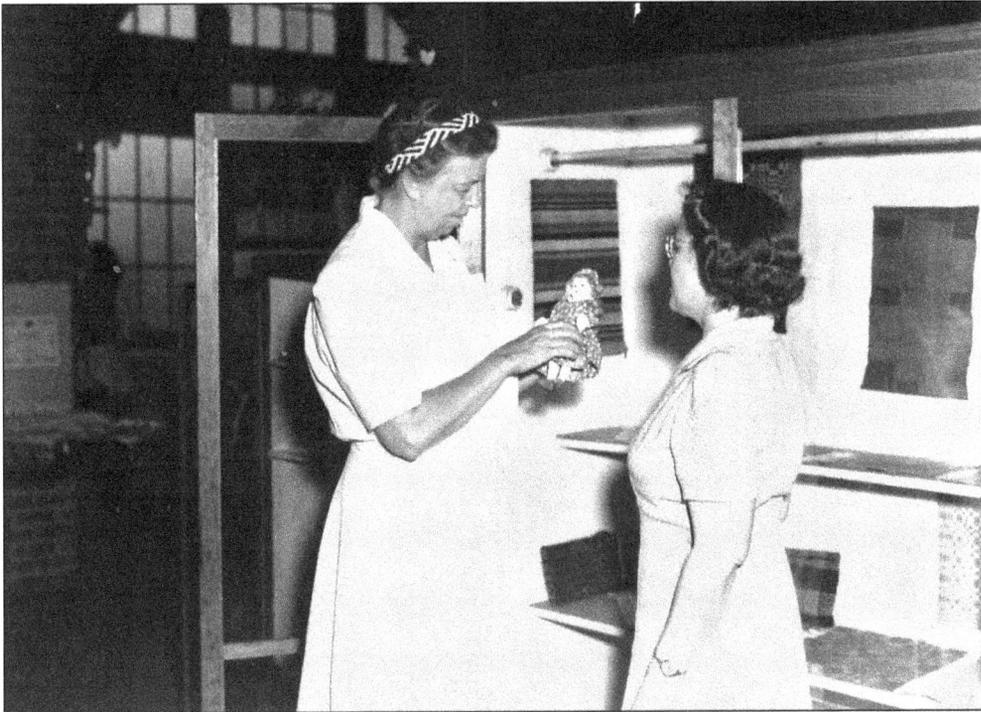

In 1942, Eleanor Roosevelt visited the mountains to promote and support craftspeople. Her stay in Asheville, North Carolina, included a visit to the Asheville Normal School, where she met Alice Pratt and was shown some of the items being made on campus. During the war, many Appalachian men went off to fight while women moved into cities to work in textile mills.

The Tennessee Valley Authority was another project that moved farm families off their land in the 1930s. Officers of the SHCG were called upon to serve as officers and advisors for the TVA's Southern Highlanders, and in the 1940s, the two organizations began to merge. Before long, negotiations were started to unite the two guilds. One bit of contention was the guild's strict jury process. It was finally decided that all Southern Highlanders members would be accepted without debate.

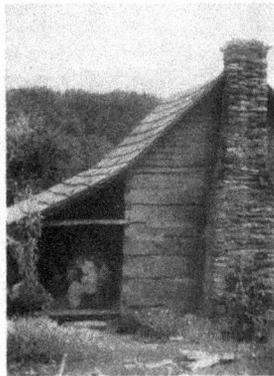

"The traveler who follows the trails of this far country, fords its rushing streams, and . . . wakes with the mist rising from every cove and valley and echoes still sounding of half-remembered traditions, folk-lore, and folk-songs . . . knows there is but one name that will do it justice—the Southern Highlands."

— John C. Campbell.

THE SOUTHERN HIGHLANDERS, INC.

HANDICRAFTS

New York City Retail Shop

Rockefeller Center Promenade
610 FIFTH AVENUE
New York 20 CO 5-3313

Other Shops at Norris and Norris Dam, Tenn.

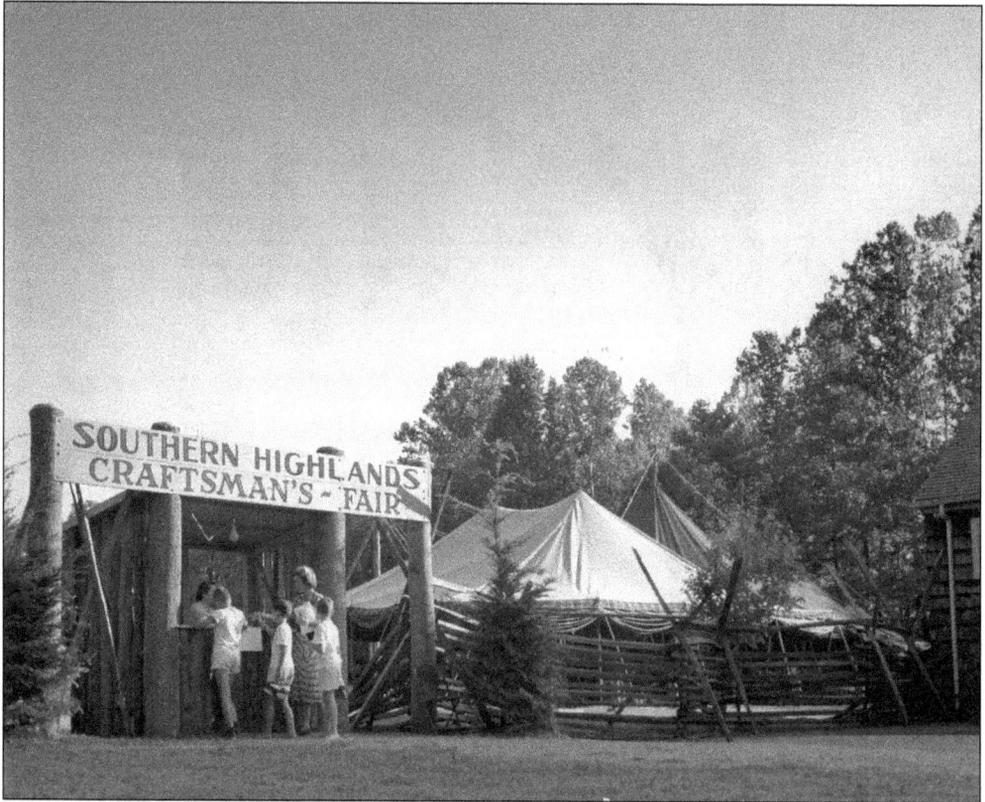

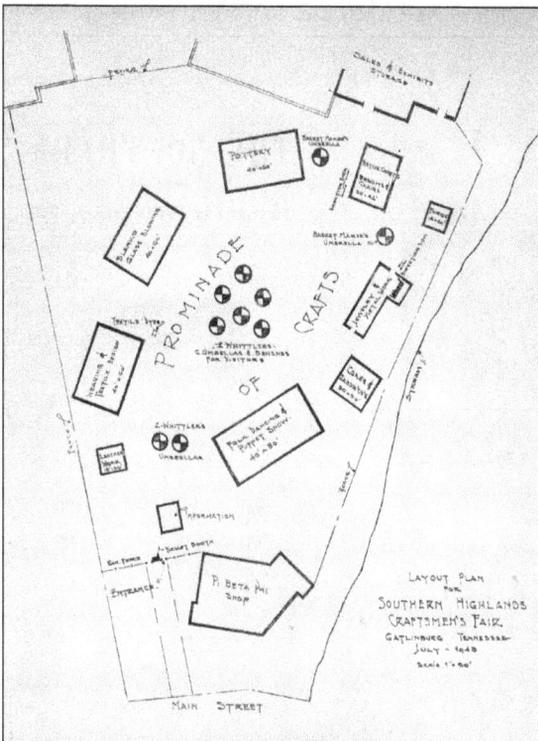

LAYOUT PLAN
FOR
SOUTHERN HIGHLANDS
CRAFTSMEN'S FAIR
GATLINBURG TENNESSEE
JULY - 1948

The World War II years were a difficult time in the mountains, but as things returned to normal, guild leaders decided to launch a Craftsman's Fair of the Southern Highlands. Guild membership had increased, and artisans were returning home. The fair was set up in Gatlinburg, Tennessee, on grounds belonging to the Pi Beta Phi Settlement School campus. The fair took place over the course of a week in July 1948, and craftspeople performed demonstrations from 9:00 a.m. until 10:00 p.m., rain or shine. Tents were arranged to house various specialties, including weaving, glass, pottery, basketry, woodwork, natural materials, metalwork, and folk dancing. Several craftspeople were situated under a scattering of beach umbrellas.

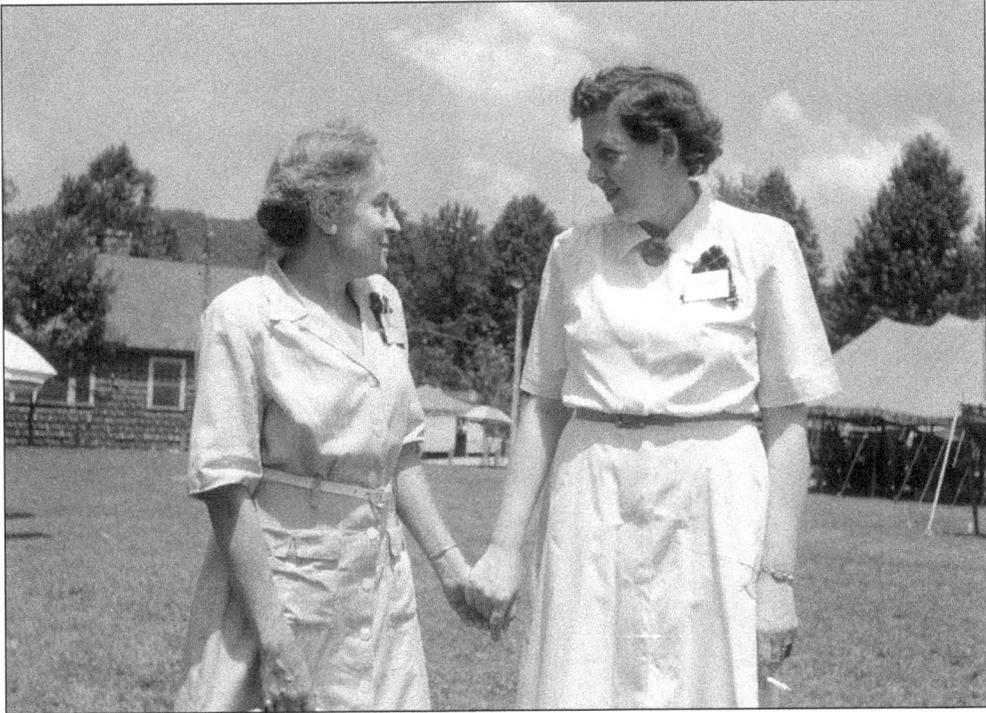

This is a rare photograph of Clementine Douglas (left), manager of the Spinning Wheel, and Marian Heard. Heard was a member of the faculty at East Tennessee University. She was able to take a sabbatical in the 1940s to help the guild collect data for a Craft Education Survey of the Appalachian States. Working with Douglas and other men and women, Heard interviewed as many isolated craftspeople as possible over three years.

The first Craftsman's Fair was a learning experience for everyone. Carvers were set up under beach umbrellas and tables in the open, which proved to be a bad idea for rainy days. Ben Hall was one of the first members of the Brasstown Carvers at the John C. Campbell Folk School. He was also a perfectionist who set a high standard for the group.

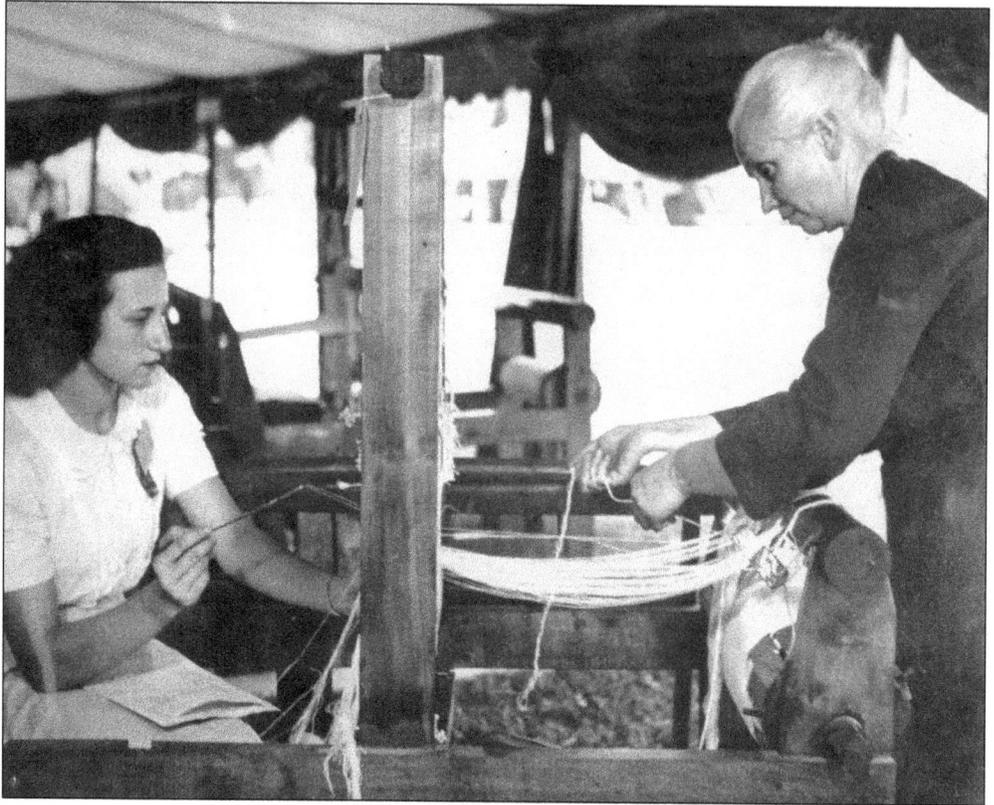

The first large tent at the fair was dedicated to weaving and other fiber arts. Mrs. Morton and her daughter are shown setting up a loom for their demonstration. Here, the warp is being threaded through the harnesses. These two women were probably associated with the Arrowcraft Shop, which was located on the grounds of the fair.

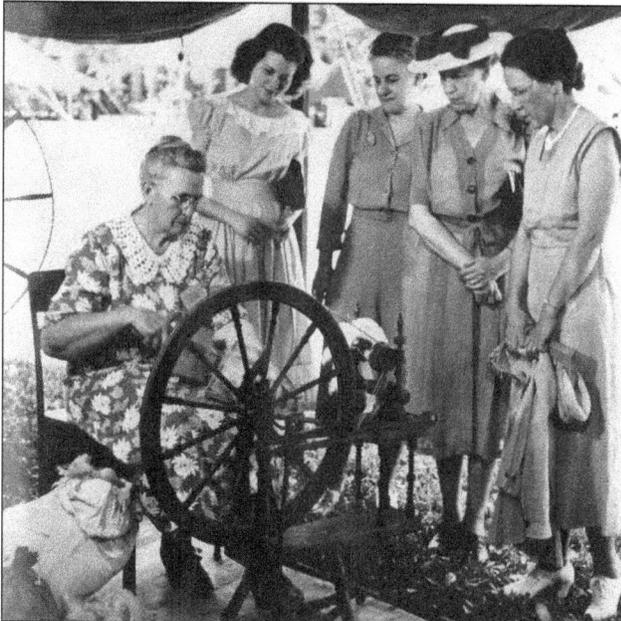

Emma Conley (seated in the image at left) traveled from Penland, North Carolina, to demonstrate the handwork necessary to create thread. Conley taught spinning and dyeing at the Penland craft school and wrote the region's first book on natural dyes. In this photograph, she is preparing wool with hand cards to be spun on her smaller spinning wheel. A great wheel is visible in the background behind her shoulder.

Rug hooking was also represented. The unidentified woman shown here is holding a sliding punch-needle and working from the back of the burlap canvas. The yarn is fed through the base of the tool, and a large needle drives it through the burlap. The rug hooker needs to keep a uniform height for the loops in order to create a finished piece.

Natural dyeing became a tradition at SHCG fairs. This first dye-pot was managed by Lucy Quarrier (left) and Wilmer Stone Viner. Flowers and plants that grow naturally in the mountains were collected to create a variety of colors. The skeins of wool were hung on a clothesline, providing a vivid background. Viner managed a weaving shop in Saluda, North Carolina. Quarrier, a weaver and dyer from Charleston, West Virginia, joined the guild in 1940.

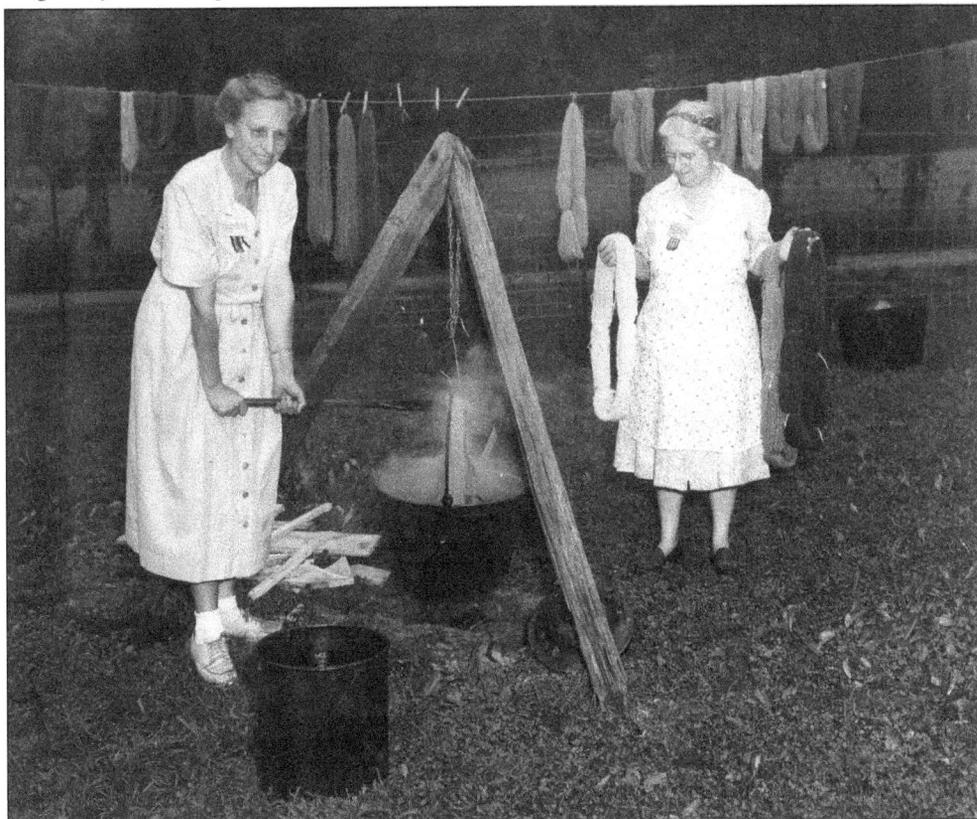

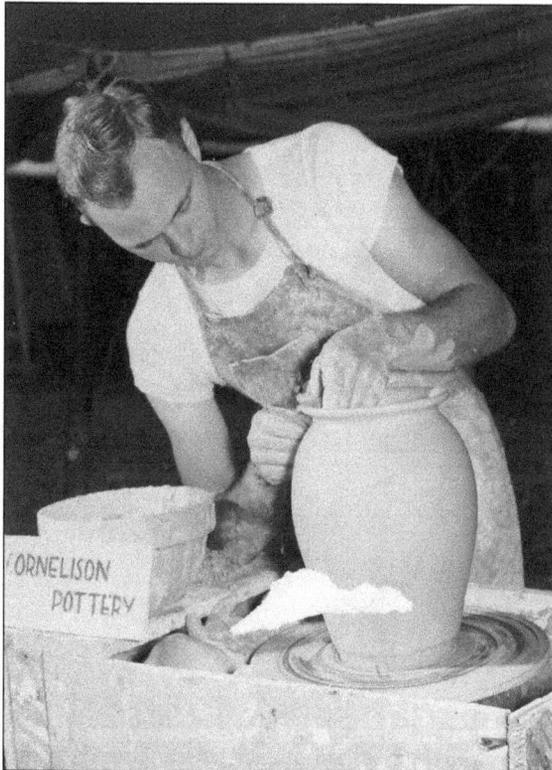

Potters were housed in another large tent for the daylong demonstrations. The Cornelison family operated the Bybee Pottery in Bybee, Kentucky, which opened around 1809. Walter Cornelison was the fifth generation of his family to manage the pottery. Raw clay was dug from an open pit and used—without additives— to create a workable clay.

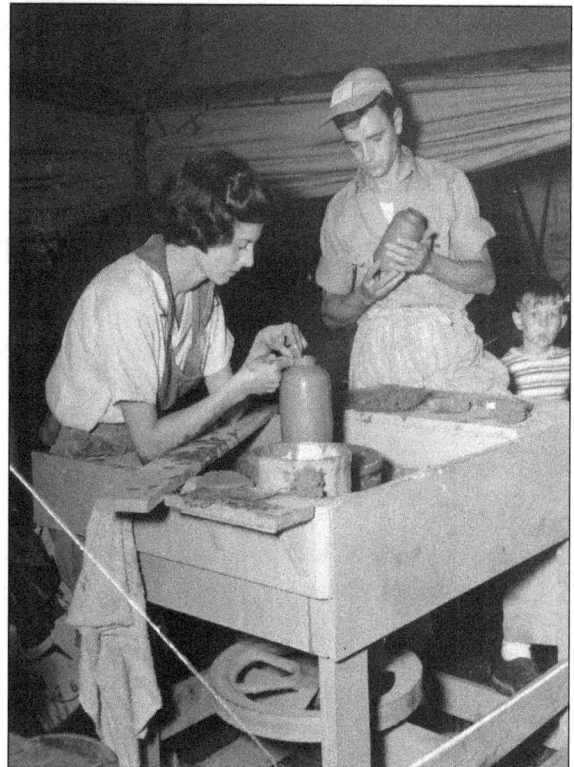

Barbara and Kennedy McDonald operated a pottery in Gatlinburg, Tennessee. Barbara joined the guild in 1947. She had a college background in ceramics and taught pottery at the Arrowmont School of Arts and Crafts and later at Oak Ridge, Tennessee. Barbara also served on the guild's board of trustees. The McDonalds' children were often a part of their demonstrations.

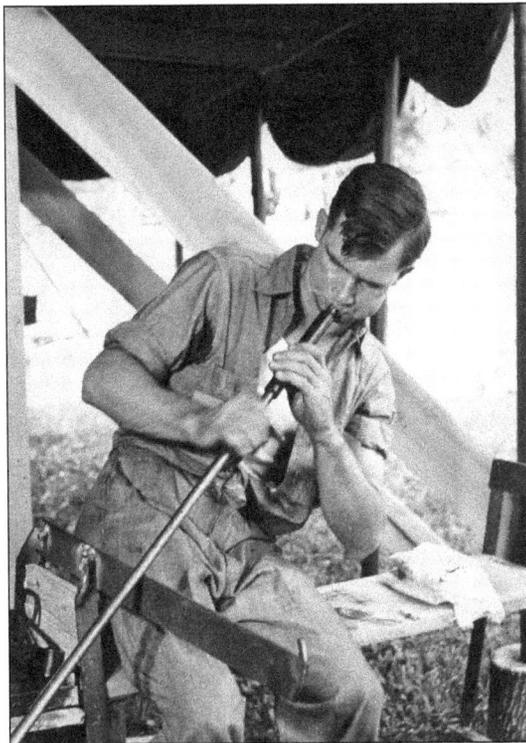

The 1948 fair was the only early fair to feature glassblowing. Workers from Blenko Glass in Milton, West Virginia, traveled to Tennessee and set up shop for the week. They had a popular demonstration, but the glassmakers' union stepped in to cancel further participation. While this was a loss for the fairs, Blenko has continued to support the SHCG through participation and sales. In the image at right, an unidentified worker blows through a tube to inflate liquid glass. Below, the shaping of soft glass is being done by another unidentified employee. The Blenko family has been making glass in the United States since 1893 and opened their current workshop in 1921.

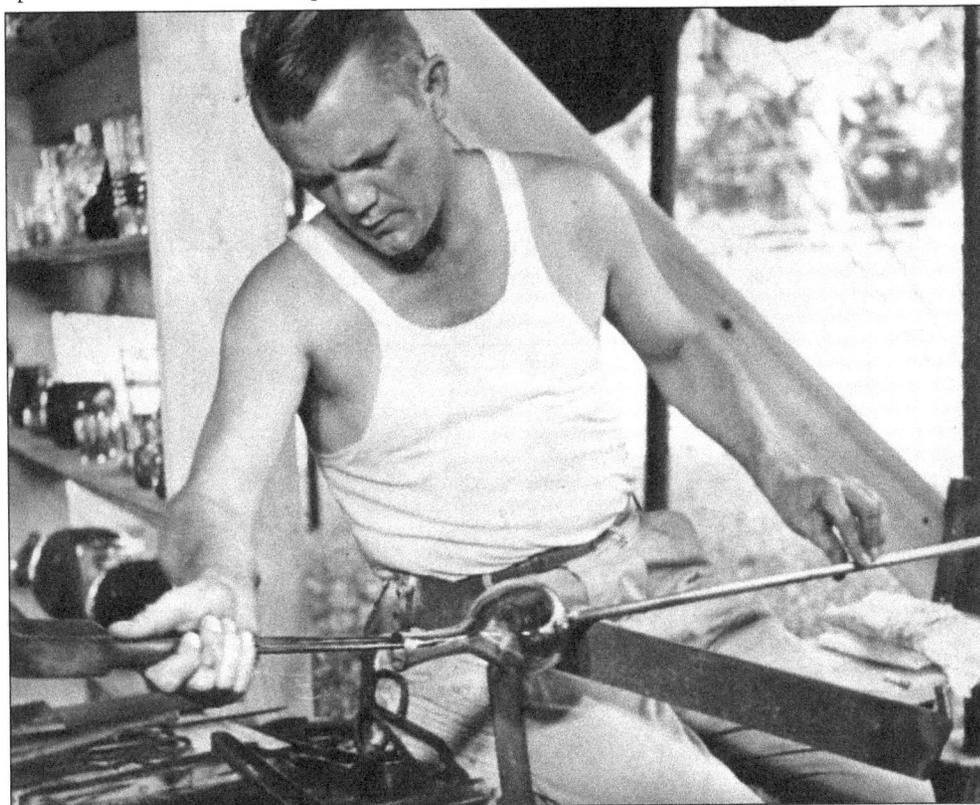

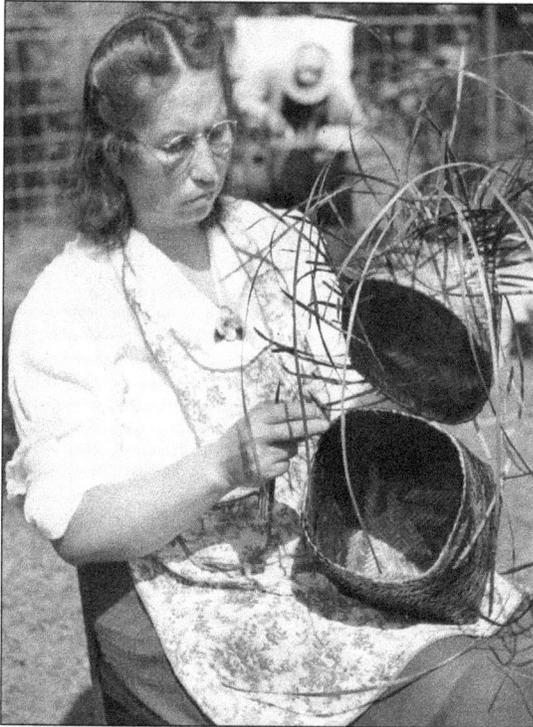

Basketmaking was well represented at the fairs. Cherokee native Lottie Stamper is shown making a traditional double-weave basket. The technique involves constructing an inner basket while simultaneously weaving the outer basket. Made from river cane, the finished baskets were woven tightly enough that they could be used to carry water. Today, the technique is rarely demonstrated, and the older baskets are treasured.

Mr. and Mrs. Matthew are demonstrating white-oak basketry, which was also done by the Cherokee. In order to make a basket, tall, straight white oak saplings were cut and stripped of their branches and bark. Splits were cut from the wood and soaked in water to soften. Mrs. Matthew is preparing the flat bottom of a basket while her husband builds up the sides of another.

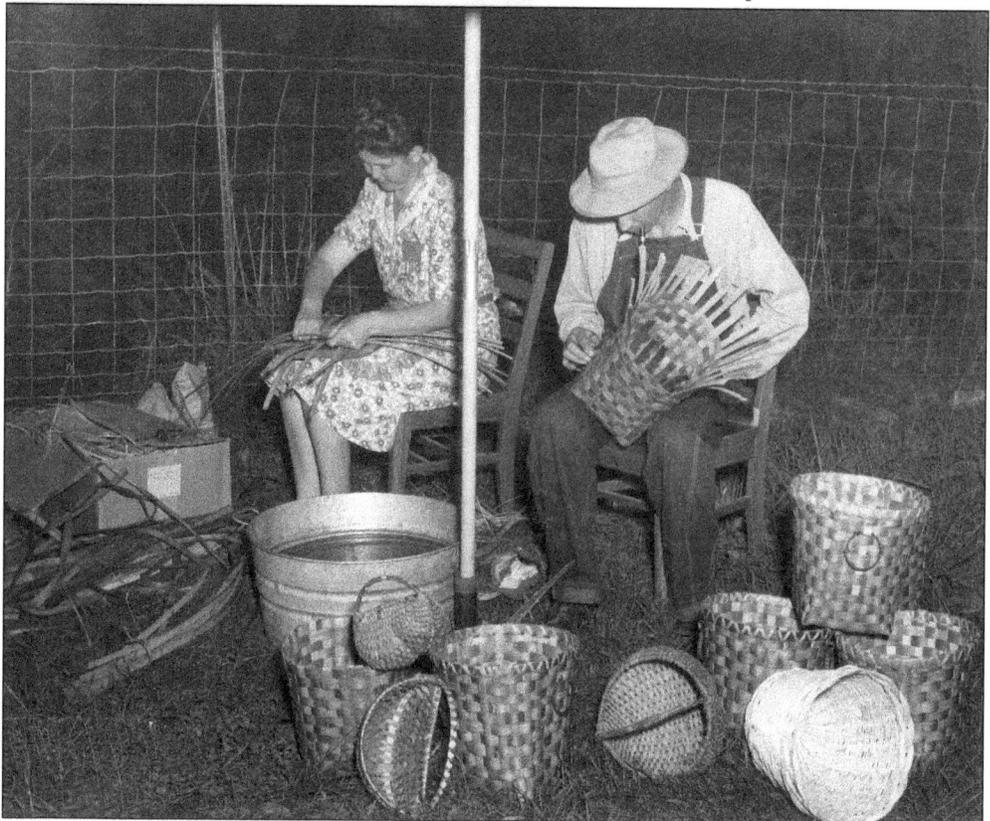

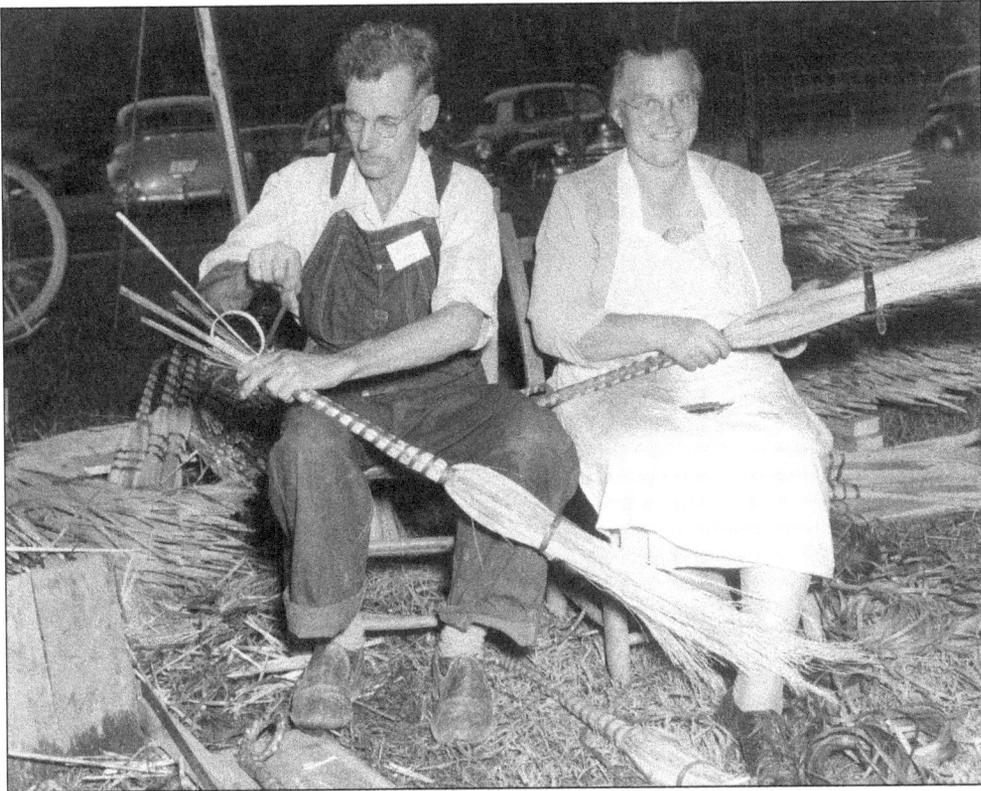

Broom-making was a popular demonstration at the fairs. The Kear family had a tradition of being craftspeople in the Gatlinburg, Tennessee, area. Elmer Kear was the third generation of broom-makers, and his son Omah continued the craft. Elmer is pictured above with his wife, Viola. The handles, which are made up of broom-sedge stalks, are being curled and wrapped, then the brush ends are cut to give an even sweep. The wrapping was originally done with soft poplar bark, but synthetic products have since replaced the need to strip tree bark. Berea College also sent its students to the fair with a good supply of broom corn (see page 22).

Ben Owenby (right) is shown demonstrating a foot lathe for fairgoers. Pumping the single foot pedal caused the wood to twist so that a sharp blade could shave the surface. This created a smooth curve for furniture legs and was also used in the making of rifles. Ed Davis, a guild officer, is standing behind Owenby. Davis made handcrafted furniture and taught at Berea College. During World War II, he served in the Navy.

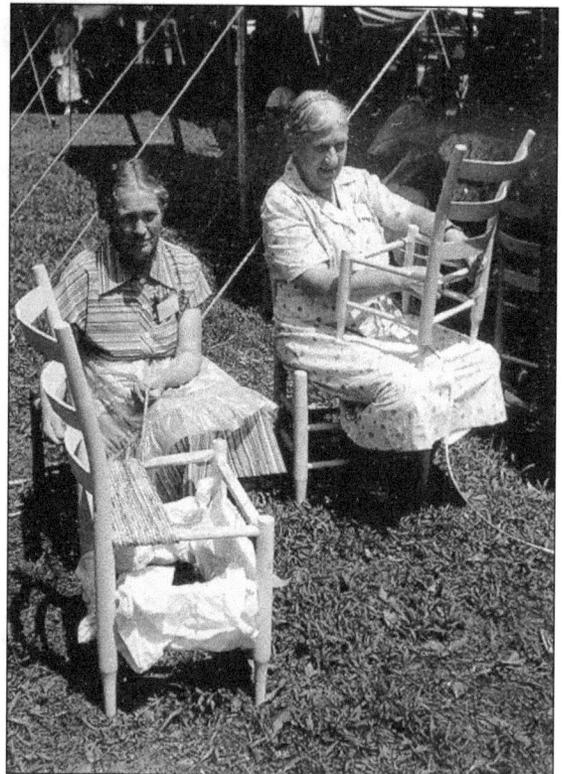

Viola Owenby (right) is shown with unidentified woman wrapping the seat of a ladder-back chair. The material of choice for chair seats was woven corn shucks. The wet shucks were tightly twisted together to create a tough but supple rope. Old ladder-back chairs—with their original seats— can still be found in use in some Appalachian courthouses and homes.

Fair visitors were entertained by mountain music and dancers from the John C. Campbell Folk School. Traditional dancing has always been a way to build community at the folk school. In 1948, the dancers met in the often-soggy green space for performances; by the next year, they had a dedicated tent and a platform.

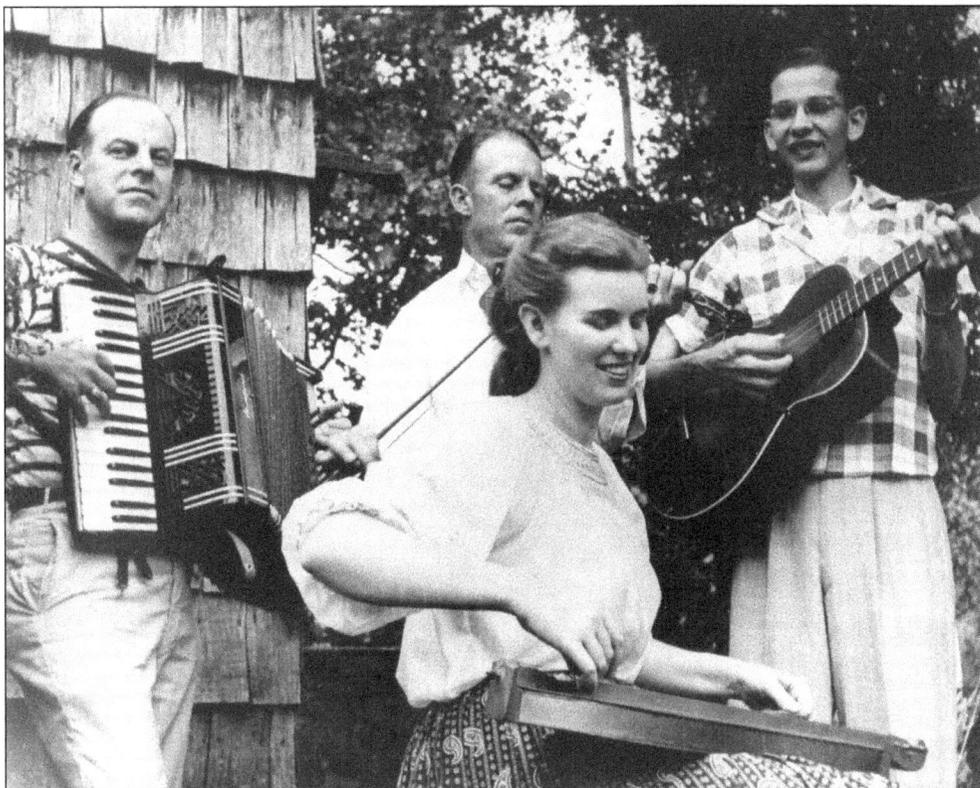

In 1949, the SHCG asked Jean Ritchie to join a group that performed at the fairs. She is shown here seated and playing a traditional mountain dulcimer. The Ritchie family was known for their preservation of old English traditional ballads with an Appalachian twist. Behind Ritchie are accordionist Philip Merrill (left), fiddler Clarence Ferrell (center), and guitarist Homer Ledford. Ledford was a luthier and joined the guild in 1951.

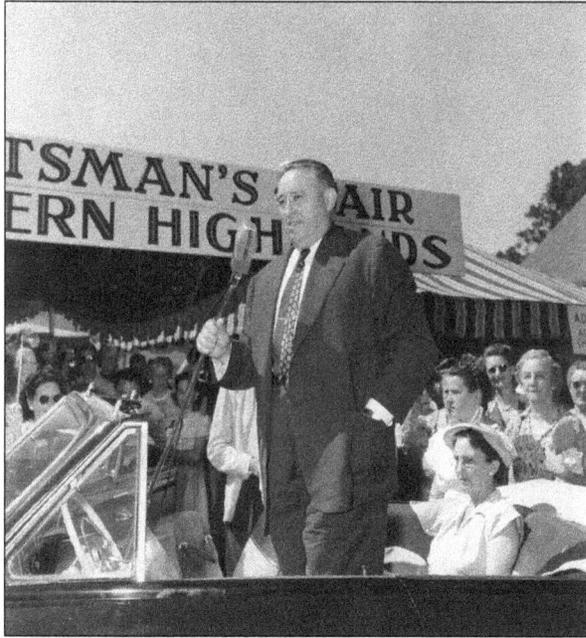

The success of the 1948 Craftsman's Fair brought Tennessee governor Gordon W. Browning to opening day in 1949 and 1950. It also attracted more member participation and larger crowds. The opportunity to socialize with visitors and other artisans was nearly as important to craftspeople as the money earned through sales at a time when telephones were rare.

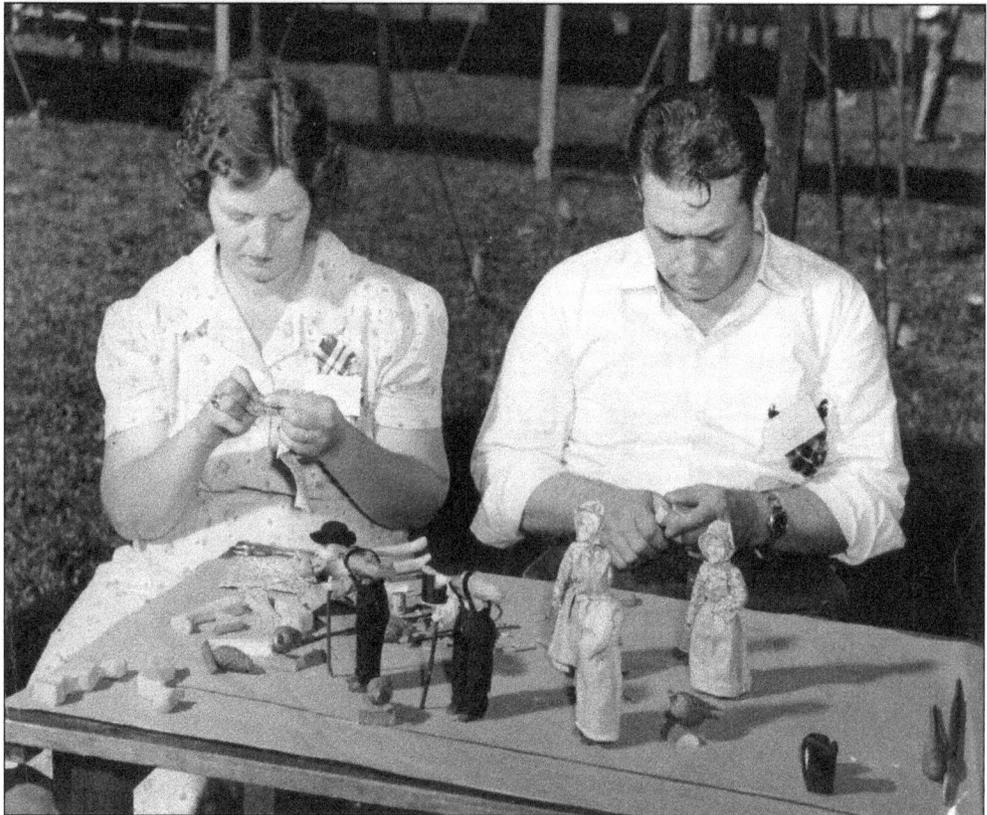

William P. Smith was a whittler known for his "Ma and Pa" dolls with carved bodies and clothes hand-sewn by his wife. William supported his family with wood carving after losing his legs in a train accident. He also created small turkeys by cutting young pinecones from their branches.

Going Back Chiltoskey joined SHCG in 1948 after returning from World War II. He worked for the US Army Corps of Engineers designing models of military installations. After his return, he produced many carvings with traditional Cherokee themes. His name refers to his family's determination to return to North Carolina after the Cherokee were forced by the federal government to march to the plains.

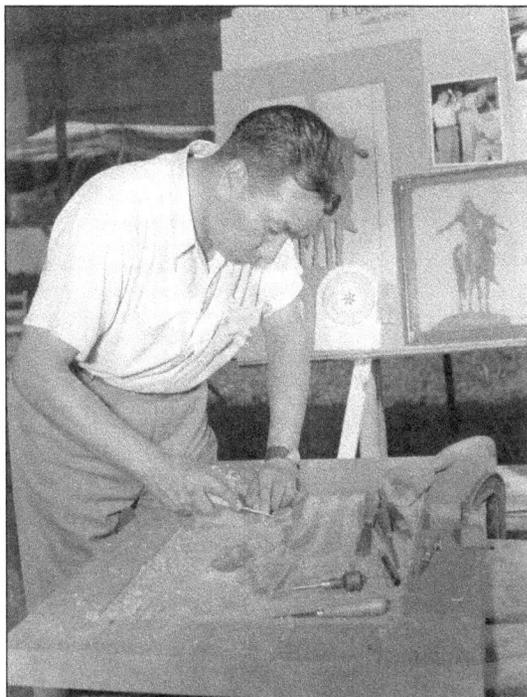

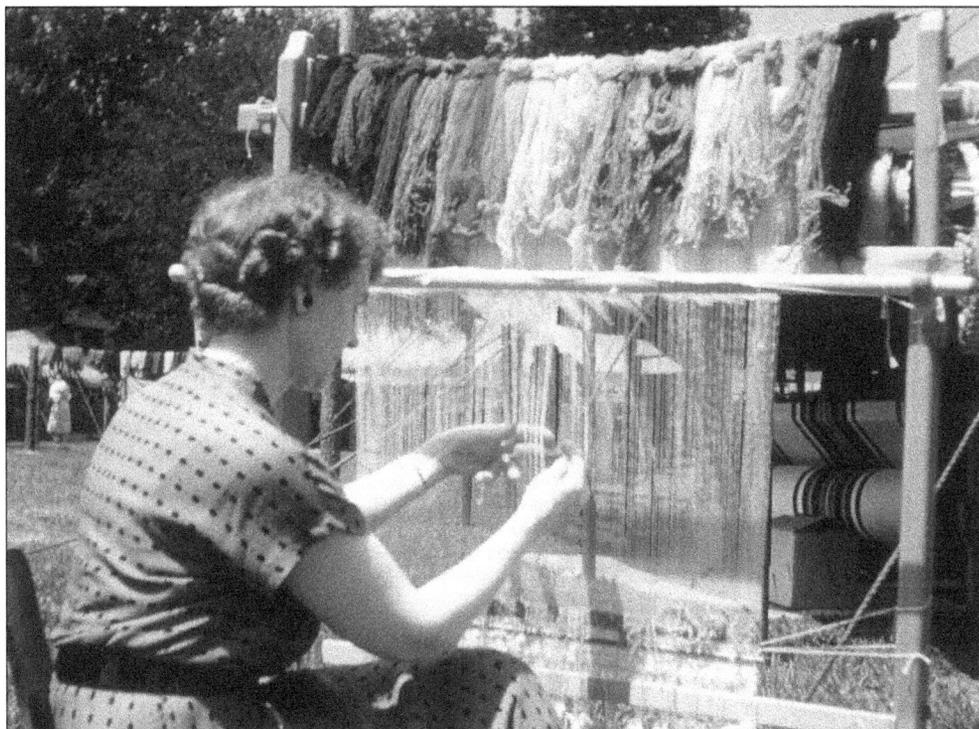

Tina McMorran joined the guild in 1948 after returning to North Carolina from Oregon, where she grew up. After taking classes at Arrowmont, she was invited to stay on as a weaving designer for the Arrowcraft Shop's cottage industry. At the fair, she demonstrated tapestry weaving, which is done on an upright loom. Her fabric color choices are arranged above the loom.

An exhibition of members' work was another part of the fair experience. When there was space, room interiors were created. In this room arrangement, a Cherokee rug is on display along with pottery, pewter, and a tall Blenko glass vase. Dolls made by Mr. and Mrs. William P. Smith are visible at far left, and a silk-screened hanging is on the wall at right.

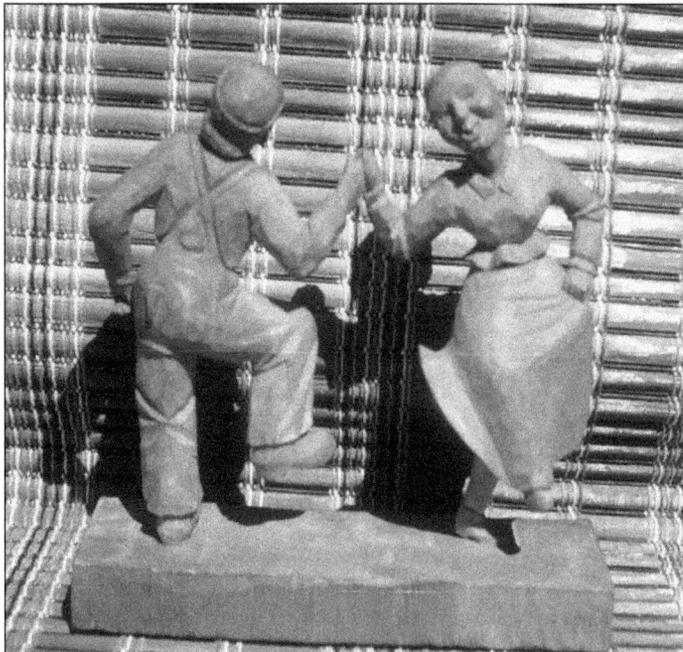

Jack Eichbaum, a wood-carver from Chattanooga, Tennessee, sold his work through the Allanstand shop before 1930. When the shop was given to the guild, all of the artists who had been approved by Frances Goodrich were accepted into the guild. Eichbaum came from a family of wood-carvers. He often looked at magazine photographs to get ideas, which he carefully drew before starting a piece. This dancing couple was on display in 1949 and is now in the SHCG object collection.

THE 1950s

NEW SHOPS AND CRAFTSMAN'S FAIRS
AT THE ASHEVILLE AUDITORIUM

The 1950s were a time of continued growth for the Southern Highland Craft Guild. At the beginning of the decade, there were 120 individual members and 30 educational center members. By 1959, a total of 240 more people and groups had joined. Displaying a guild membership sign carried prestige and presented a guarantee of quality handmade workmanship.

The SHCG merger with Southern Highlanders was finally completed in 1950, and it brought several more shops under guild management, including one at Norris Dam in Tennessee, which is pictured above. In addition to shops in Tennessee offering members' work, there were shops in Chicago and New York City. The shop in Rockefeller Center was a source of great pride. The large window displays were devoted to educating New Yorkers about mountain life, and several guild members traveled to New York to demonstrate their work. Unfortunately, it became too difficult to manage a busy but distant shop while keeping other guild shops stocked with craftwork. Most guild members were part-time craftspeople who fit their craft time around a busy country-life schedule. The New York City shop closed in 1955.

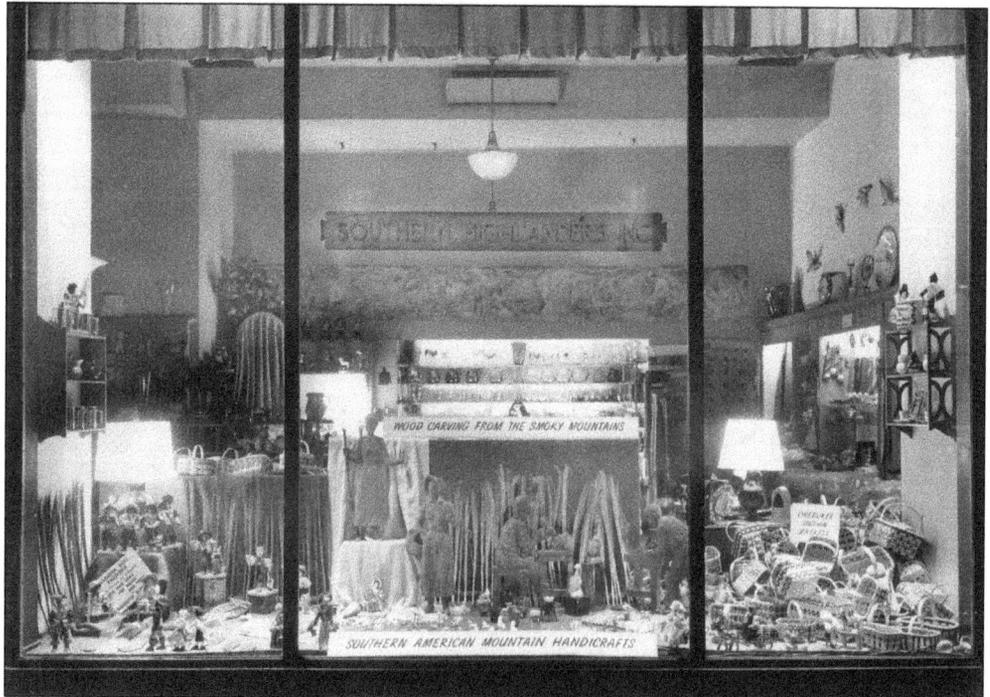

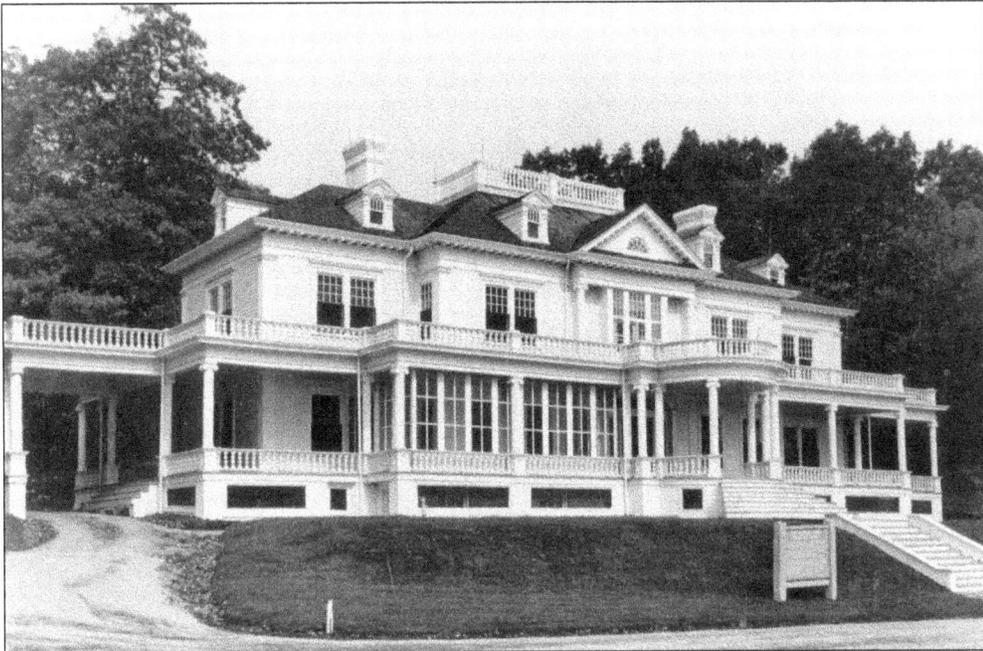

Negotiations with the National Park Service (NPS) led to a guild shop being opened at the Moses Cone Mansion in Blowing Rock, North Carolina. The estate became part of the Blue Ridge Parkway in 1950. Guild leaders helped to maintain the beautiful property by managing a sales shop and a pioneer museum, which featured objects from Frances Goodrich's collection. During the tourist season (from April to October), the staff and demonstrators were able to live on the second floor of the mansion. The shop in the mansion's entrance and living rooms was known as Parkway Craft Center. Frances Goodrich's original coverlet was hung in the museum until a break-in led to the exhibition being closed. The guild's shop at Moses Cone Manor is still in operation. (Below, National Park Service, Blue Ridge Parkway.)

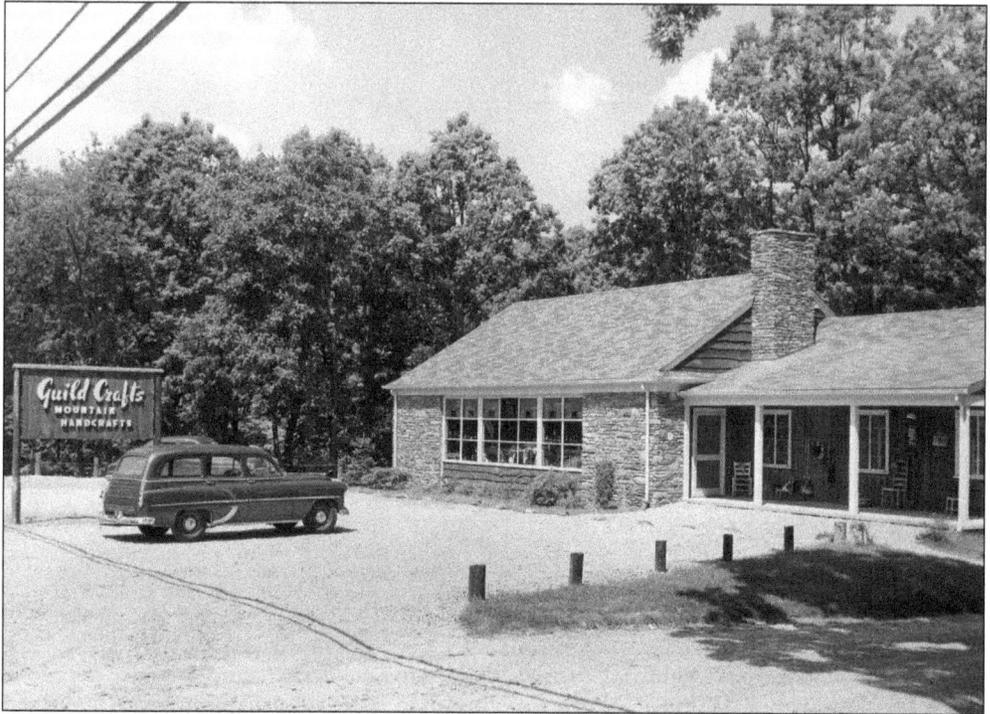

The Guild Crafts shop on Tunnel Road in Asheville, North Carolina, was built for the guild by Stuart Nye Silverwork's Ralph Morris Sr. in 1955. The rented building included space for offices, which were needed for the growing administrative demands of the guild, and supplied storage for sales stock downstairs. The interior has an intimate, homey feeling, with wood paneling and a fireplace and mantel. The Stuart Nye workshop is still in operation next door to the shop. After the guild offices moved to Redick Road in 1968, the Tunnel Road shop expanded to include the entire building, and it is still open for business today. The display shown below includes marquetry work, a Fannie Mennen print, and Rude Osolnik's candleholders.

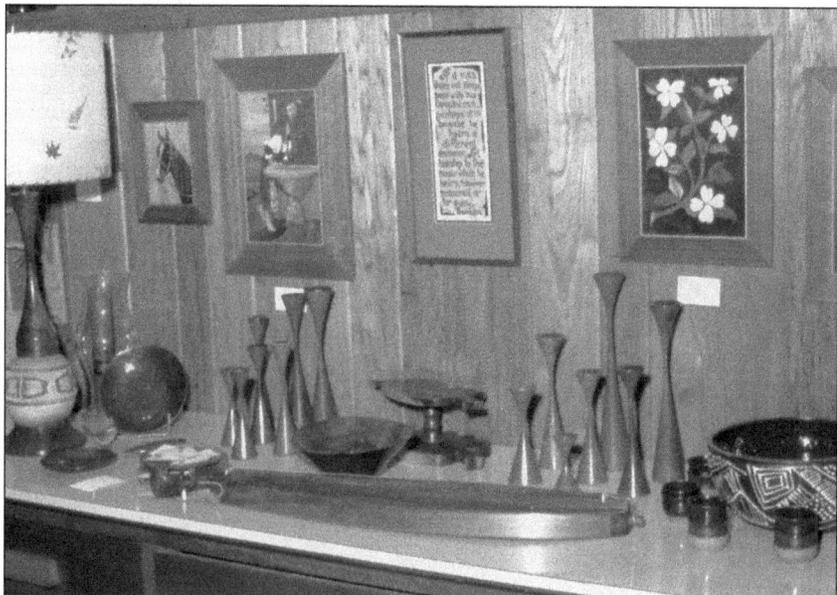

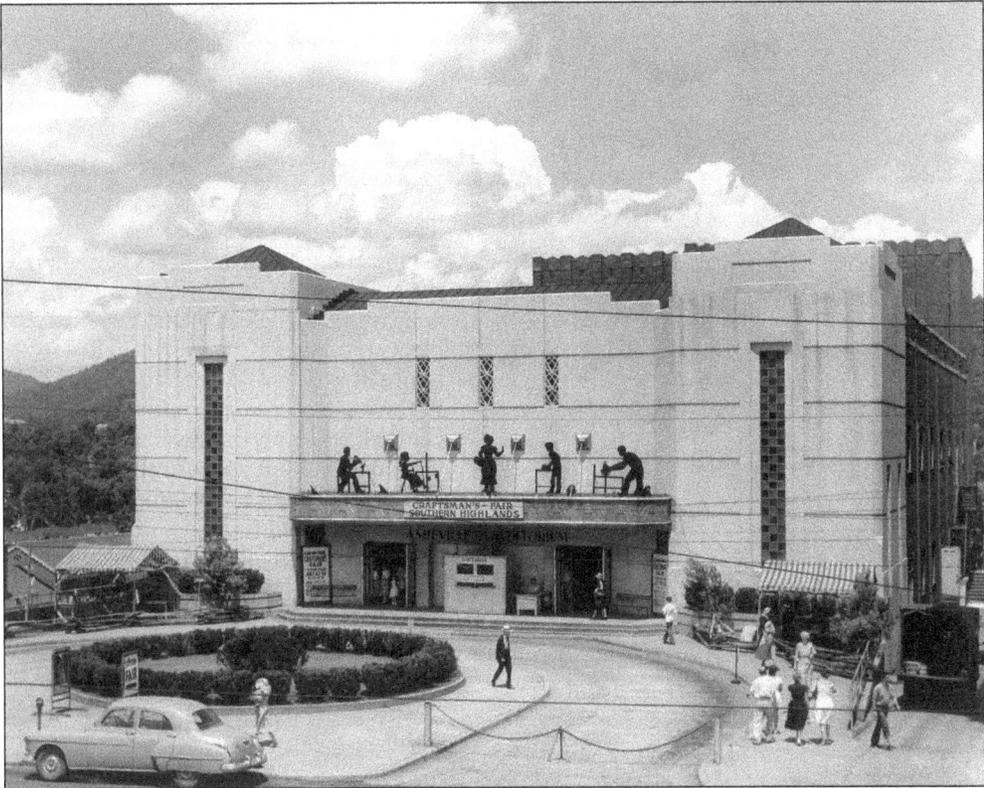

In 1951, the Craftsman's Fair of the Southern Highlands moved to the Asheville Auditorium in downtown Asheville, North Carolina. The auditorium area was used for displays and entertainment. The lower level provided a protected weatherproof space for members to set up their displays. Demonstrators to the right and left of the entrance gave visitors a preview. The silhouettes on the portico were brought along from the Gatlinburg fairs and decorated the entrance on fair days for many years. The opening-day photograph below includes guild members eager to enter and make sales. The fairs became an annual attraction for the city.

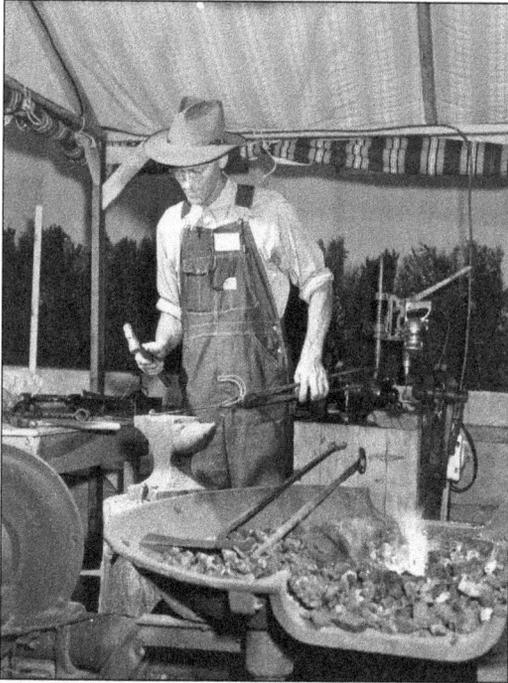

The outside area had space for demonstrators such as Oscar Cantrell, shown at left working his portable forge, and Fannie McLellan (below), who had plenty of room for the dye pot. The large hanks of wool would have dried quickly in the breeze coming toward Asheville. Cantrell was born in Brasstown, North Carolina, and was active at the John C. Campbell Folk School from its beginning. He did odd jobs in the early days but later established the metalwork program there and set up the first forge. McLellan worked at the folk school teaching dyeing, which she learned from the guild's first director, Louise Pitman.

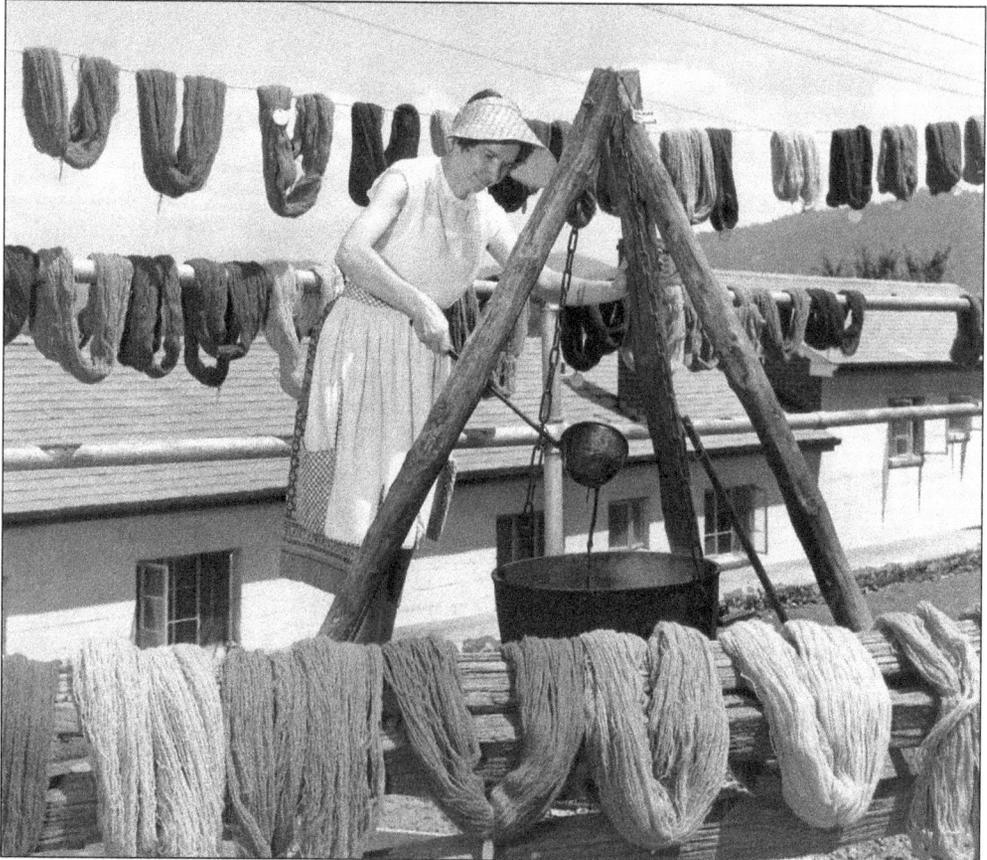

The one-floor sales area was packed with displays and craftspeople. A simple setup supplied for each artisan by the SHCG included cardboard-wrapped tables and snow fencing to designate aisles. The general sales area was the first attraction visitors passed through and offered work from members who could not attend the fair or needed additional display space.

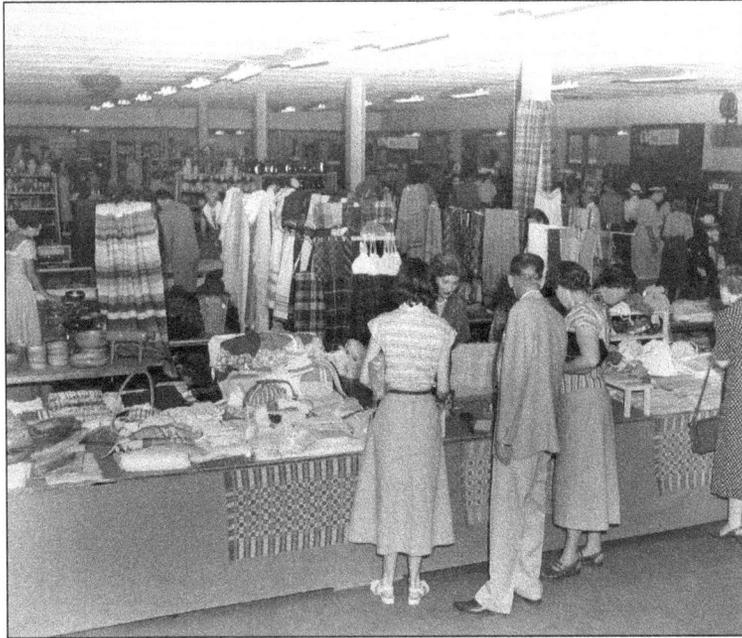

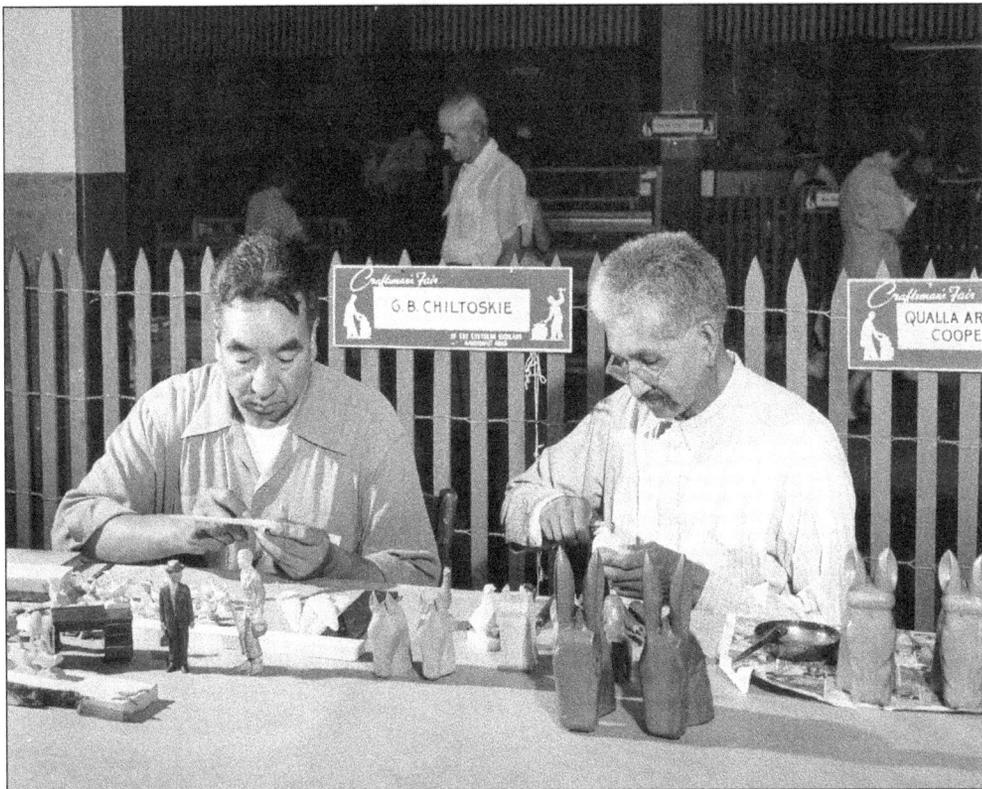

Going Back "G.B." Chiltoskey (the spelling of his last name varied until his wife, Mary, won the "key" to his heart) and his brother Wattie Chiltoskie (right), representing Qualla Arts and Crafts Mutual, are shown demonstrating wood carving. Wattie was known for his mule- and horse-head bookends. This setup was simple and kept the focus on demonstrations.

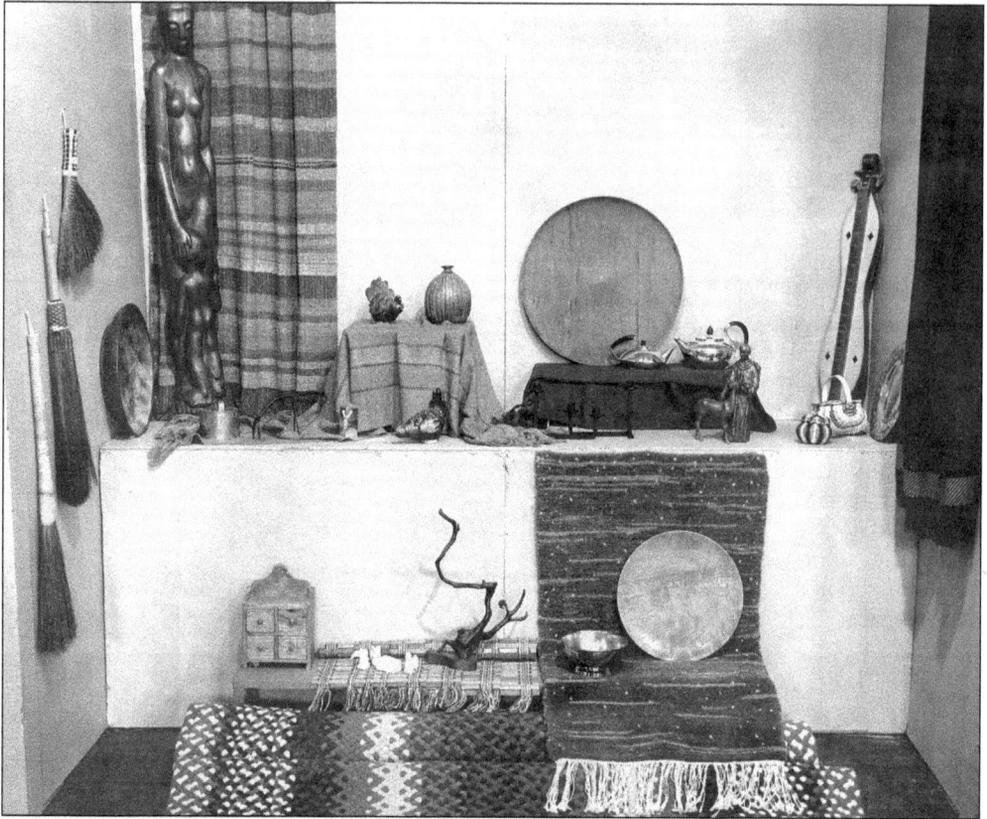

The auditorium area of the building was devoted to the members' exhibition and entertainment. The large wood sculpture on the left was done by Amanda Crowe. Braided oval and round rugs were beginning to replace hooked rugs in popularity. Pottery chickens, metalwork, candleholders, and woodwork are also on display. A carved figure of St. Francis of Assisi with a deer was a popular design done by the Brasstown Carvers.

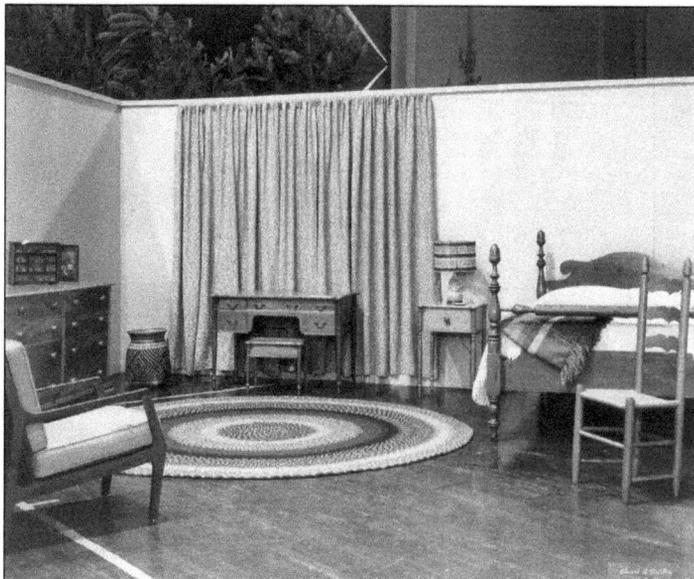

Room arrangements were set on the stage of the auditorium. The guild had many fine, traditional furniture-makers, including Berea College Student Industries and Edward DuPuy. A small marquetry chest by William Bader sits on the bureau. There is a Cherokee woven wastebasket in the corner, and the lamp on the side table has a wooden shade.

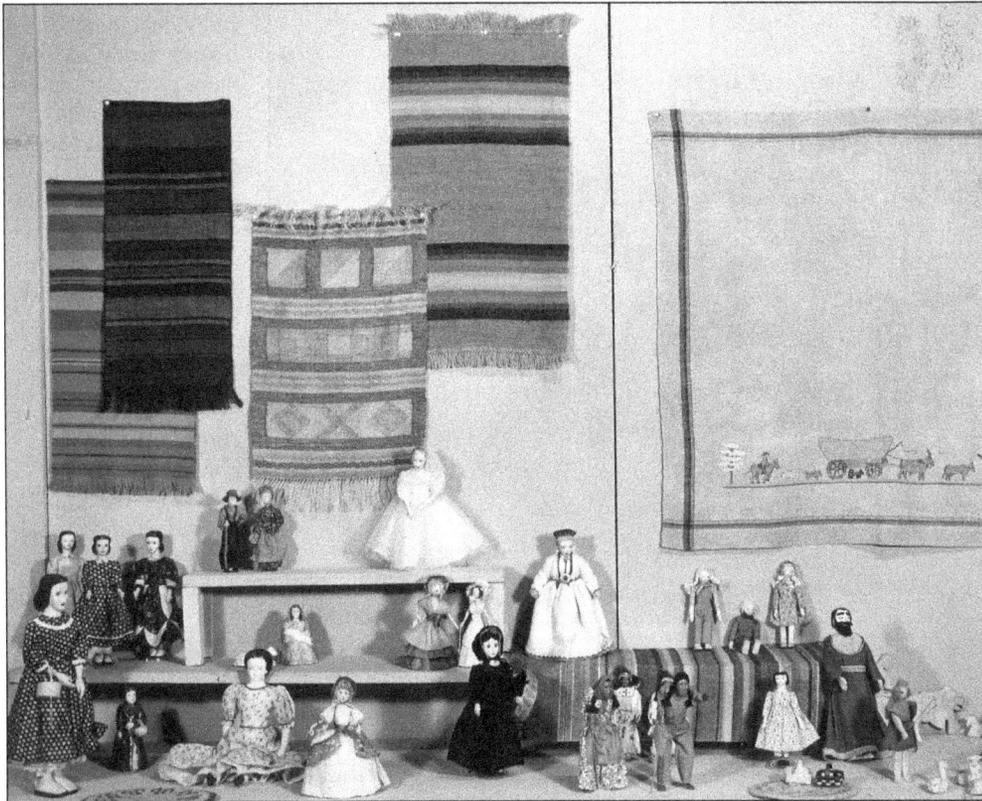

The display shown above—from the 1952 fair—features a variety of dolls. Helen Bullard's are at far left; they were known as Holly Dolls after a book character. Clara Hilton's figurine stands next to a large Holly Doll, and her colonial-style doll sits in front of a Madonna figure with sheep (also by Hilton). The dolls in fancy skirts were created by Ann Burke, and on top of the shelf are William Smith's Ma and Pa dolls. Cherokee dolls in traditional dress are just right of center. Small weavings and a piece from the Spinning Wheel hang at the back. Below, a close-up view shows an overshot weaving, a mountain dulcimer, pottery, and a carving by Tom Brown.

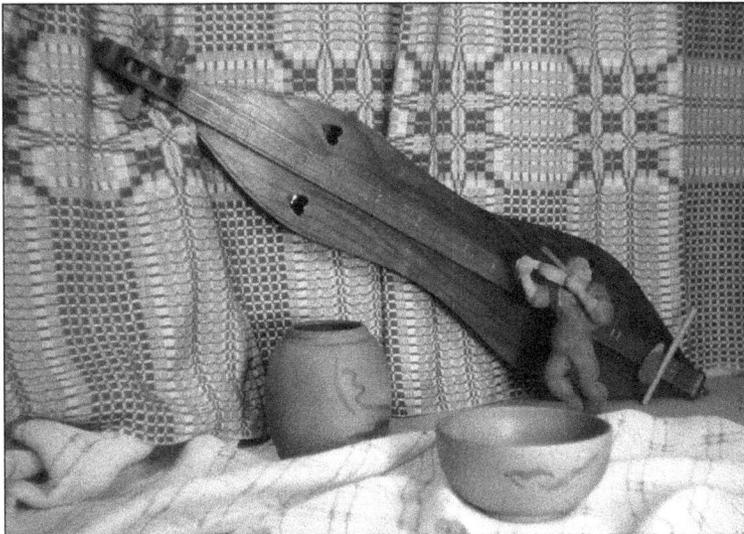

Individual member booths slowly became more prominent at guild fairs. Qualla Arts and Craft Mutual had a triangular arrangement of shelves to focus attention on a variety of Cherokee craftwork. Metalwork, hand-built pottery, dolls in soft leather clothing, woodwork, and basketry were contributed by Qualla's many members. The Qualla booth became a focal point for basket-making demonstrations.

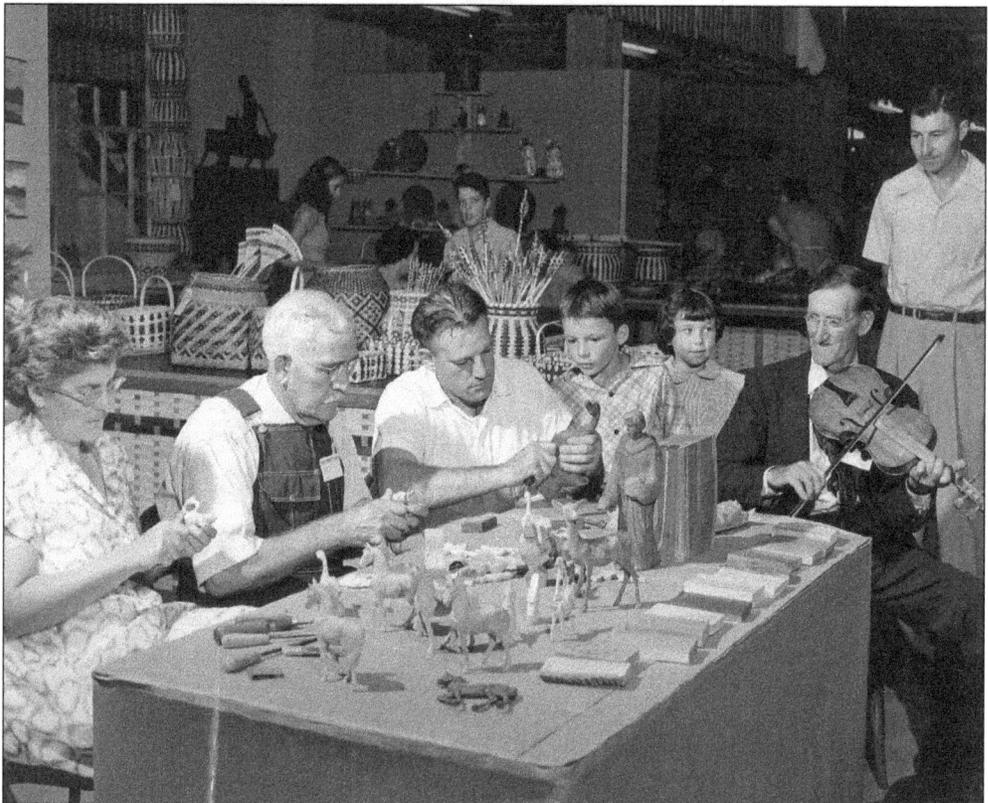

It was the individual craftspeople who made the Craftsman's Fairs so successful. Many original members were on hand, including the Brasstown Carvers shown here: Sue McClure (left), Ben Hall (center), and Jack Hall (Ben's son). The fiddle player, Marcus Martin, was the head of another wood-carving family.

Wade Martin joined the guild in 1951. He was a self-taught wood-carver living in Swannanoa, North Carolina. His family had made a home in the mountains for several generations, and Martin's carvings were a lively portrayal of mountain life. His fiddle-playing father was an inspiration for some of his pieces.

This display features Wade Martin's musicians. The band includes a banjo picker, a fiddle player, a guitar strummer, a bass player, and a man with a lap dulcimer. The background is covered with block-printed fabric and supports a mountain dulcimer probably made by Jethro Amburgey, who joined the guild in 1953.

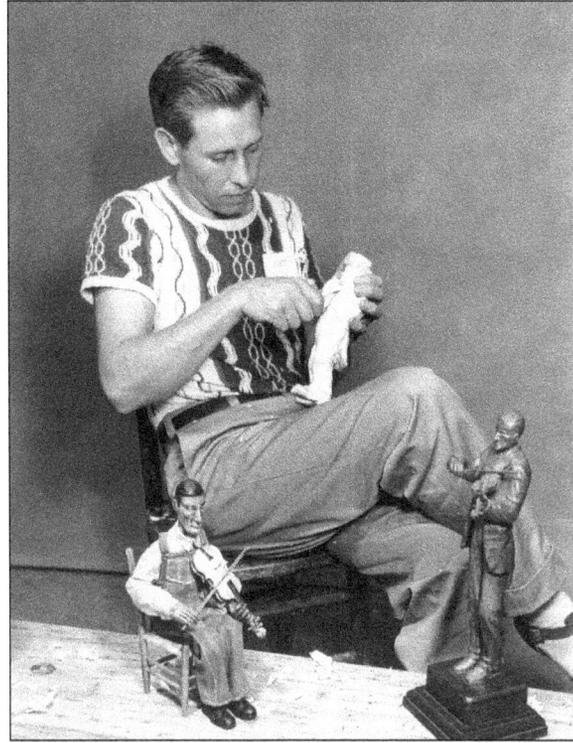

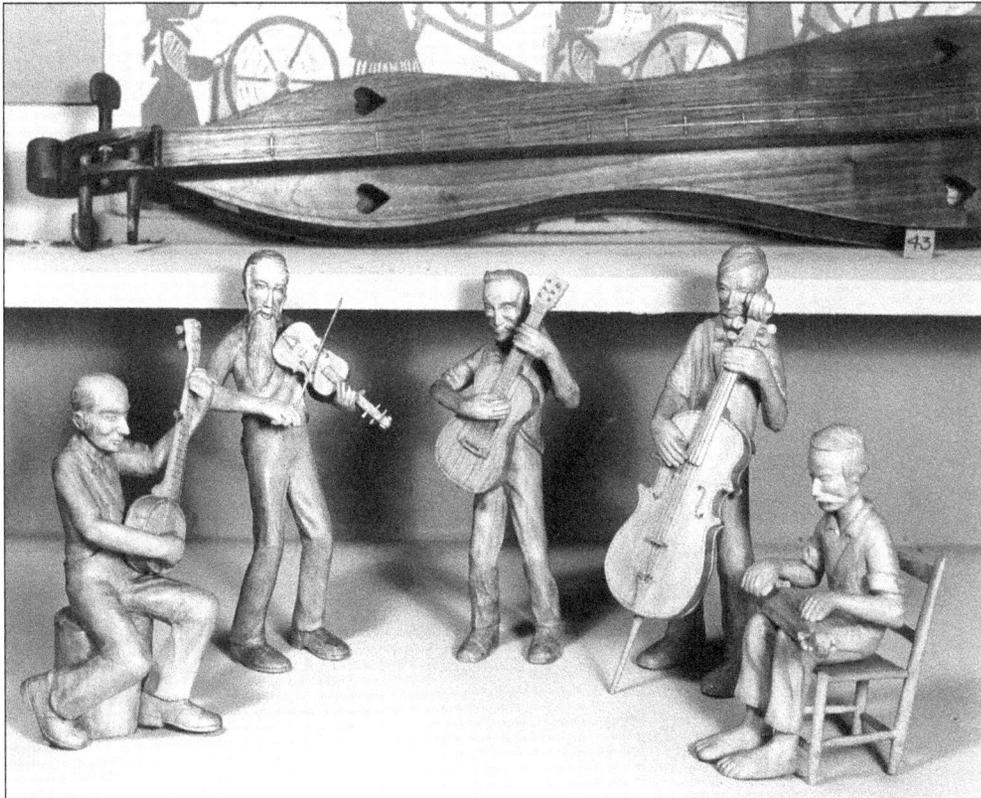

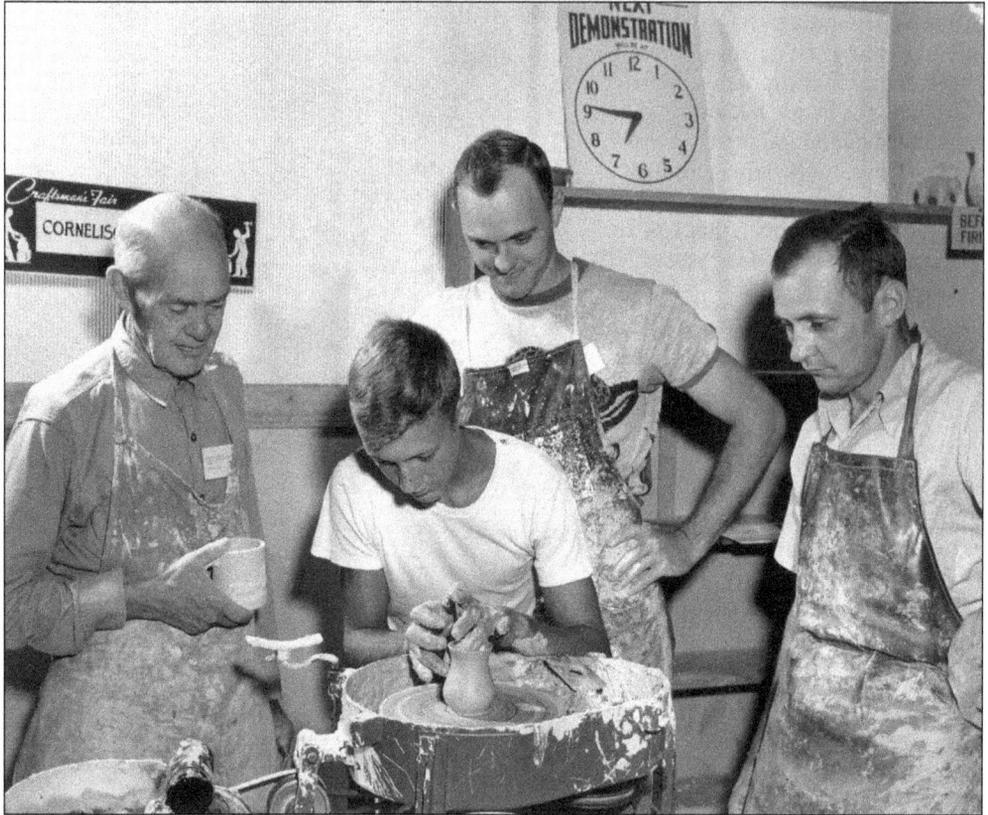

During the long fair days, potters took turns demonstrating thrown pottery work. Above, from left to right, Walter Stephen, Walter Cornelison, and Grady Ledbetter, who worked at Pisgah Forest Pottery, watch as a Hilton family grandson, Bill Hendley, takes a turn at the wheel. Hilton Pottery and McDonald Pottery were also involved in the 1950 fairs.

Lynn Gault came to Cherokee, North Carolina, as a set designer to work on the play *Unto These Hills*, a summer outdoor theater production. He began doing pottery as a break from his theater demands. He juried into the guild in 1952 and was the John C. Campbell Folk School's first pottery instructor.

Fiber arts continued to be well represented by a number of centers and individuals. Dorland-Bell School was a women's school in Hot Springs, North Carolina, and joined the guild in 1938. When the school combined with the all-male Farm School to form Warren Wilson College in 1944, the weaving program continued. Warren Wilson College kept its SHCG membership until 1962.

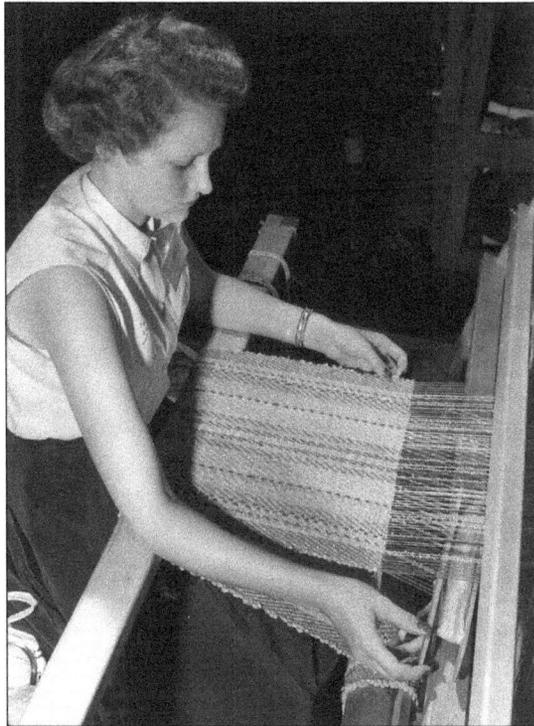

Lola Norton (left) and Elizabeth Edens demonstrated the preparation of fiber at many fairs. Norton joined the guild in 1938. She taught weaving at the Cabin Weavers in Norton, North Carolina. Norton is shown carding wool and combing the fiber into rolags, which Edens will use as she draws out the thread on the great wheel. Edens joined the guild in 1953 and was also a weaver.

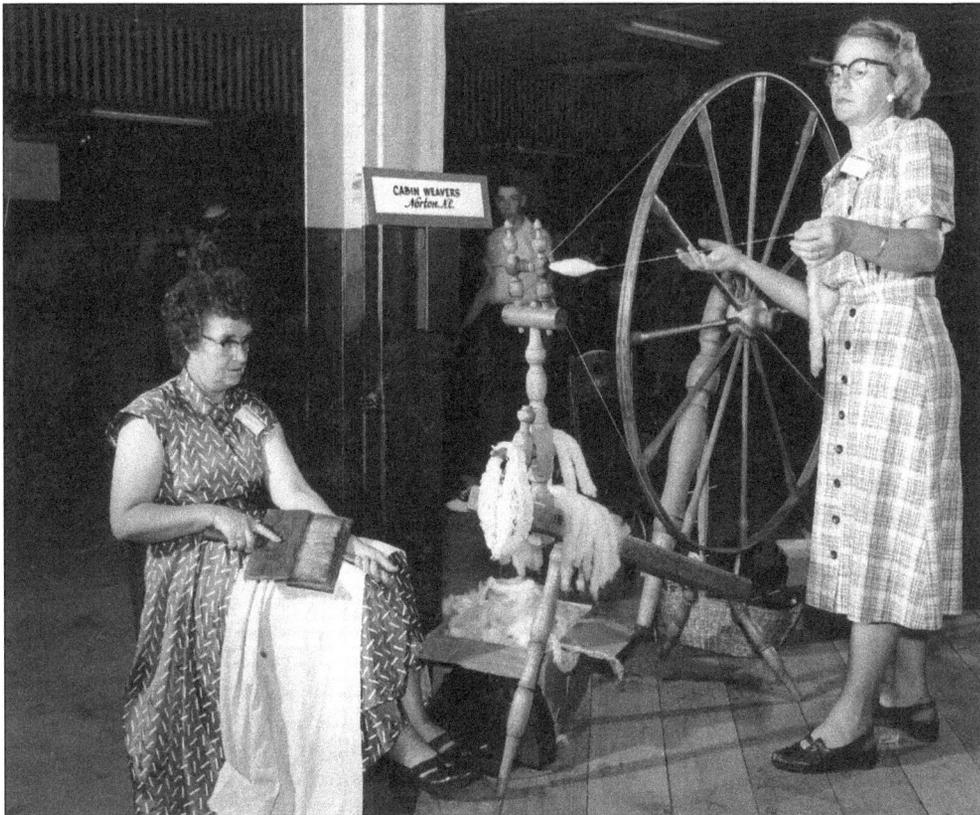

Bertha Cook (seated at left and wearing a bonnet) and her daughter Carrie Hodges (seated at right and wearing a bonnet) brought additional fiber techniques to the fair. Bertha is holding a white bedspread in her lap that will be decorated with white colonial knotwork, sometimes called candlewicking. Carrie is making fringe to be applied to bedspreads and canopies.

Fiber crafts changed as public interest in hooked rugs began to wane and braiding became more popular. Edna Charles seized on the interest in handmade braided rugs and founded Avietta Rugs, a Tennessee group that joined the guild in 1947. She used her skills to employ women in her community. Her daughter continued the business for several years.

Stuart Nye managed a workshop where silver jewelry was created in Asheville, North Carolina. In this photograph from the 1953 fair, he is near the center of the image and chatting with one of his workers, Ed Holland (seated). Nye learned to do silverwork as a recovering veteran after World War II. The workshop continued under Ralph Morris Sr. and has since passed to his son.

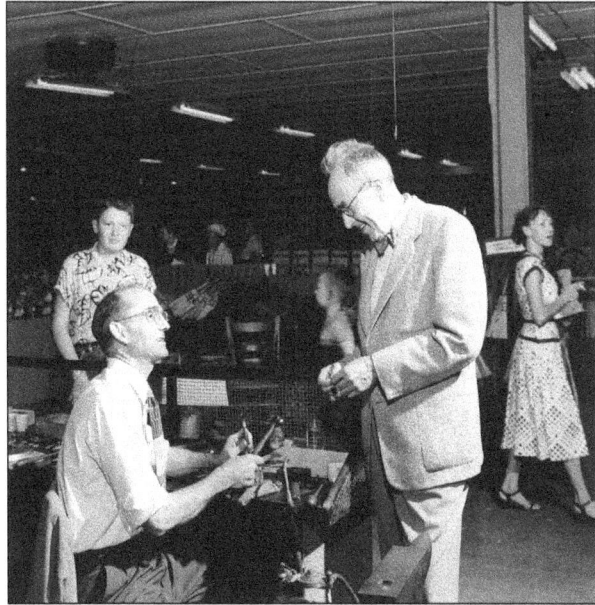

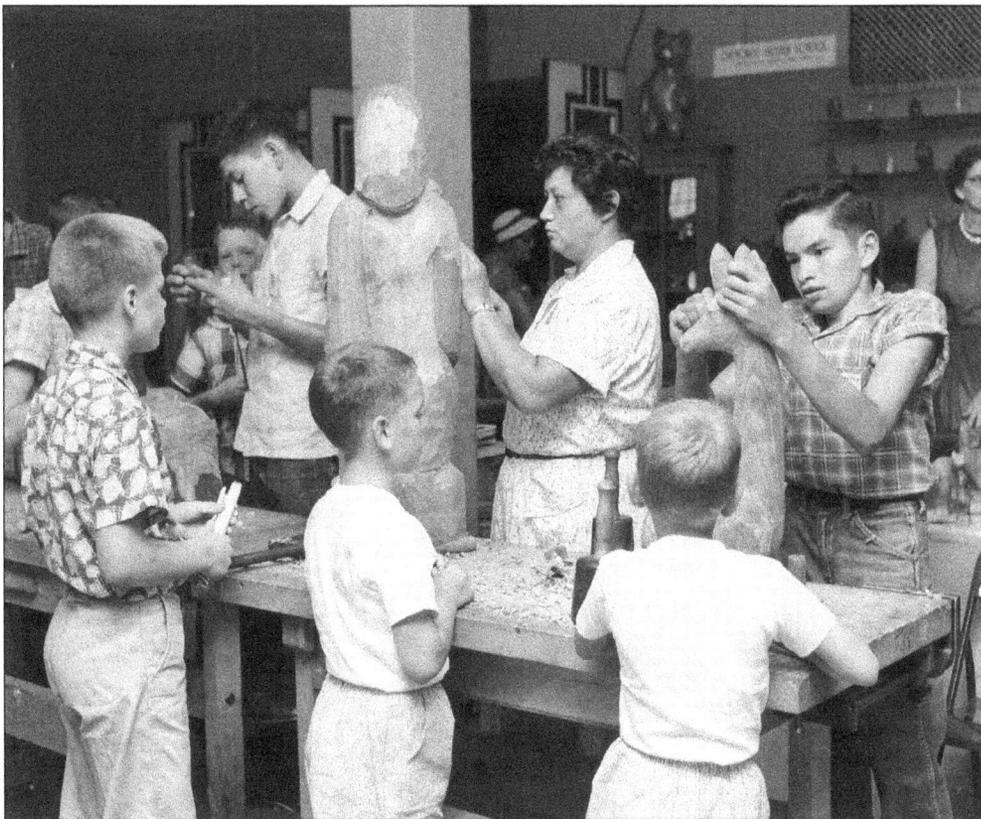

Amanda Crowe was a gifted carver who taught at the Cherokee Indian School and sold her work at Qualla Arts and Crafts Mutual. She studied at the Chicago Institute of Art, where she received a bachelor's degree and a master's in fine arts. After 12 years in Illinois, she returned to her mountain roots and shared her training with the community.

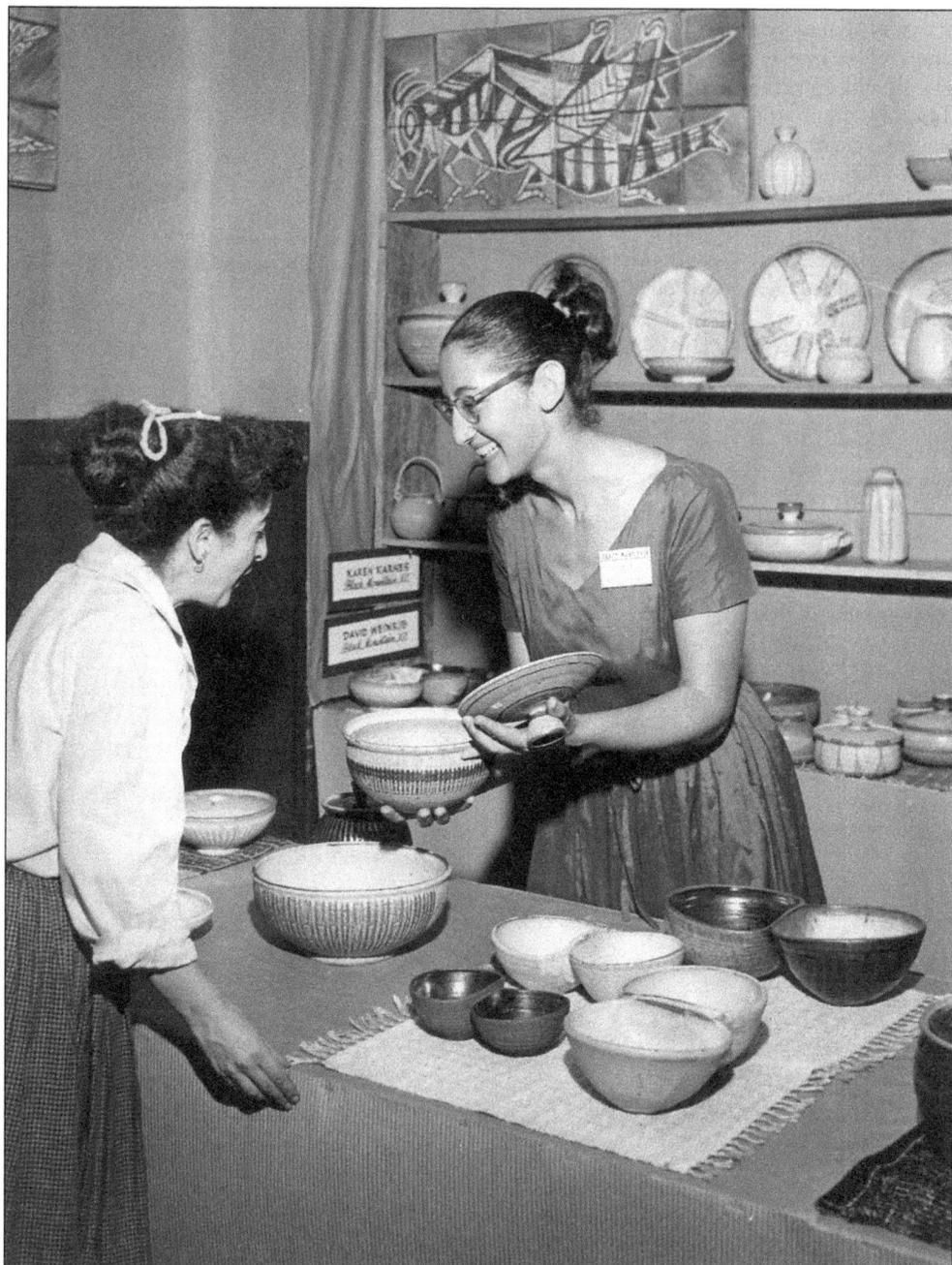

Black Mountain College was an art college in Swannanoa, North Carolina, that brought many internationally known artists to the area. Karen Karnes and her husband, David Weinstein, were the only two people from the school to participate in the guild. They kept their membership for two years before moving out of the area to pursue their craft.

Five

THE 1960s

A CRAFT REVIVAL

In 1961, SHCG hired a paid director, Robert W. Gray, to administer and develop the guild. Louise Pitman had served as guild director from 1951 to 1961 with the help of the board of trustees. Robert Gray had a varied experience as a craft administrator in New England, including work with Sturbridge Village in Massachusetts. His wife, Verdelle Gray, a potter, accompanied him and became an active guild member. Pictured here at the 1961 fair are, from left to right, Verdelle Gray, Robert Gray, board of trustees president Rude Osolnik, and Pitman.

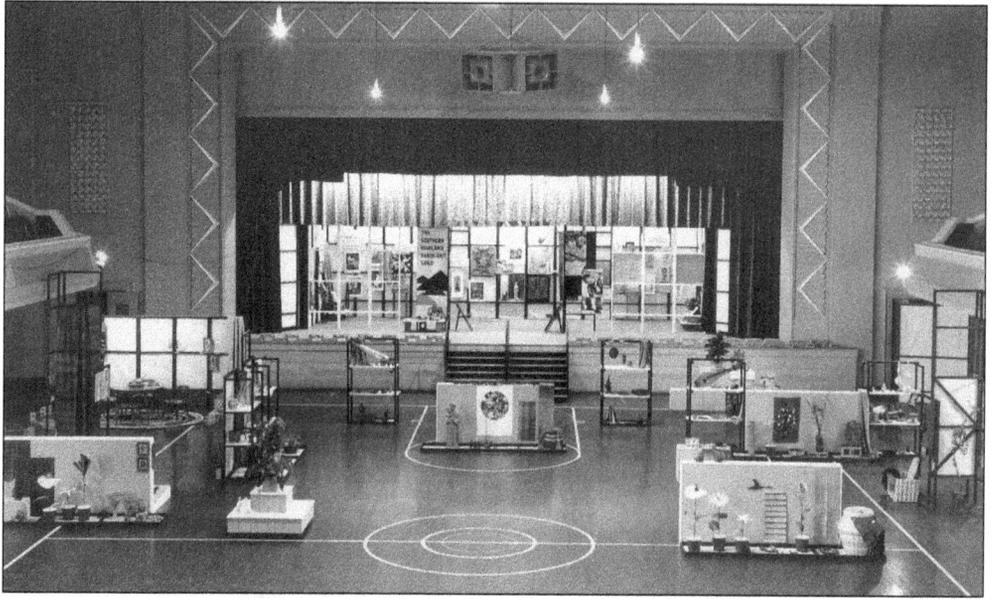

One big change in the 1960s was the addition of a second Craftsman's Fair. The July fair in Asheville, North Carolina, continued to be a huge success with a growing number of artisans and visitors; however, the auditorium venue was no longer large enough to comfortably fit all of the members who wanted to participate. Shadrack Birdic Mace, known as "Birdie," is shown below sitting at a furniture maker's draw horse and greeting visitors as they arrive. Many groups took advantage of the educational aspect of the demonstrations and displays. The exhibitions and member displays were becoming more sophisticated. Music and dance had also grown into a full schedule, with various schools and community groups participating.

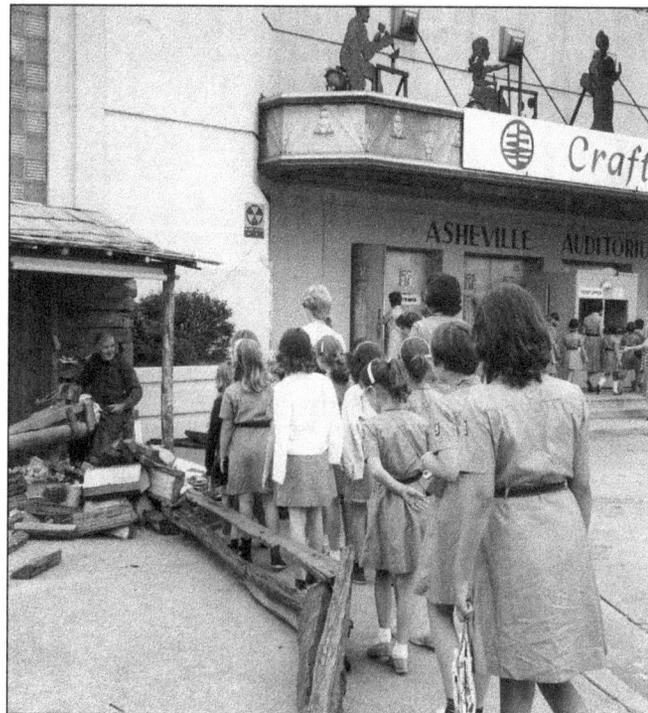

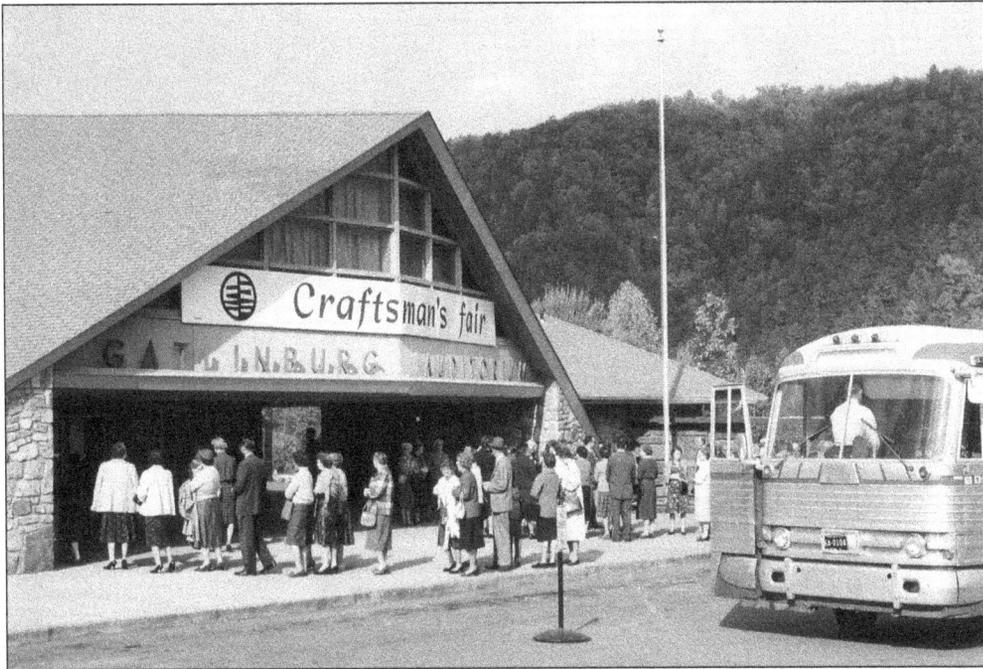

In 1960, the guild decided to add a second Craftsman's Fair that would be held in Gatlinburg, Tennessee, in the town's new auditorium. Nestled into the colorful foliage of the Smoky Mountains in October, the new fair was an instant success and was applauded by the numerous Tennessee guild members. The auditorium offered a generous open area for members to set up and a stage (shown below with a Christmas sales display), a large lobby, and an open courtyard area. The guild was still supplying tables wrapped with brown paper and pegboard backing for the member sales area, and the focus of the booths was moving away from demonstration and toward display.

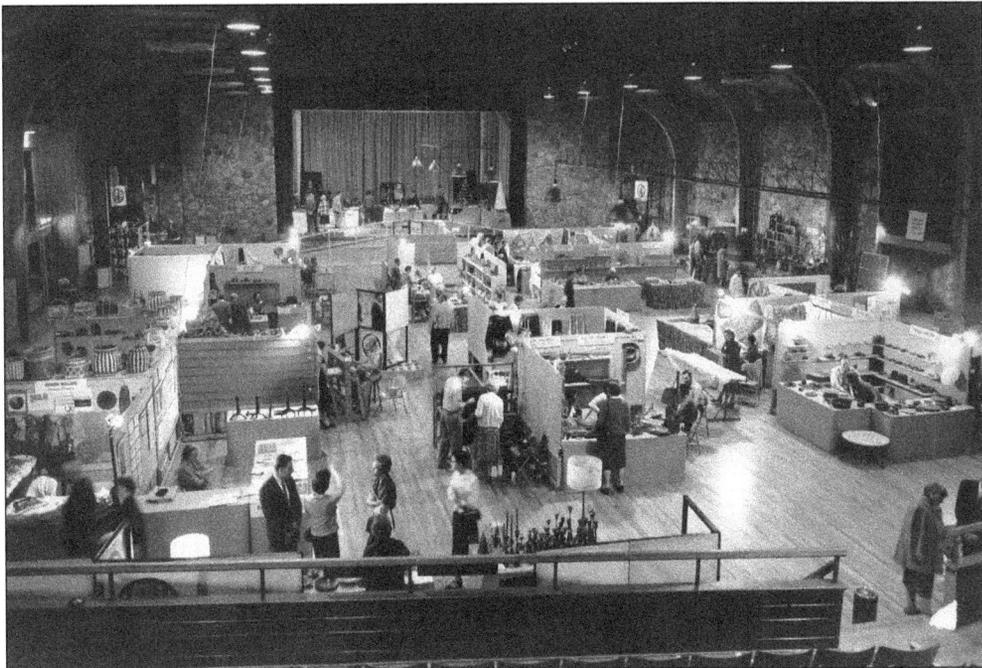

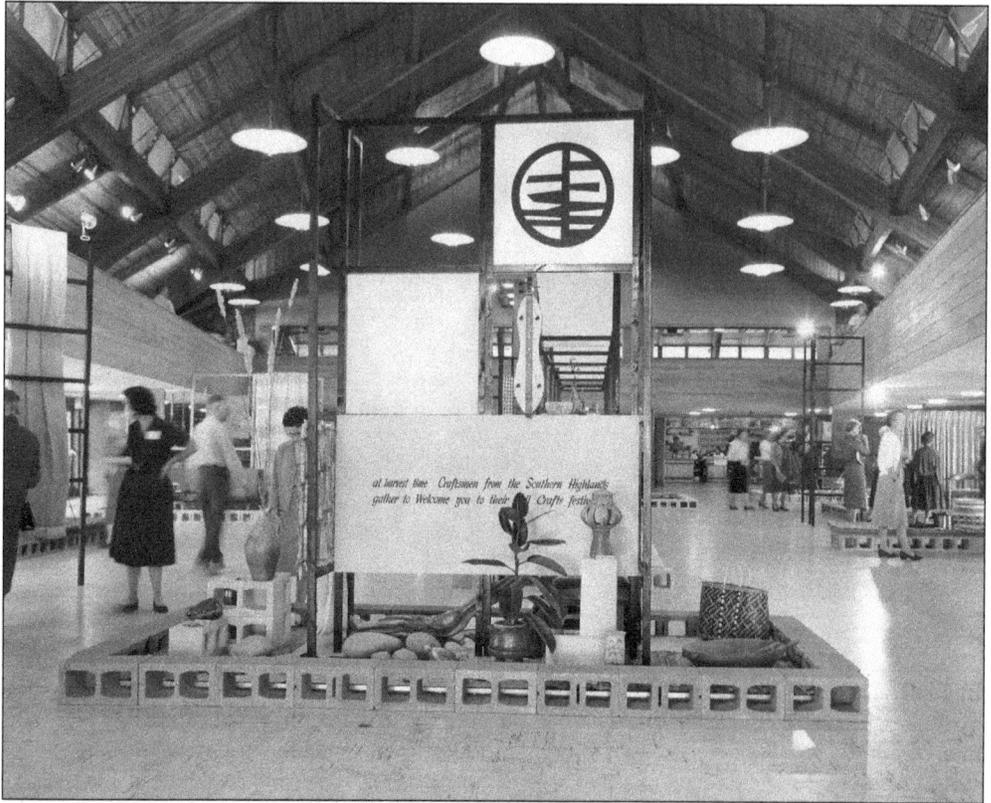

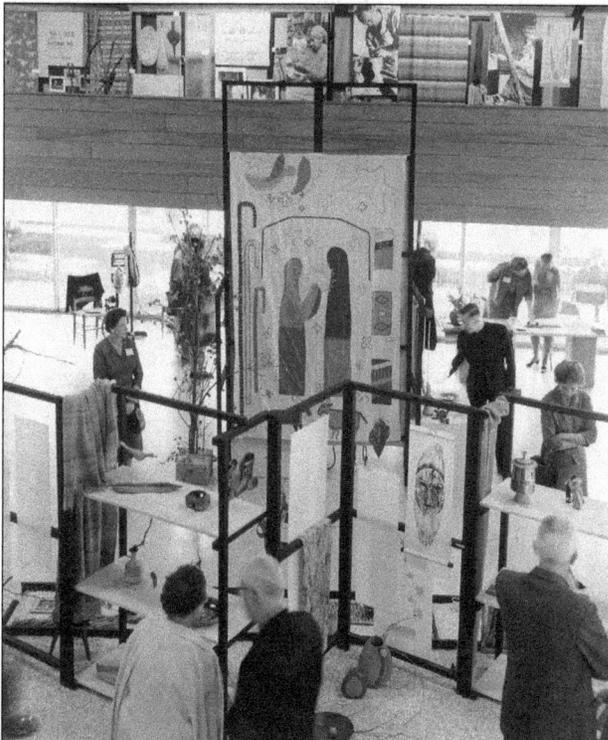

In October 1960, the Gatlinburg fair opened with a lobby display designed by Charles Counts and a team of Tennessee members. The arrangements were lacking fancy settings but effective in their simplicity. The opening message reads, "At harvest time Craftsmen from the Southern Highlands gather to Welcome you to their fall Crafts festival."

This photograph from the 1962 Gatlinburg fair shows how a walkway around the second floor of the entrance lobby allowed for further exhibits and educational displays. Large photographs and text panels told about guild history and membership. The timing of the fair being held in October allowed artisans to aim their sales with an eye toward Thanksgiving and Christmas.

Outdoor demonstrations were a part of both fairs as the little log cabin continued to travel from Arrowmont twice a year. Mary Frances Davidson is managing the dye pot in this picture from the 1962 Asheville fair. Davidson was teaching dye work at Arrowmont in the summers, while during the school year, she taught mathematics in Tennessee public schools.

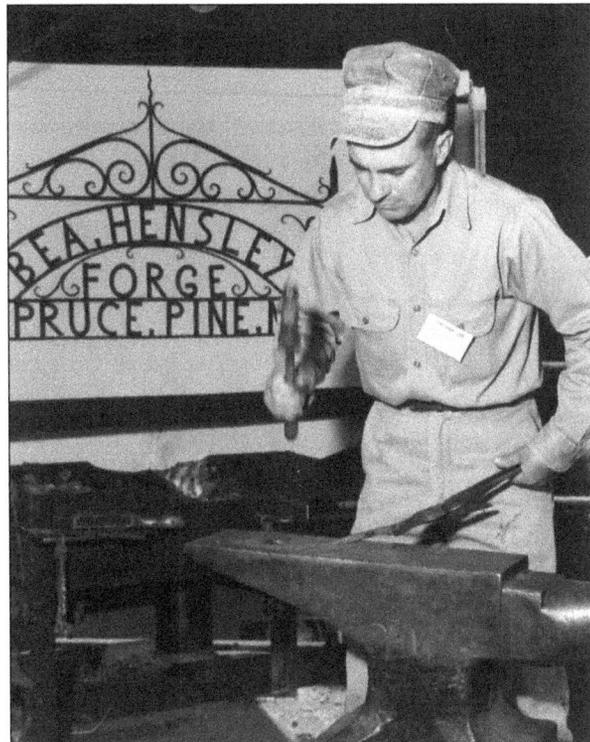

Bea Hensley did his apprenticeship with Daniel Boone VI and later purchased the forge in Spruce Pine, North Carolina, from Boone. Hensley joined the guild in 1957 as a blacksmith and put on demonstrations of his craft nearly every year after joining. As he hammered iron, he also beat out a recognizable tune on his anvil. In 1993, he was awarded the North Carolina Heritage Award. Today, his son Mike runs the forge.

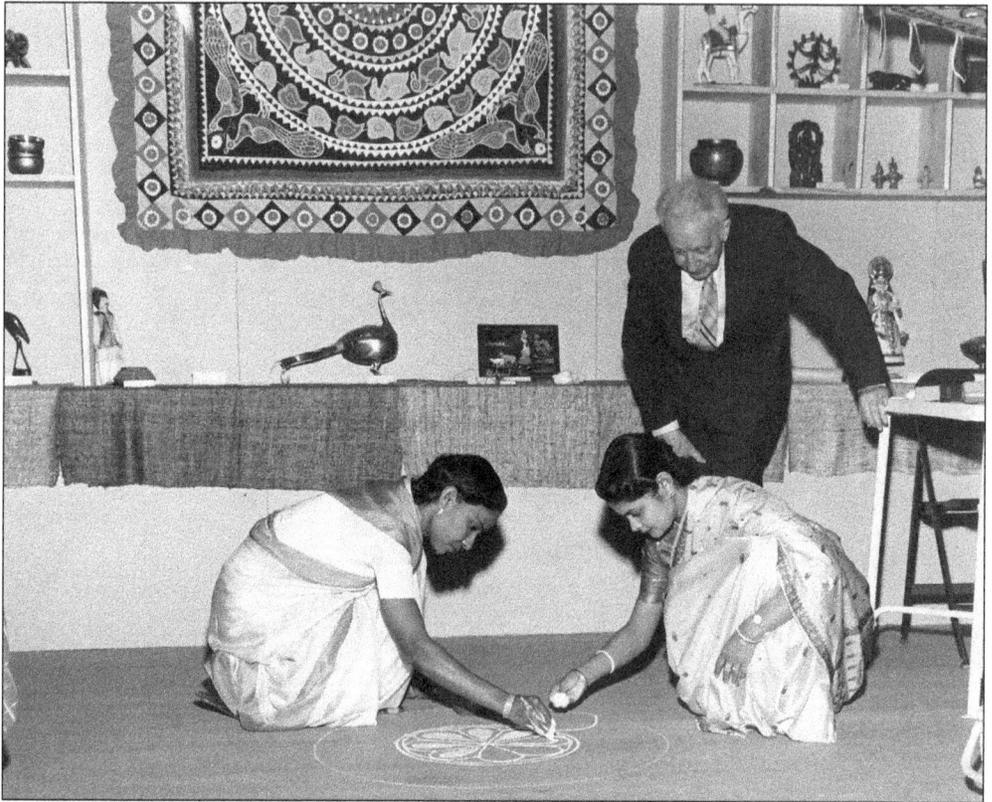

Alan Eaton continued to take part in guild activities as well as doing international work for the US Department of Commerce. In 1960, he brought a display of crafts and several craftswomen to participate in the fair. The two women pictured here are creating a temporary mandala on the floor of the auditorium stage.

In some years, the educational section focused on a craft medium, which was demonstrated by guild members. In 1963, the Asheville Auditorium stage was dedicated to weaving and the steps that precede the making of cloth. Several looms and spinning wheels were kept busy by guild members. Craft lectures were also given twice daily.

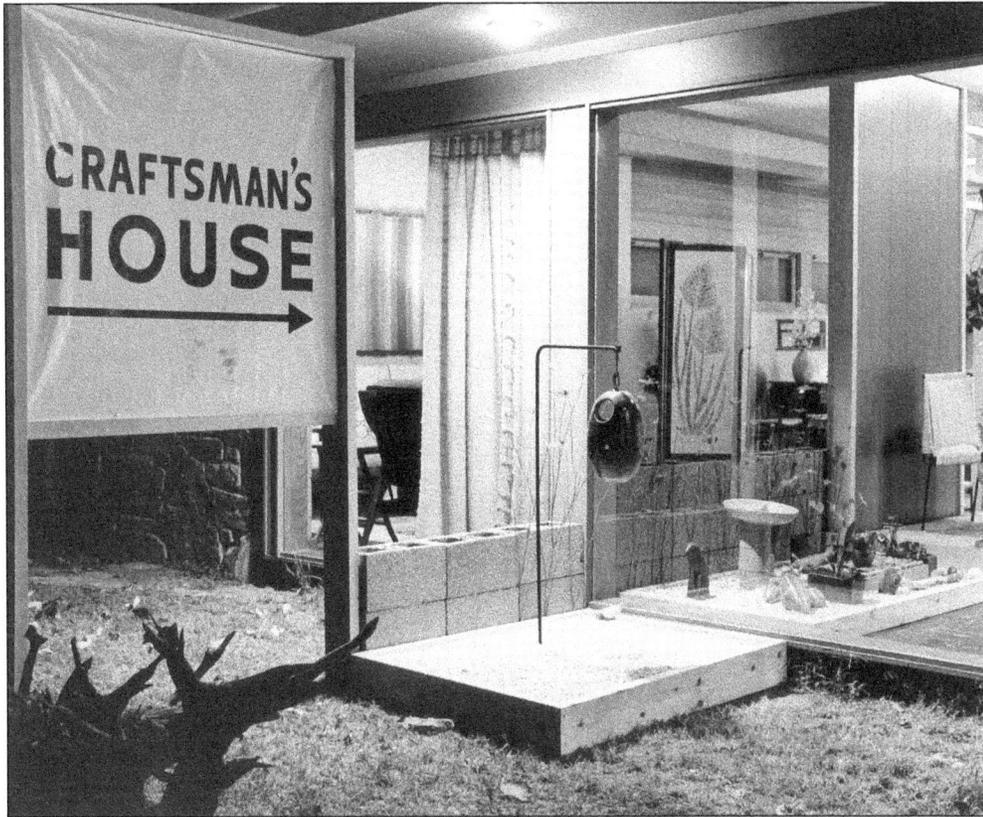

The 1962 Craftsman's House was designed by guild member and architect Sam Dunlap from Oak Ridge, Tennessee. The exhibition showcased six room displays, including a kitchen, all furnished with handmade items. The furnishings were for sale, but shoppers had to wait until the fair's end to acquire their purchases.

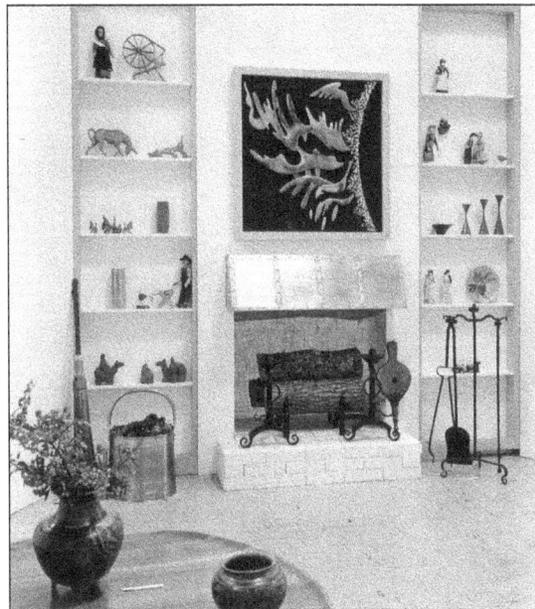

The 1964 Craftsman's House featured this lovely living room furnished with material from members. Smaller items include Brasstown carvings, Willie Smith's dolls, Polly Page's apple-head dolls, and Rude Osolnik's candleholders. The fireplace showcased a large, enameled work done with flame-colored glass powder by Jane Glass, who joined the guild in 1946.

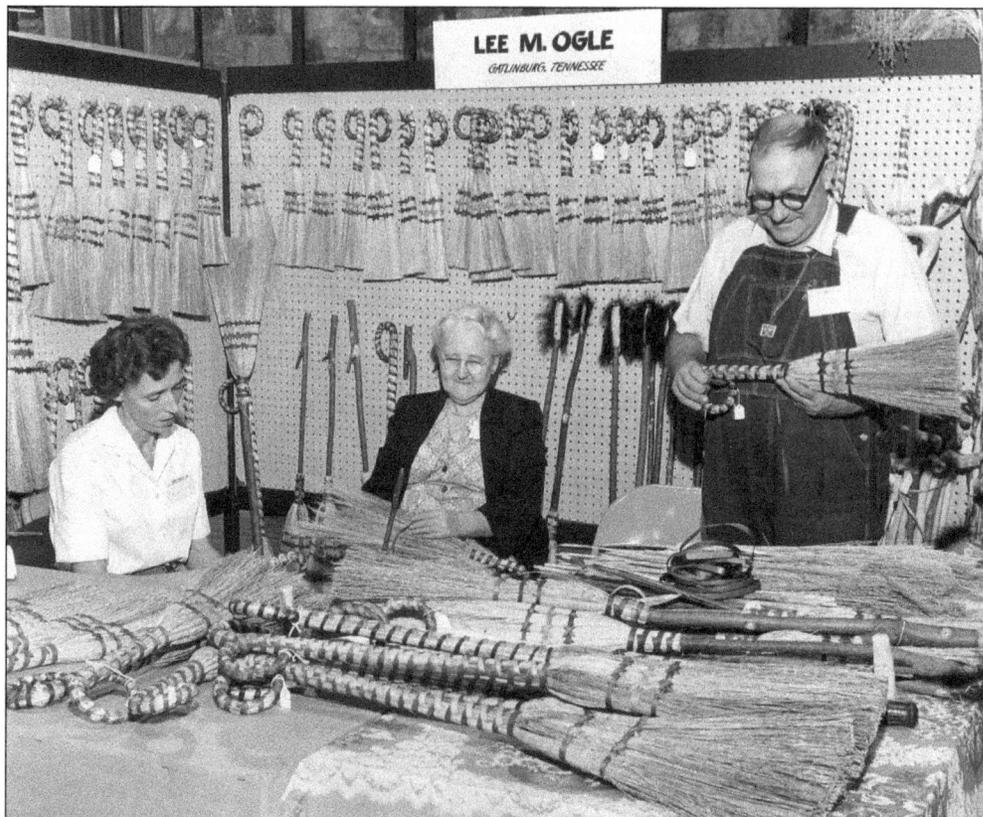

LEE M. OGLE
GATLINBURG, TENNESSEE

Booth accoutrements supplied by the guild included tables, chairs, lights, and a pegboard background for the working areas. The construction and arrangement of the booths, which took days to set up, were done by member volunteers. The Ogle family from Gatlinburg, Tennessee, were members in 1962 and used their pegboard to display an assortment of brooms and brushes.

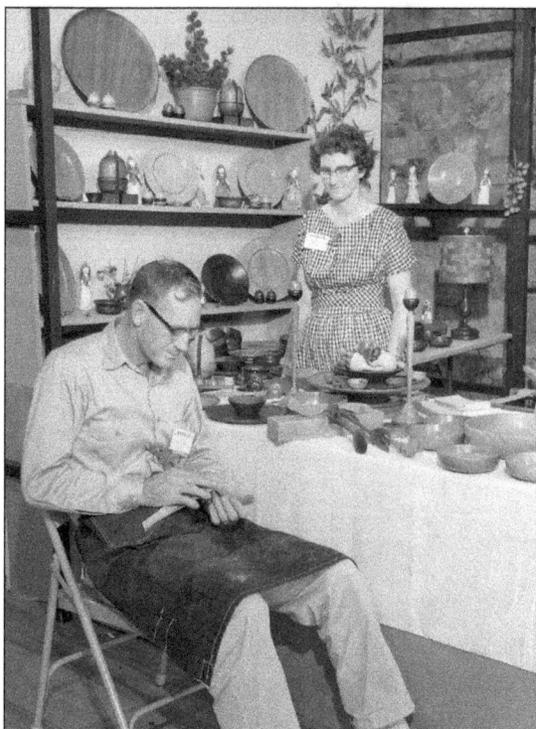

Carl Huskey joined the guild in 1946 and established the Village Craft Shop in Gatlinburg, Tennessee. He also participated in the early Gatlinburg fairs. His sons Earl and Ray were the fifth generation of the family to do woodcraft in the Appalachian region. They made everything from bowls and bookends to custom furniture.

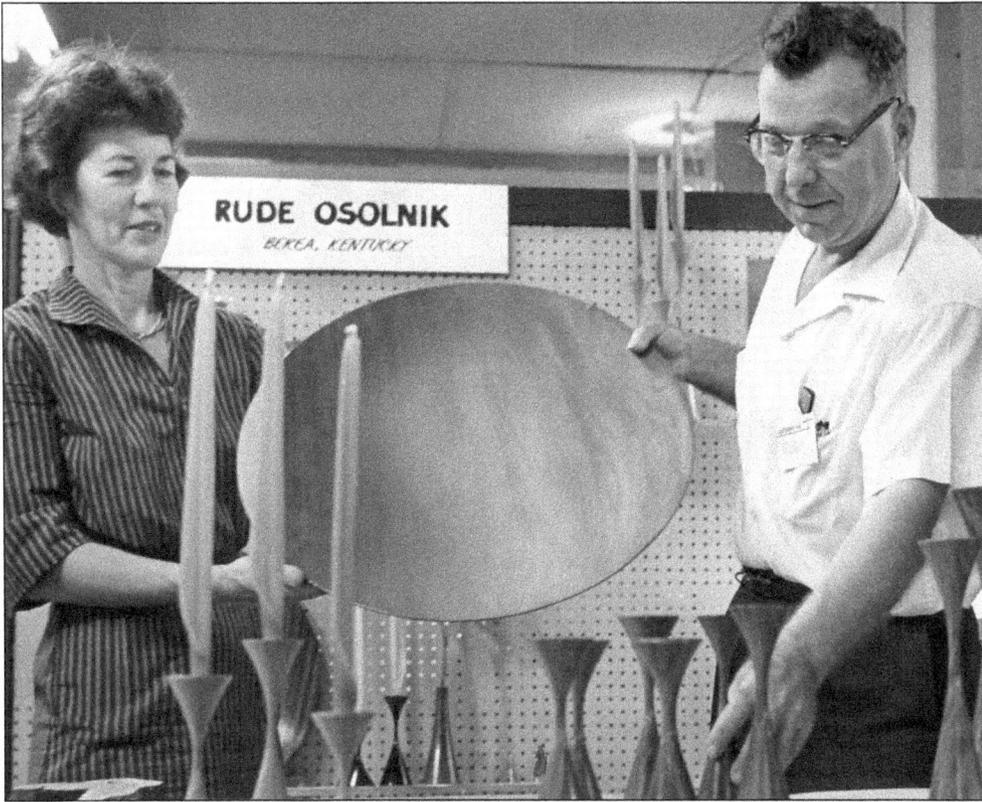

RUDE OSOLNIK
BEREA, KENTUCKY

Rude Osolnik, shown here with his wife, Daphne, joined in 1955 and was one of the most active guild members. He was the woodshop teacher at Berea College and promoted wood-turning techniques with a light touch still admired by collectors of his work. He served on the guild's board of trustees for many years and was always on hand to help set up and break down the fairs.

Fred Smith joined the guild in 1941 and made a variety of carved trays and bowls. The work was done with native woods and hand gauges, then lightly sanded and finished with a clear varnish. Smith learned woodworking at John C. Campbell Folk School. His skill allowed him to give up farming and work full-time to support his family with woodwork.

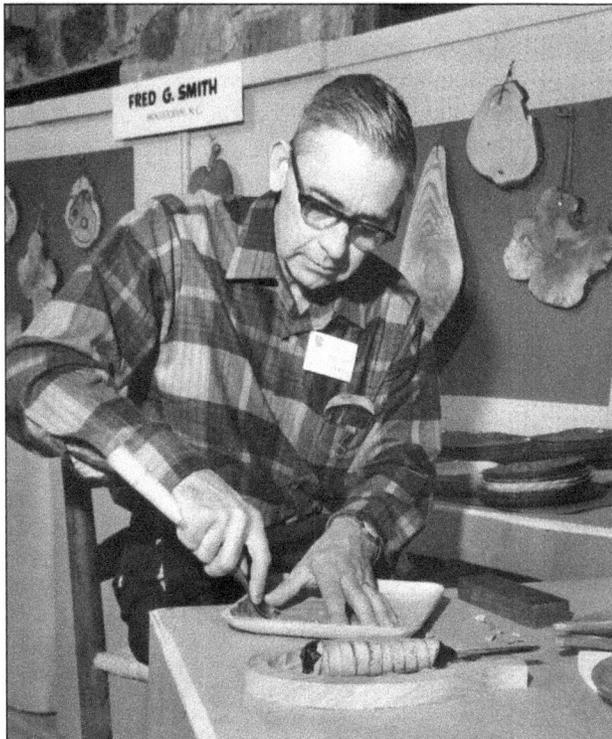

FRED G. SMITH

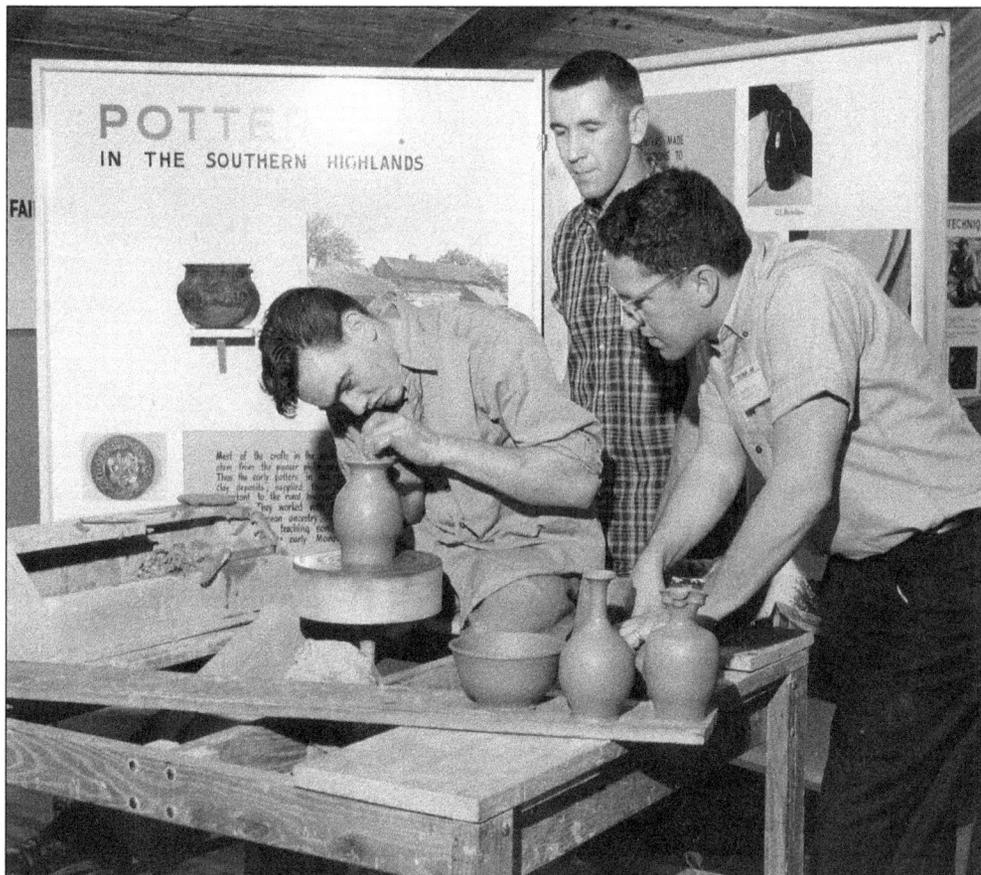

Pottery was the focus of the fair in 1961. Here, Paul Hudgins is receiving intense scrutiny from Don Lewis (standing behind him) and Charles Counts. Hudgins and Lewis studied pottery at the Rising Fawn studio with Counts. Lewis became a full-time potter and taught at multiple colleges and schools; he was also active in guild leadership and served on the board of trustees.

Charles Counts, from Rising Fawn, Georgia, gained a national reputation. He and his wife, Rubynell, were both guild members in pottery but also worked with local people to produce a variety of fiber crafts. He was active in the guild and in the region as the War on Poverty began. Several guild members studied at the Counts' Rising Fawn Studio, including Don Lewis, Paul Hudgins, Wanda Lee, and Nancy Darrell.

Hugh Bailey was a graduate of Berea College, where he taught ceramics for several years. He juried into the guild in 1959 with pottery and later with stained glass. He was especially known for his whimsical animal figures. With a degree in graphic design, he generously designed many of the materials used for guild fairs and brochures.

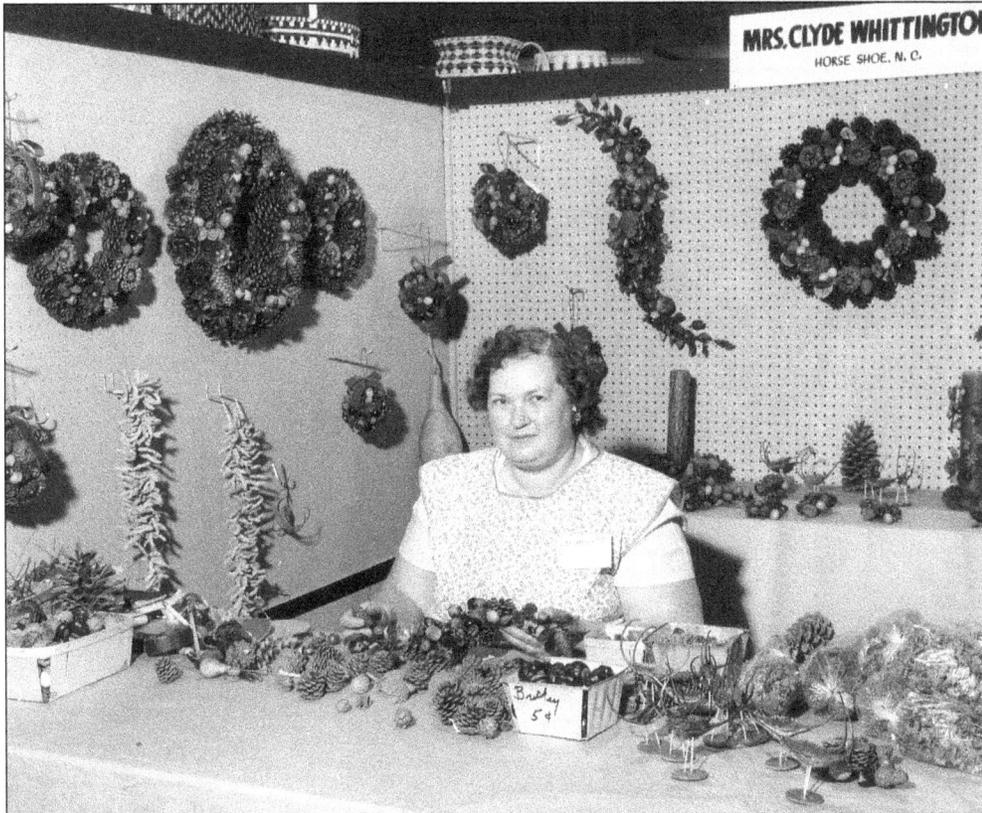

Hazel Whittington lived in Mills River, North Carolina, and joined the guild in 1962 with work in natural materials. All of her materials were either locally gathered or homegrown. She was proud of the self-sufficient life her family lived on their farm. She was also known for her jellies and canned goods, which she took—along with her wreaths—to the Curb Market in Hendersonville, North Carolina.

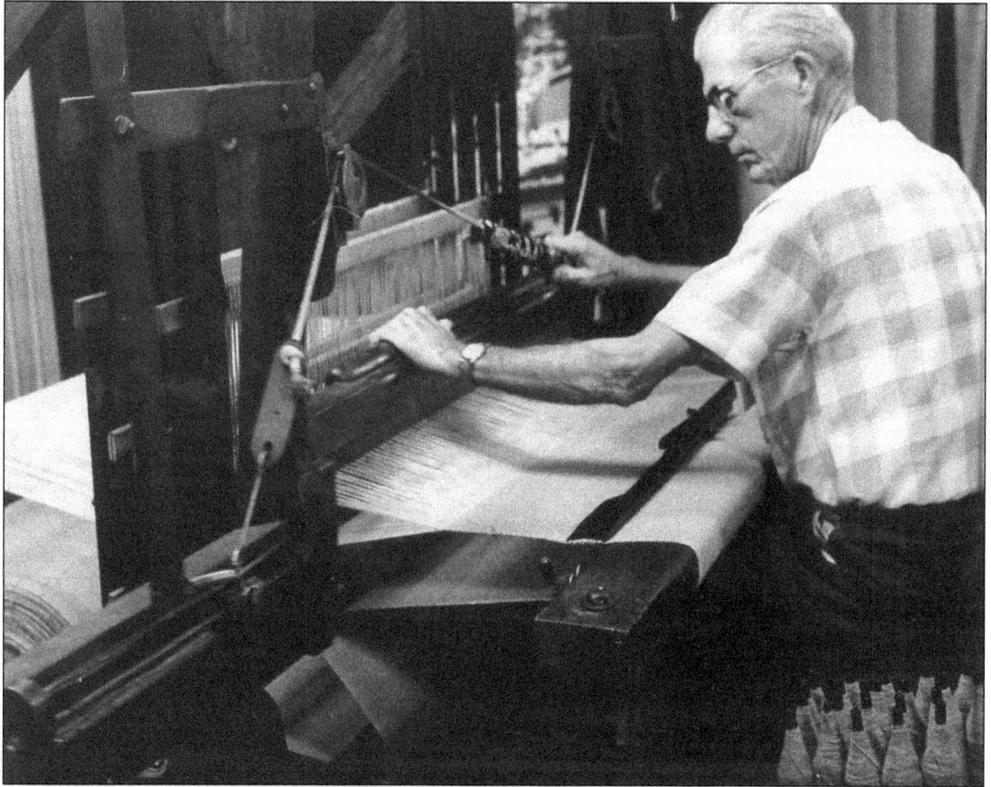

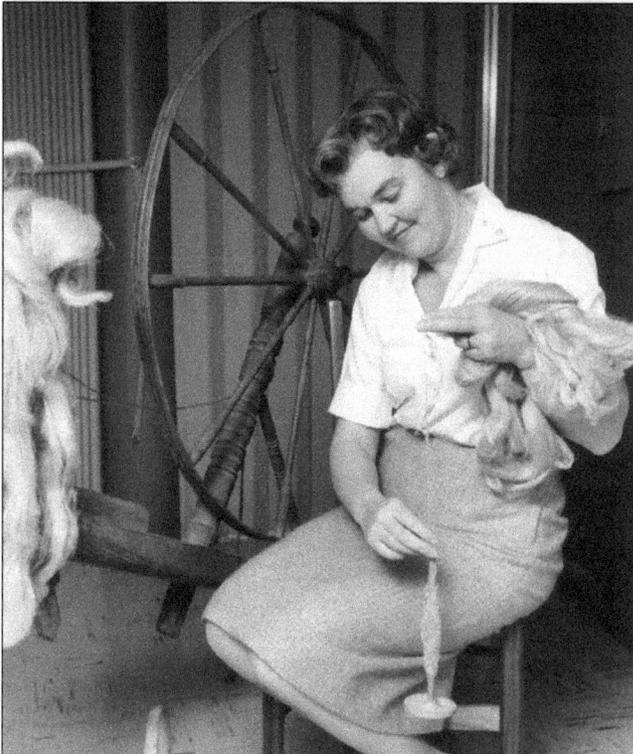

Biltmore Industries joined the guild in 1960. The Biltmore Handwoven Homespun shop was originally founded under the auspices of the Vanderbilt family in 1901. At one point, it was the largest homespun industry in the world. Later, the shop moved to the Grove Park Inn area, where it is now both a craft shop and museum.

Persis Grayson joined the guild in 1958 and was a beloved guild leader. As an avid spinner and weaver, she taught workshops and classes throughout the region. Here, she demonstrates the use of a drop spindle for spinning flax while an antique great wheel stands ready behind her. Grayson was also the first president of the Handweavers Guild of America.

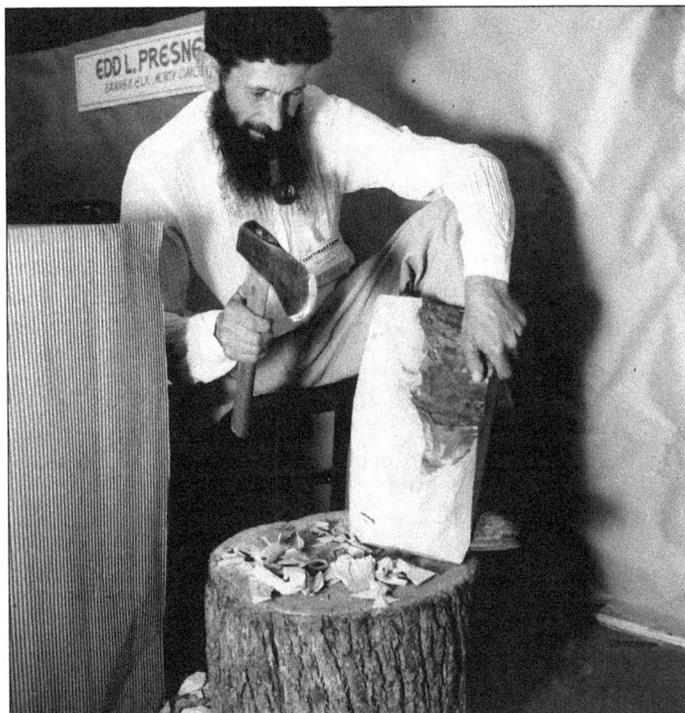

Edd Presnell lived in the mountains of North Carolina and joined the guild in 1956. He learned woodworking from his father-in-law as a supplement to farming. All of his work for bowls and treenware was done by hand. His dulcimers won special recognition and can be found in museums in Washington, DC, and Cairo, Egypt. His son Baxter continued this type of work.

Don Ward operated a furniture workshop in Gatlinburg, Tennessee, and joined the guild in 1955. He learned his craft in the Civilian Conservation Corps and opened his business after World War II, employing men who returned to the mountains in need of work. The workshop relocated to Stanton, Kentucky, in 1973. His showroom and Berea College Student Industries supplied much of the furniture in the room displays.

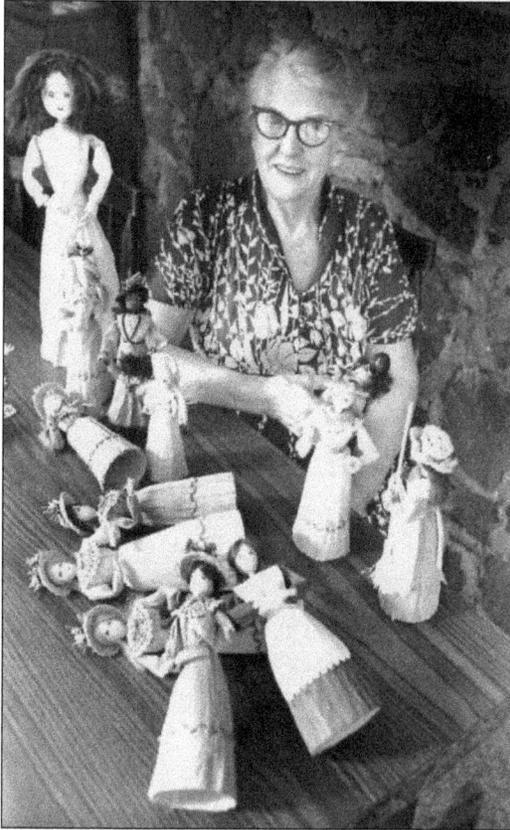

Mae Ritchie Deschamps was the eldest of the 14 Ritchie children growing up in rural Kentucky. She met her husband, Leon Deschamps, at the Pine Mountain Settlement School. They moved to Swannanoa, North Carolina, in 1943, when Leon began teaching at Warren Wilson College. They both sold craftwork at the early Allanstand shop. In 1955, Mae joined the guild with her distinctive corn-shuck dolls. Leon joined in 1938, doing woodwork.

Helen Bullard from Ozone, Tennessee, joined the guild in 1951 as a wood-carver. She trained and managed a group of women who helped to carve and clothe her wooden dolls. Aside from a variety of historical dolls, Bullard also carved primitive sculptures. She helped to organize the National American Institute of Doll Artists (NAIDA) and served as the group's first president in the 1960s.

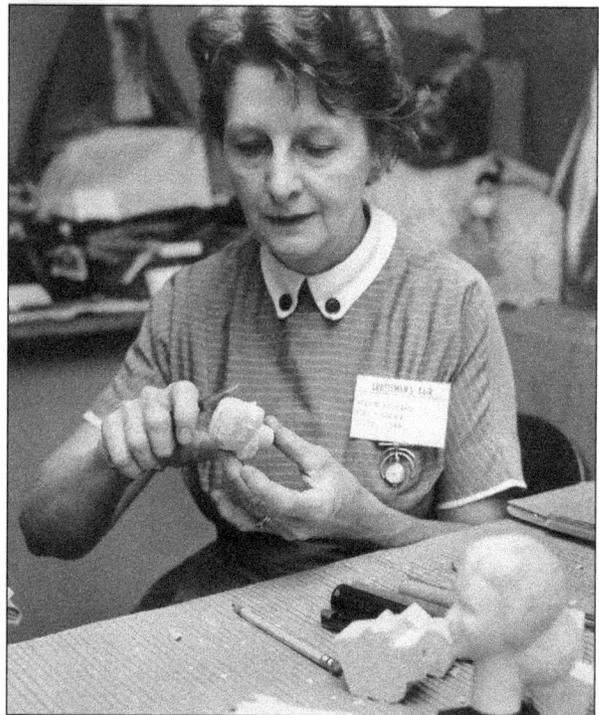

The 1960s were a time of change, and craft techniques were moving beyond traditional mountain work. Maxine Aycock's batik work brought a new process to the guild's offerings. She and her husband, William Aycock, a potter, joined the guild in 1968. Maxine studied at Cooper Union in New York City before the couple settled in Huntsville, Alabama.

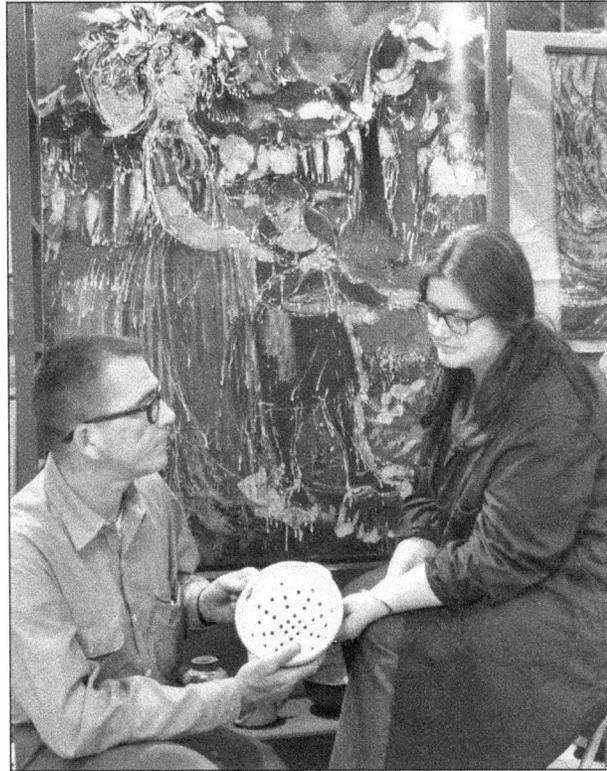

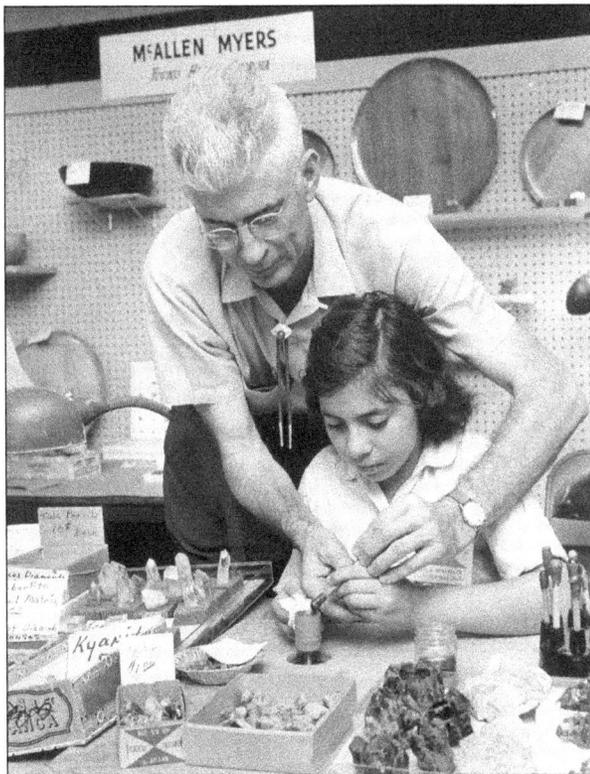

The guild also had several candlemakers and lapidary craftspeople. McAllen Myers, who joined in 1950, lived in Young Harris, Georgia, where he was able to collect precious and semiprecious rocks. He is shown helping a girl polish a stone. Myers collected rocks throughout his life and learned lapidary from guild member Roby Buchanan. He also did wood turning.

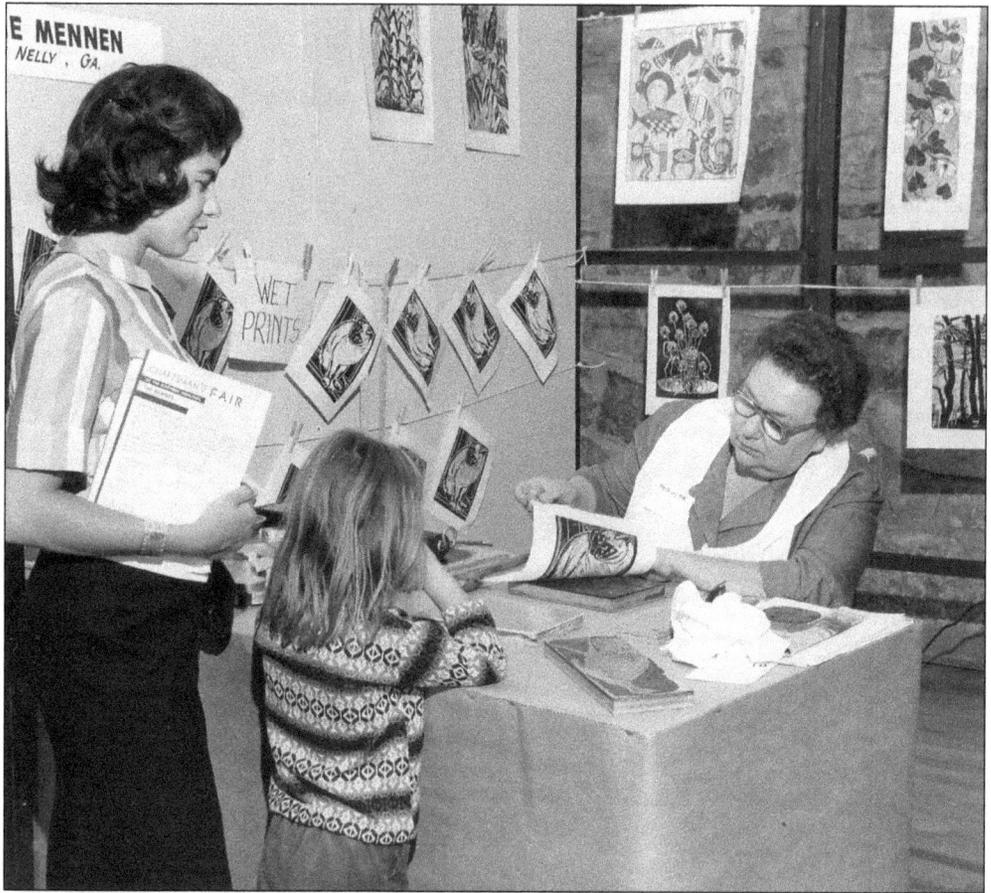

Fannie Mennen joined the guild in 1959 as a printmaker. While confined to a wheelchair, she operated a busy workshop and supervised a craft fair in Plum Nelly, Georgia. She did print work on both paper and fabric. Some of her printed fabric was quilted as part of a cottage industry. She taught art for 30 years at the University of Chattanooga in Tennessee.

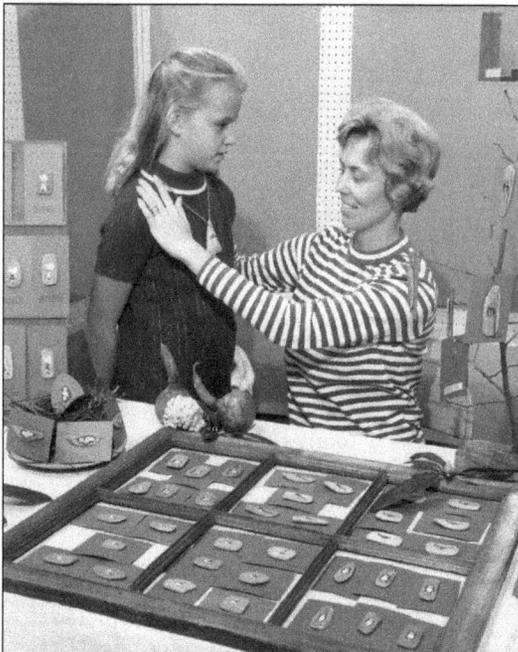

Barbara and Hugh Webb joined the guild in 1966. Barbara grew up on Lake Michigan and collected driftwood "coins" that washed up on the shore. Later, she began painting them with delicate woodland scenes and animals. Hugh does woodwork and creates miniature boxes and easels that complement Barbara's painting.

Bill Lett joined the guild in 1960 with unique metal sculptures. Lett had a background in arts education and taught art at a high school in Corryton, Tennessee. He constructed metal sculptures that were built up around a wire frame in layers of copper and bronze rather than being cast. Selective welding added color to the metals.

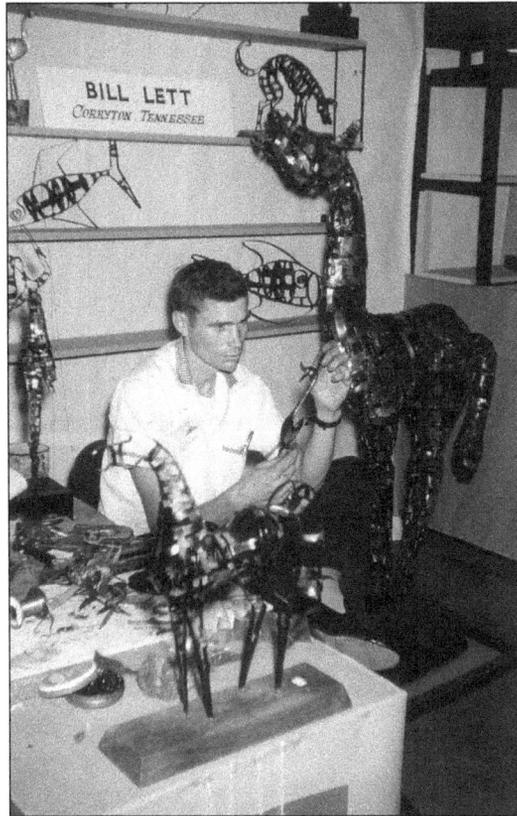

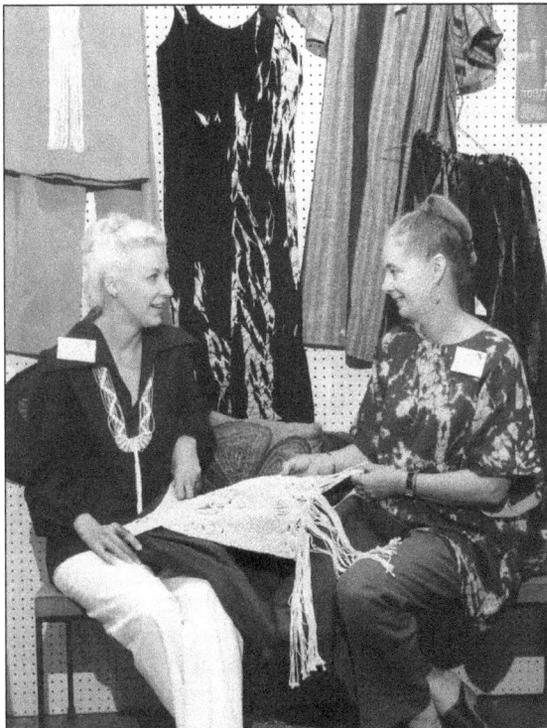

Clothing began to appear at the fairs in the 1960s as artisans created painted, dyed, woven, and pieced fabrics. Lynda Thomas (left) did batik and tie-dye work and created the dresses hanging in the background. She is speaking with Ellen Jones, who joined the guild in 1959 with jewelry and stitchery. Jones was an active member who served on several committees and the board.

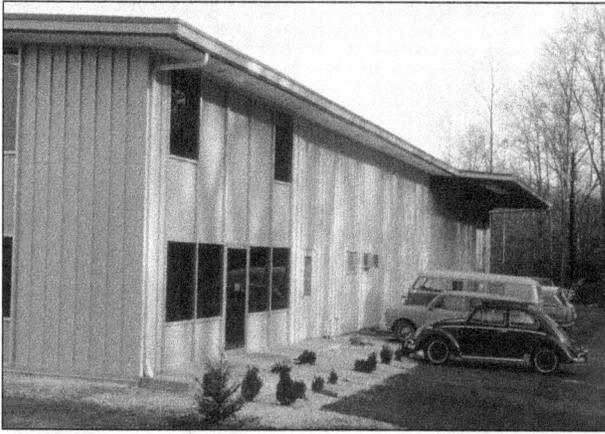

In 1968, the guild purchased a warehouse building just off the Blue Ridge Parkway in Asheville, North Carolina. The SHCG was operating a wholesale business, the Crafts of Nine States, to supply craft shops around the country with Appalachian work and needed storage space. The building also provided comfortable offices for a larger paid staff, along with conference rooms and a display area.

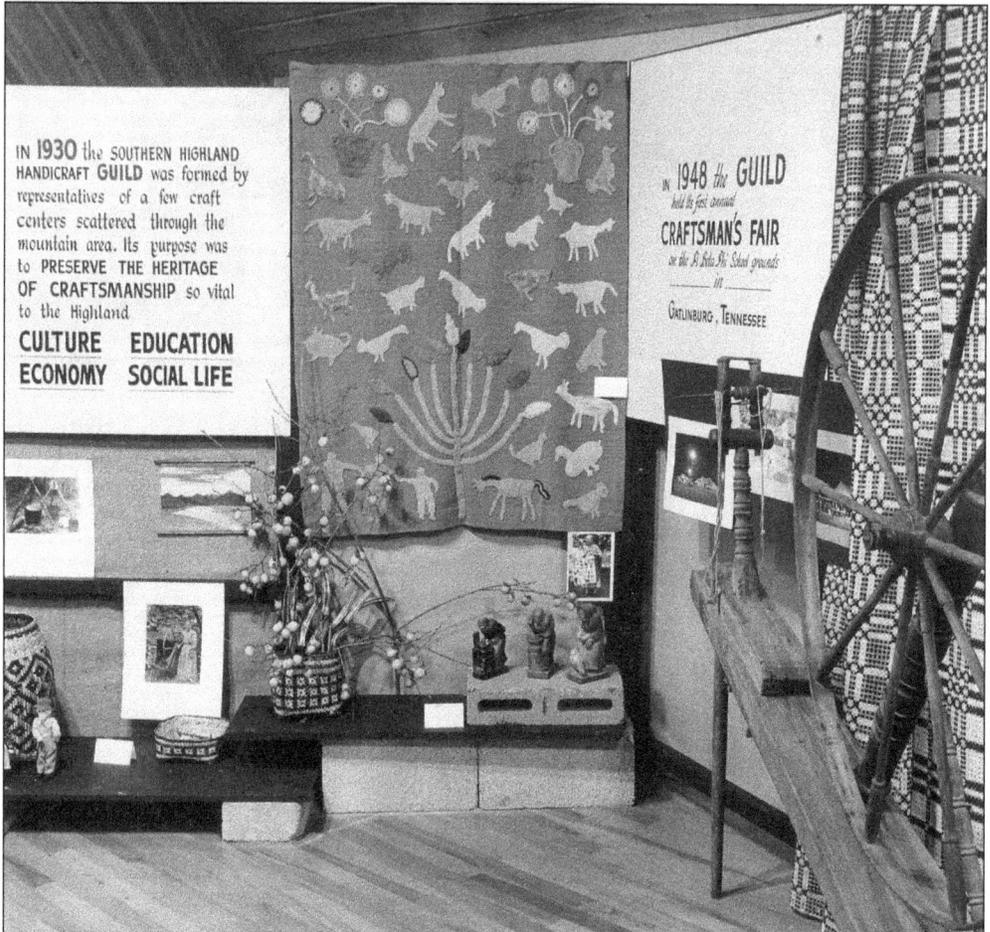

The Southern Highland Craft Guild was more popular in the 1960s than at any other time in its history, but there were tensions as old mountain crafts met with an influx of youthful new members. The guild worked hard to maintain its support of native Appalachian heritage craft while encouraging new artisans coming from outside the region with formal art training. This 1962 display offered a look back at the guild's origins. It includes Cherokee basketry and the work of Granny Donaldson and Tom Brown.

Six

THE 1970s

FAIRS AND CONSTRUCTION

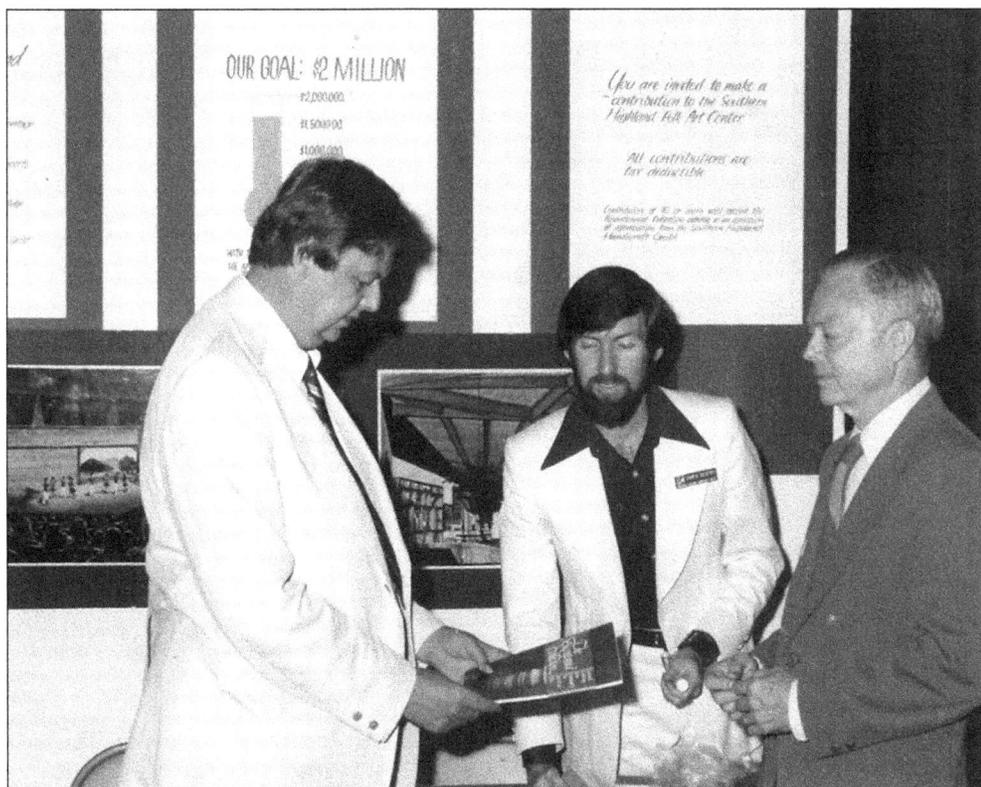

The success of the SHCG brought new plans for the organization. Robert W. Gray (right), was guild director from 1961 to 1980 and envisioned a guild headquarters—the Folk Art Center—that would include a sales shop, a gallery, offices, and educational opportunities. In this photograph, William Cecil (left), who was the chairman of the Folk Art Center advisory board, looks over a brochure created as part of fundraising efforts. He is shown conferring with Jim Gentry, guild educational director (and later director), and Gray.

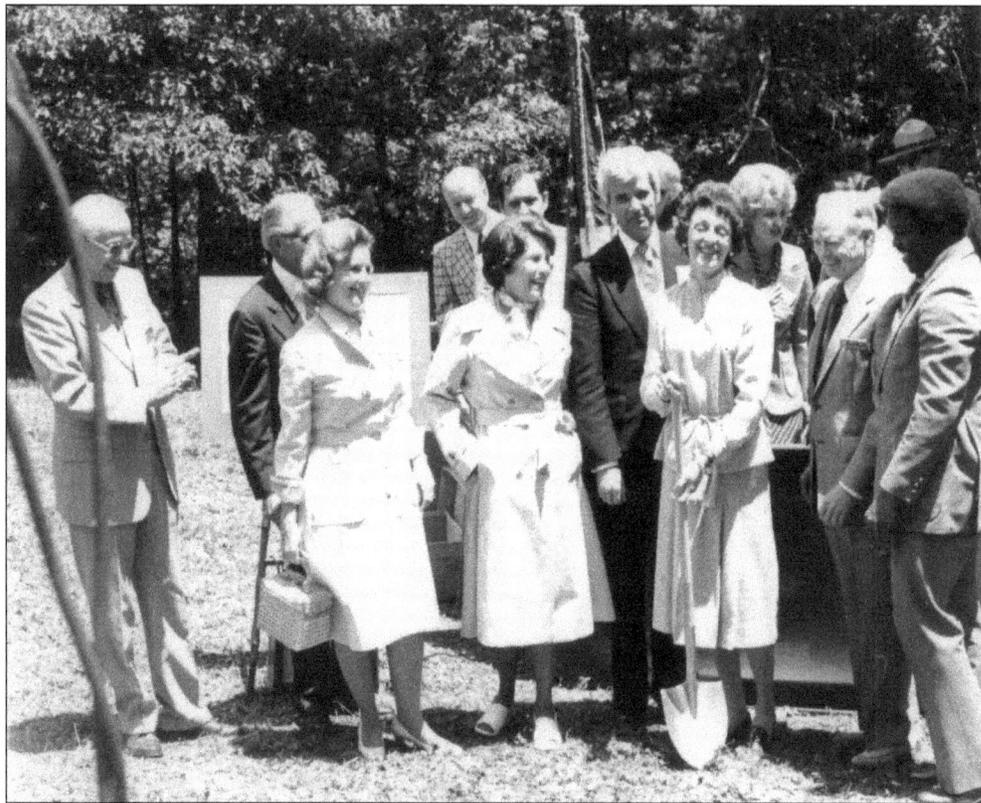

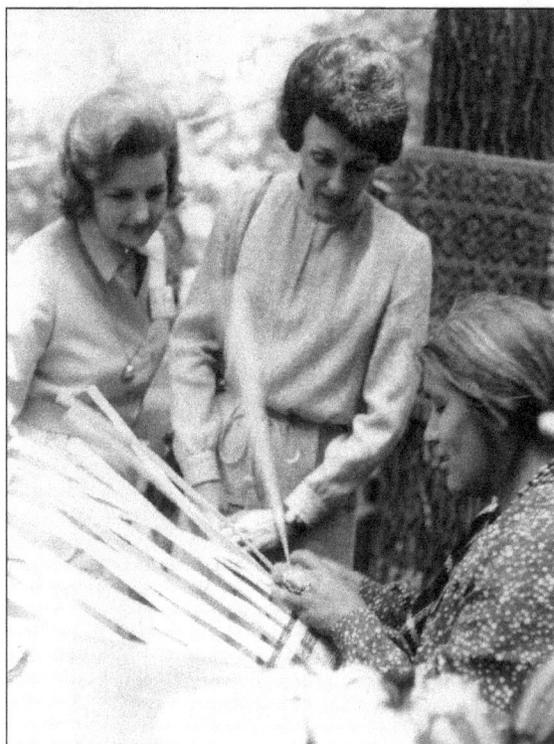

Fundraising for the guild's Folk Art Center progressed with an investment by the Appalachian Regional Commission and many members contributing to the guild's future. On June 7, 1977, Joan Mondale, a potter and the wife of Vice President Walter Mondale, came to Asheville, North Carolina, for the groundbreaking ceremony. She is pictured above holding the shovel next to various guests. Guild artisans were on site to demonstrate some of the crafts to be celebrated at the Folk Art Center. In the image at left, Nancy Conseen (right), a guild member in 1980, is working on a traditional Cherokee basket. A woven Cherokee mat hangs on the tree behind her. Mondale (center) is accompanied by Eugenia Gudger, the wife of North Carolina congressman Lamar Gudger.

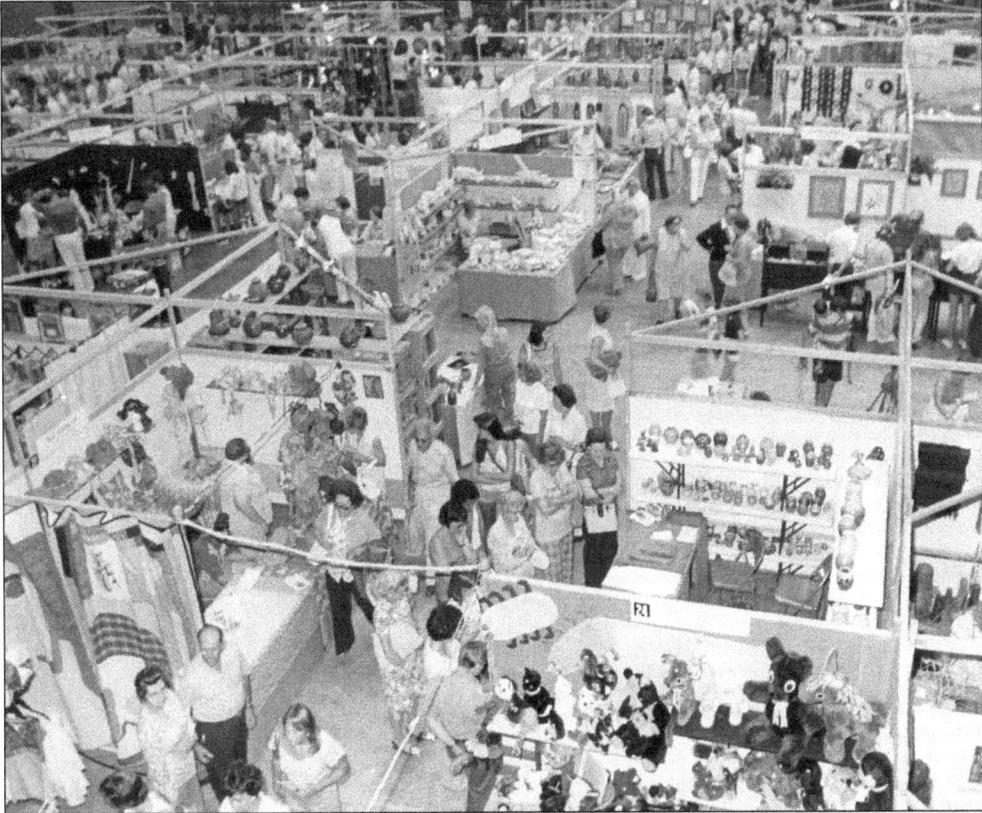

The Craftsman's Fairs continued to grow in the 1970s. The Asheville Auditorium had transformed into the Asheville Civic Center (today it is Harrah's Cherokee Center–Asheville). The guild continued to tighten application requirements, looking for the best of the best in a growing field of Appalachian craftspeople. The uniform booth construction of the 1960s is still in evidence at the 1976 fair but was giving way to modern displays and lighting as artists invested in individual booths.

Familiar faces were still on hand, such as Birdie Mace (pictured), who continued working the draw horse to create chair parts. Mace's daughter Pauline Keith and son-in-law Robert Keith had joined the guild in 1962 and continued the family's demonstrations of seat-weaving and chair-making. The dye-pot and forge also continued as outdoor demonstrations, along with occasional guests such as Guatemalan weavers.

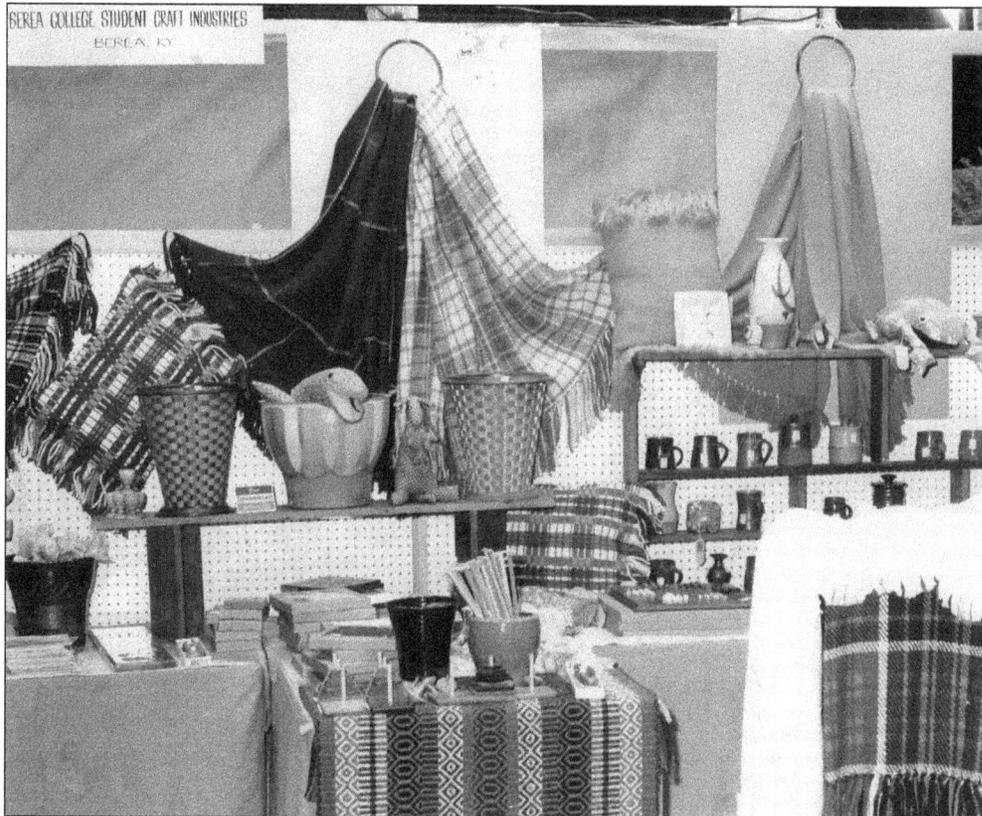

Many of the old members still participated in the 1970s. Berea College Student Industries expanded their program over the years; the group's weavings, pottery, and stitchwork are shown on display in 1976. The school also brought furniture and games, which were set up for visitors to play.

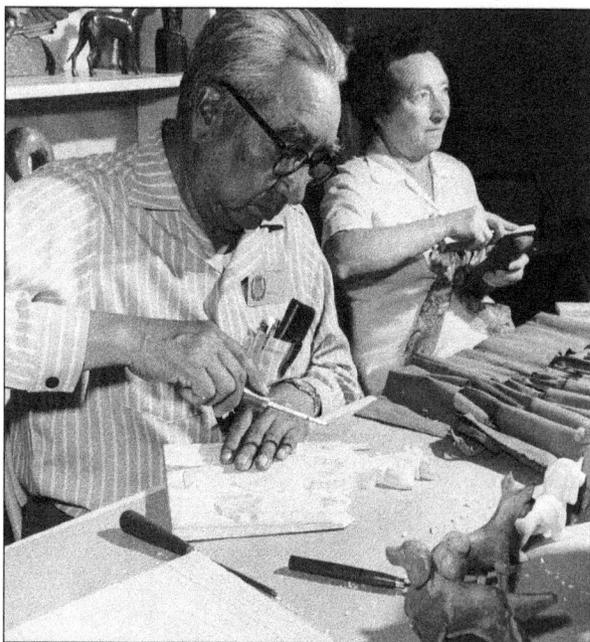

Going Back "G.B." Chiltoskey shared his booth with his wife, Mary Ulmer Chiltoskey. Mary was a teacher and took up wood carving after G.B. gave her her first knife. She helped found the Cherokee Community Library and wrote several books about Cherokee culture and language.

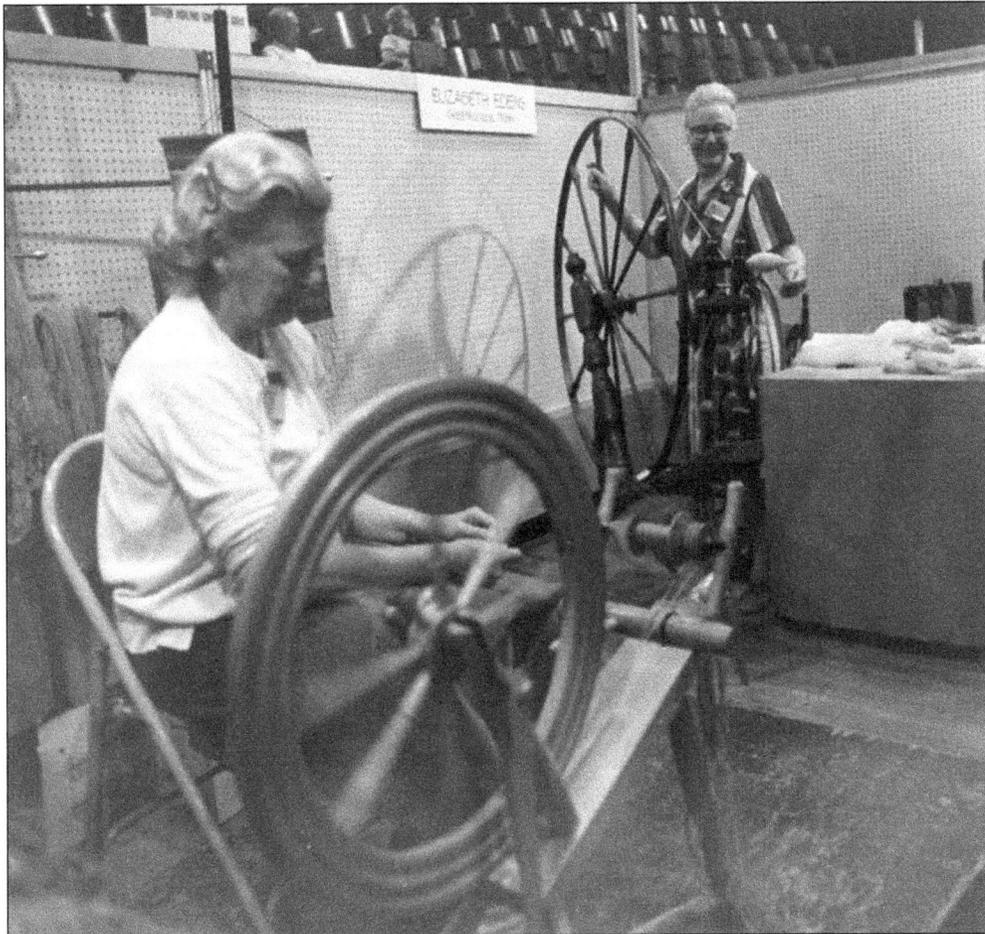

Weaving and fiber arts were always well represented at the fairs. Elizabeth Edens continued to demonstrate with her great wheel at the 1971 fair. Here, she is joined by Beatrice "Billie" Bannerman (left) of West Virginia, who joined the guild in 1963 and studied with Lucy Quarrier. Bannerman was also a proficient weaver and taught throughout the region.

Lila Marshall lived in Nichelsville, Virginia, and learned her craft at the Episcopalian Mission center. She joined the guild in 1956 after the death of her husband pushed her to find a reliable market for her corn-shuck dolls. She helped to found two other groups for artisans who work with natural materials: the Clinch Valley Handicraft Center (in Tennessee) and the Shuckery and Wood Pretties Center.

Each year brought new members and new skills. Jimmie Benedict (right), became a guild member in 1971. She did macrame and fiber work, often on a large scale, which was displayed in businesses and hospitals around Knoxville, Tennessee, and at the Opryland Hotel in Nashville, Tennessee. In the 1980s, Benedict began to focus on quilted clothing in lush colors with tribal themes.

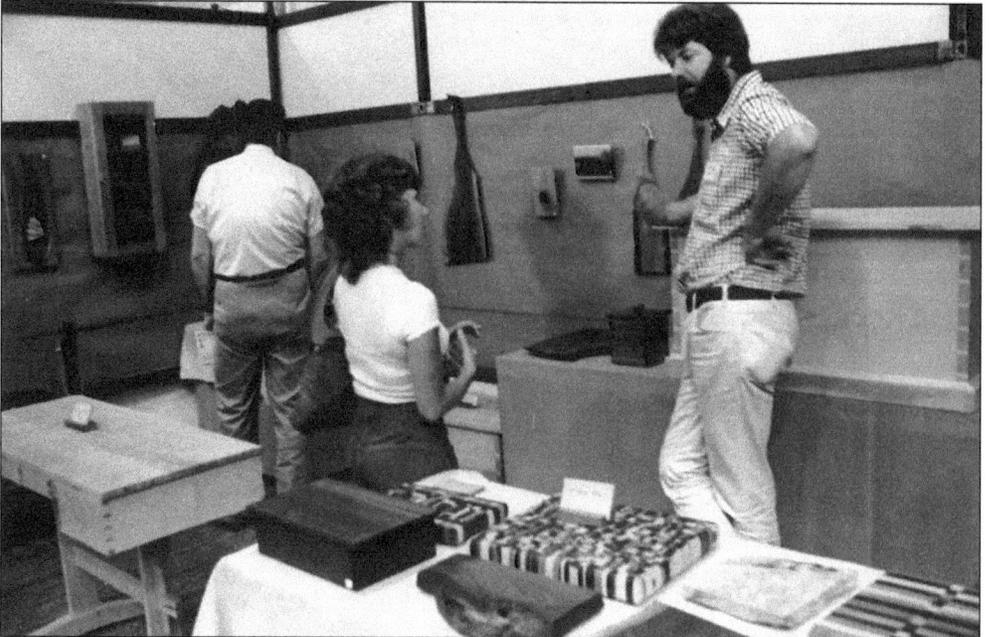

Robert Brunk came to Asheville, North Carolina, in 1966 and joined the guild in 1973. He did a wide range of woodwork with native woods using traditional techniques. His walnut cradle is in the Smithsonian collection. His woodworking led him to pursue the history of mountain chairs and other crafts. He took an active role in the guild, serving on committees and the board.

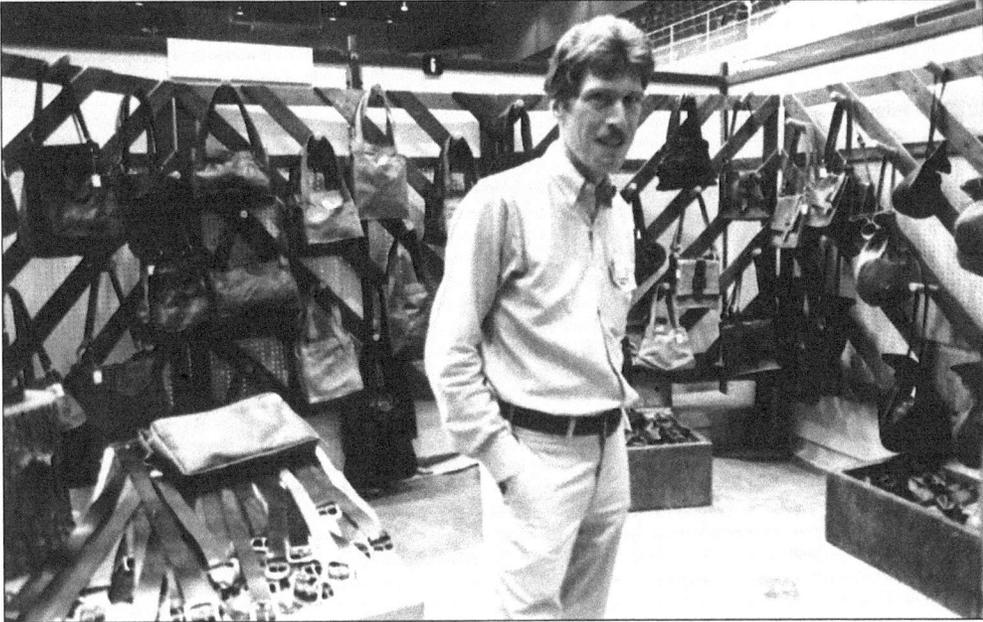

Rudy Tell (pictured) and Linda Loviner traveled before settling in Tennessee. They worked together to build the Rudy Tell Design Group, doing leatherwork. At one time, their workshop was the largest employer in Cosby, Tennessee, but office business was taking up too much time, so Tell decided to downsize and get back to working creatively with the materials.

Robert Owens had university training in art and was the founder and head of the fine arts department at North Georgia College in Dahlonega, Georgia (now the University of North Georgia). Outside of the college, Owens operated his pottery studio where he worked with a combination of production and experimental techniques. He was active on guild committees and the board. In 1985, he received the Georgia Governor's Award in the Arts.

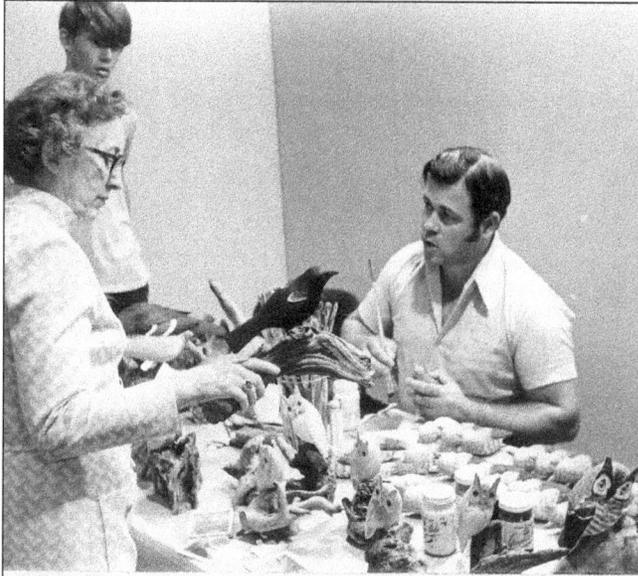

JAMES POWERS Demonstrating

James Powers, born and raised in Oakdale, Tennessee, was a self-taught wood-carver. He and his wife, Jeanette, spent their early married years working in a textile mill, but they left the mill in order to make a living as wood-carvers. They both juried into the guild in the 1960s. Powers had a full-time job supplying the market with his carvings of birds and fish.

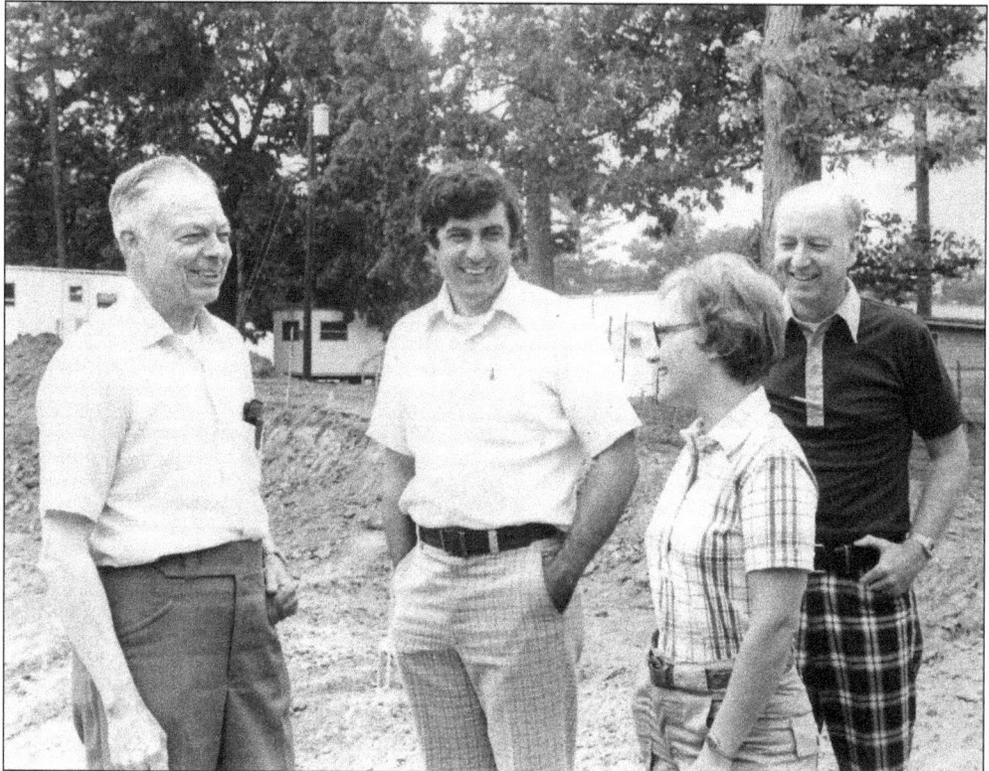

The construction of the Folk Art Center continued moving toward completion in the late 1970s. Pictured here surveying the construction site are, from left to right, director Robert Gray; board of trustees members Richard Bellando (of Churchill Weavers); Sandy Blain, a potter and director of Arrowmont School of Arts and Crafts; and Jerry Edmundson, head of the art department at East Tennessee State University.

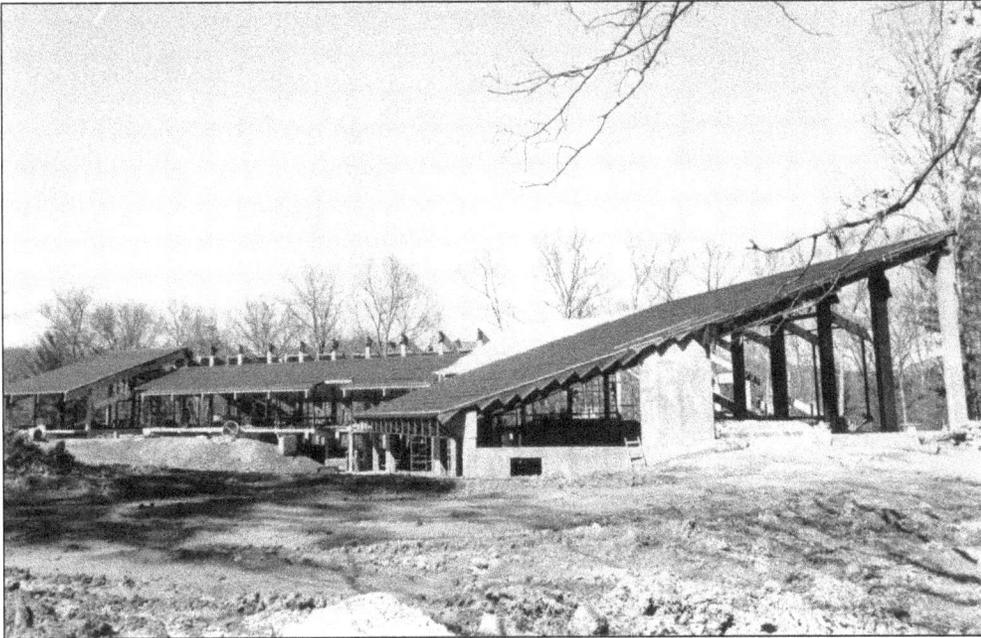

The Folk Art Center is a 30,000-square-foot building designed by Wood and Cort, PA, of Asheville, North Carolina. It was the product of cooperation between the Southern Highland Craft Guild, the Appalachian Regional Commission, and the National Park Service. The guild was contracted to "produce, present, and arrange for exhibitions, demonstrations, productions, and activities to interpret the culture of the people of the Southern Highlands" on the NPS site. The NPS maintains a souvenir shop and information desk in the center's lobby. The building was designed to be in harmony with the environment and "reflect the character of the regions' heritage."

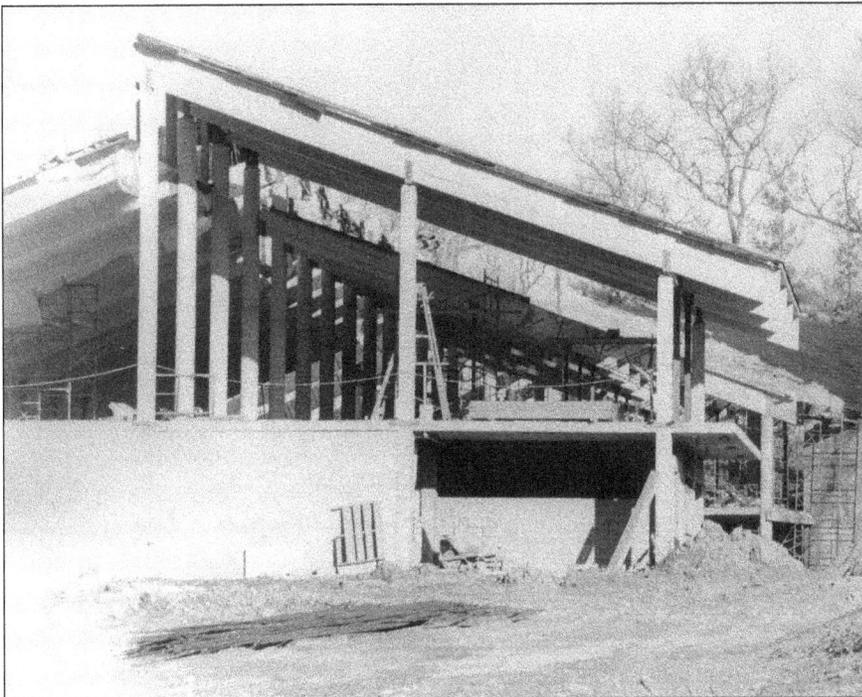

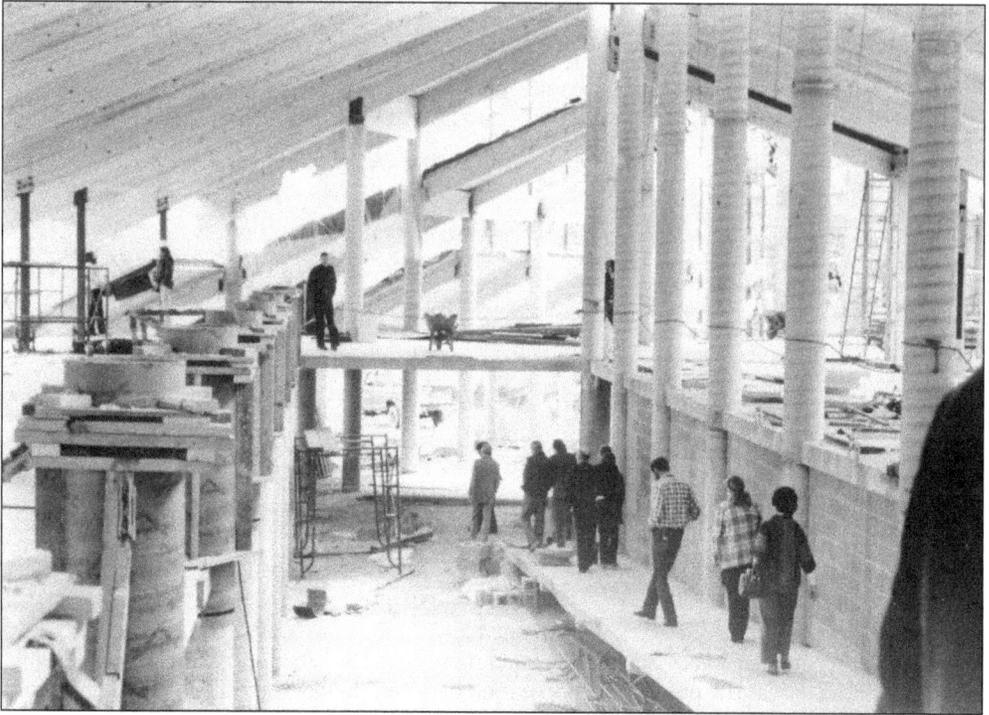

A group of volunteers and members received an inside tour as the building neared completion. The ramp leading to the second floor allows visitors to review the displays below in the shop area. Clerestory windows at the roofline augment the large windows bringing natural light into the gallery areas.

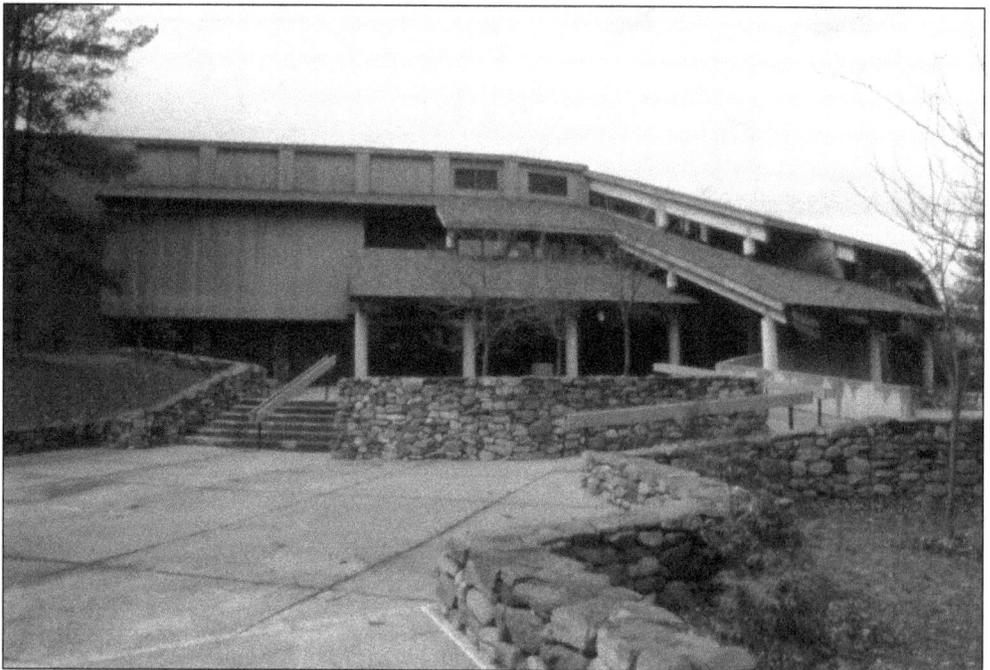

The building is ready for its opening celebration in this April 1980 photograph.

Seven

THE 1980S AND 1990S

A NEW HOME AT THE FOLK ART CENTER

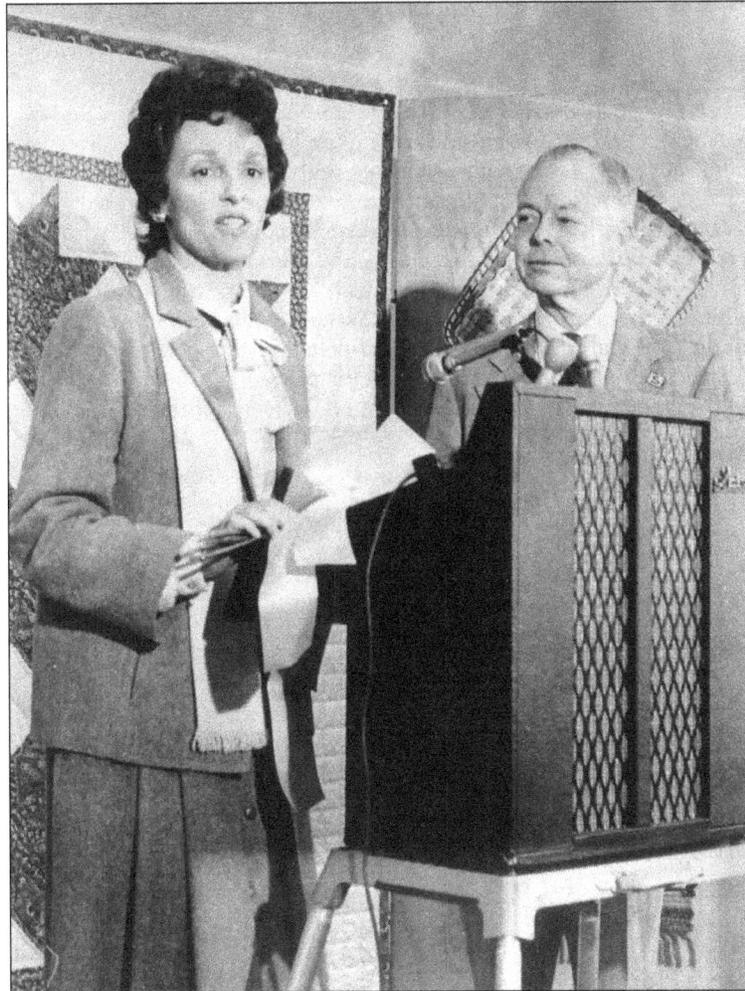

On April 17, 1980, Joan Mondale returned to the site of the 1977 ground-breaking ceremony to open the completed Folk Art Center on the Blue Ridge Parkway. Staff had moved into the offices, a library and reading area was available to the public, the gallery was full, and the Allanstand Craft Shop was stocked and ready for sales.

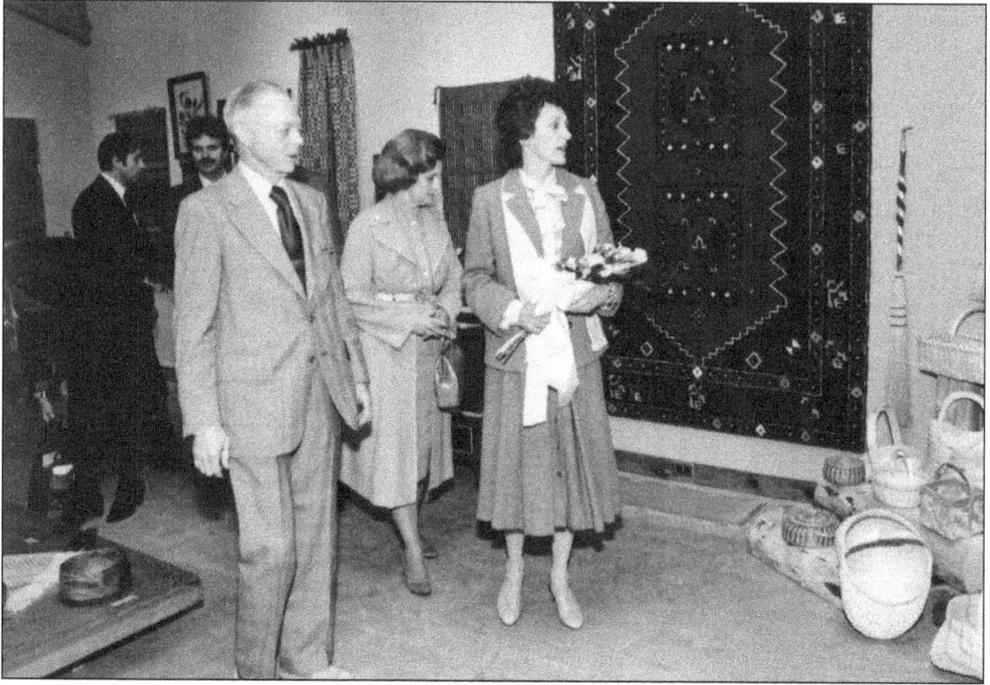

Before the 1977 ground-breaking ceremony, Joan Mondale was given a tour of the building by the guild's director, Robert Gray. Mondale (right) and Gray (left) are pictured above with Eugenia Gudger, wife of North Carolina congressman Lamar Gudger. The SHCG was celebrating 50 years as an organization, and a section of the main gallery was filled with members' craftwork. A large crowd filled the outdoor amphitheater and the auditorium. They were entertained with speeches and music. Also in attendance were Carolyn Hunt, wife of North Carolina governor Jim Hunt; Gary Everhardt, the superintendent of the Blue Ridge Parkway; Ira Hutchison, deputy director of the National Park Service; Richard Bellando, president of the SHCG board; Albert P. Smith Jr., federal cochairman of the Appalachian Regional Commission; and Eudorah Moore, director of the crafts program for the National Endowment for the Arts.

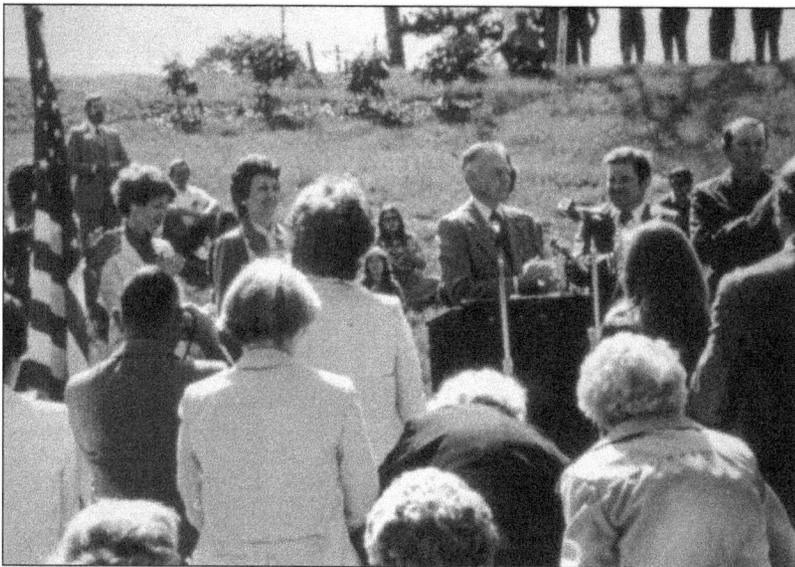

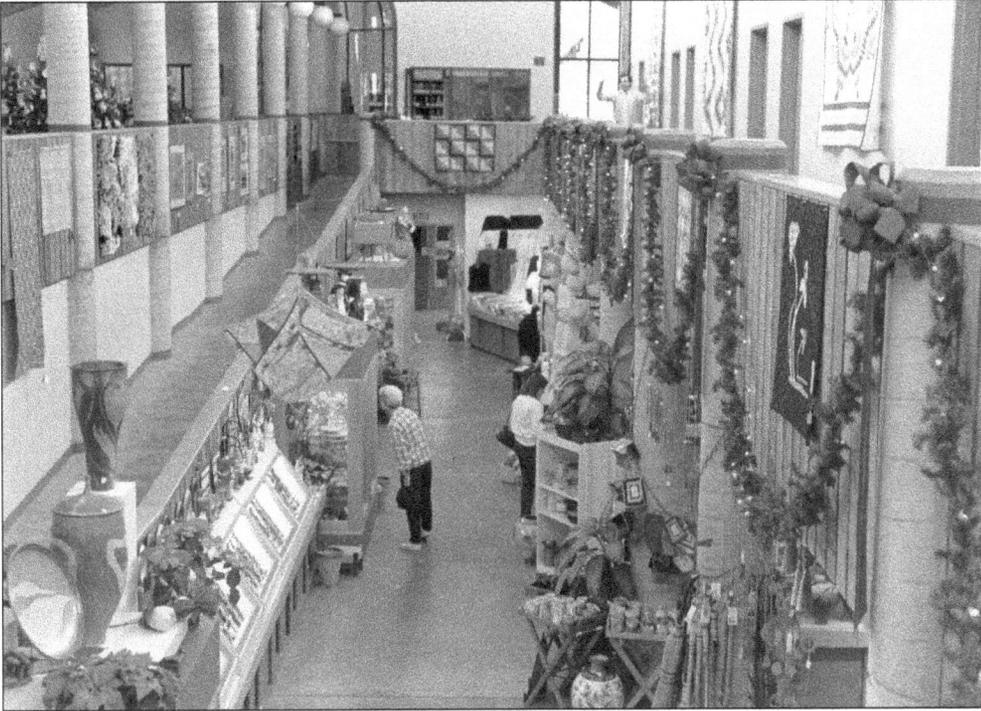

The ground floor of the Folk Art Center was filled with shop displays presenting the work of about 200 guild members. Quilts were hung on the walls above pottery, jewelry, and woodwork. This view from the Christmas season shows the garlands decorating the second-floor office area and community Christmas trees in the gallery at left.

The inaugural exhibition on the second floor of the Folk Art Center was titled *Appalachian Crafts in Transition*. There were more than 300 objects celebrating the 50th anniversary of the SHCG. The exhibition was intended to show traditional crafts as well as the way "evolving designs and techniques of newer craftsmen" were influencing the arts.

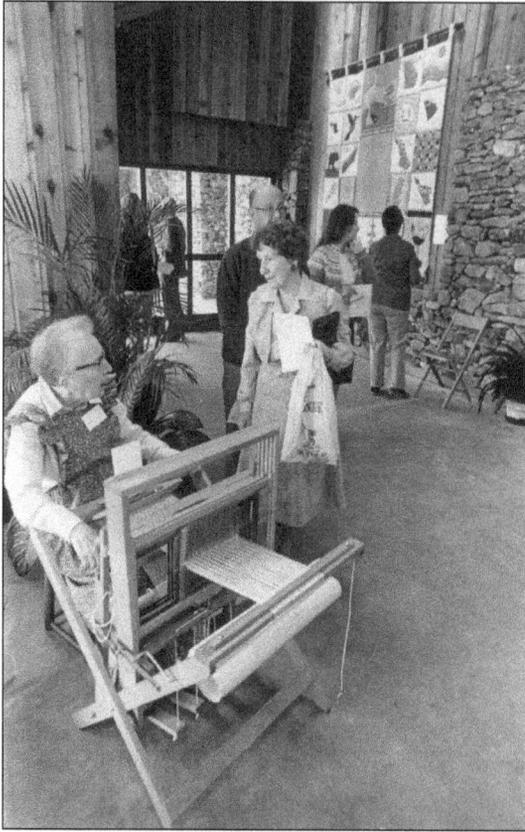

The new lobby provided an open area where guild members could do demonstrations. Alice Willard, who taught at John C. Campbell Folk School, is shown seated at her loom. She worked as an occupational therapist in New York before moving to North Carolina, and she joined the guild in 1983. Here, she is speaking with guild members Gus and Maggie Masters, who taught enameling at John C. Campbell Folk School.

Bill Henry, from Oak Ridge, Tennessee, joined the guild in 1965 and was a popular demonstrator. His careful whittling created detailed tools and antique farm equipment that were carefully researched for accuracy. Henry's interest in heritage craft led him to study coopering with Alex Stewart, a nationally recognized craftsman from Sneedville, Tennessee.

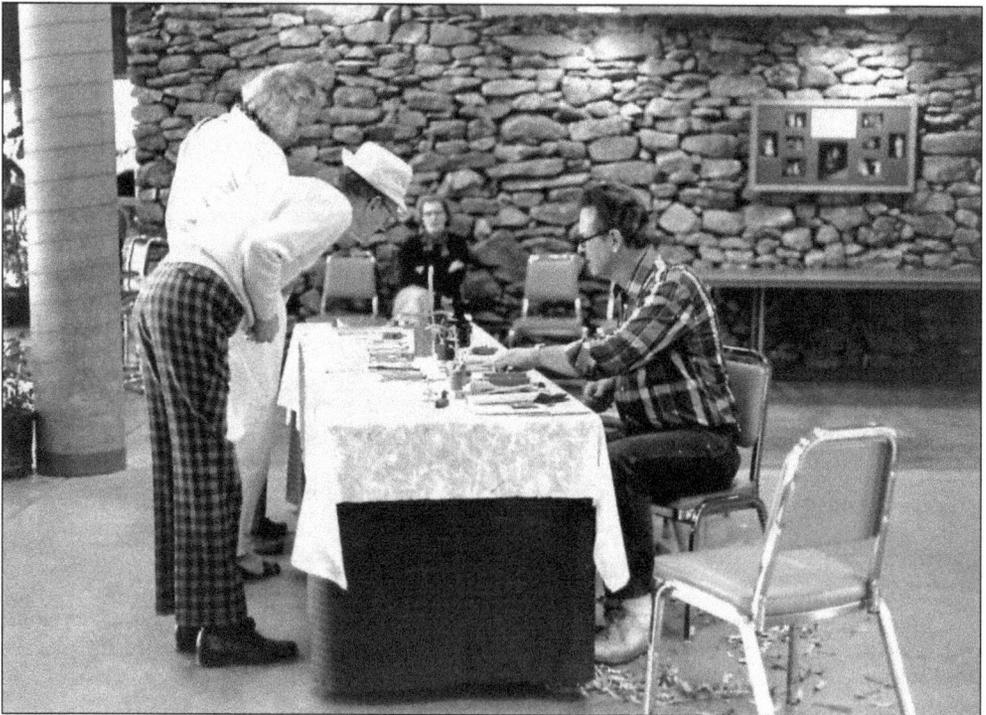

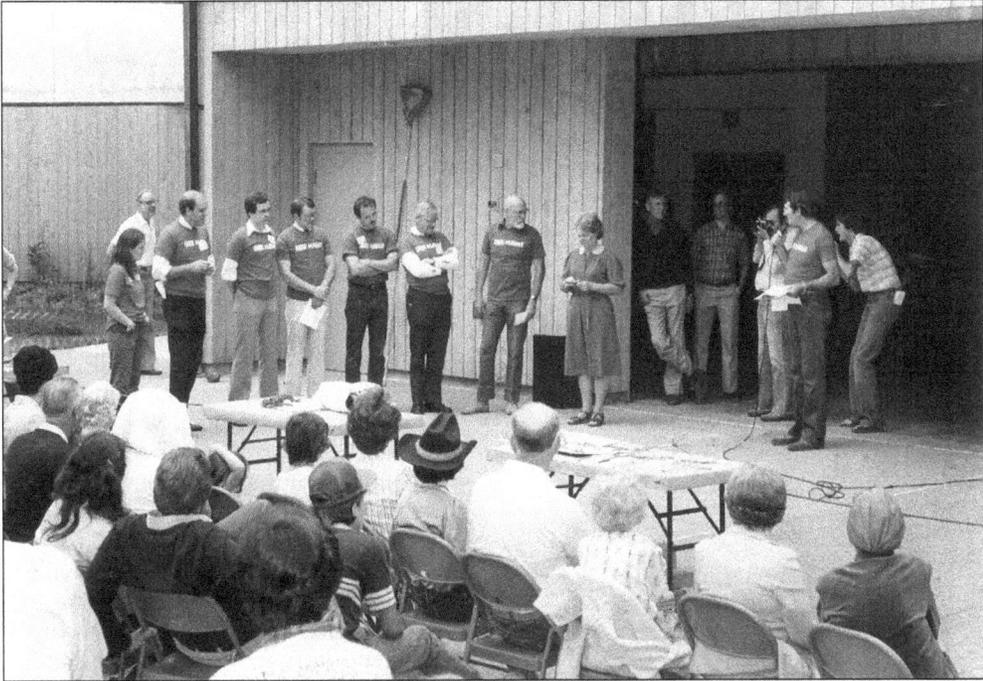

The large auditorium and outside amphitheater are wonderful arenas for hosting events. The first Gee Haw Whimmy Diddle contest was held in May 1981 with local VIPs and music. The contest was a stand-alone event, but over the years, it merged with Celebrate Folk Art/Heritage Day. Edsel Martin, one of the Martin family of wood-carvers, is shown demonstrating how to "gee" (go right) and "haw" (go left) using the propeller at the end of the notched stick. The competition was to see how many times a person could change direction in 12, 8, and 4 seconds, followed with the opposite hand, and then behind one's back. Edsel Martin joined with country music performer and songwriter Billie Edd Wheeler to compose the "Gee-Haw Whimmy Diddle" song and entertained as part of the program.

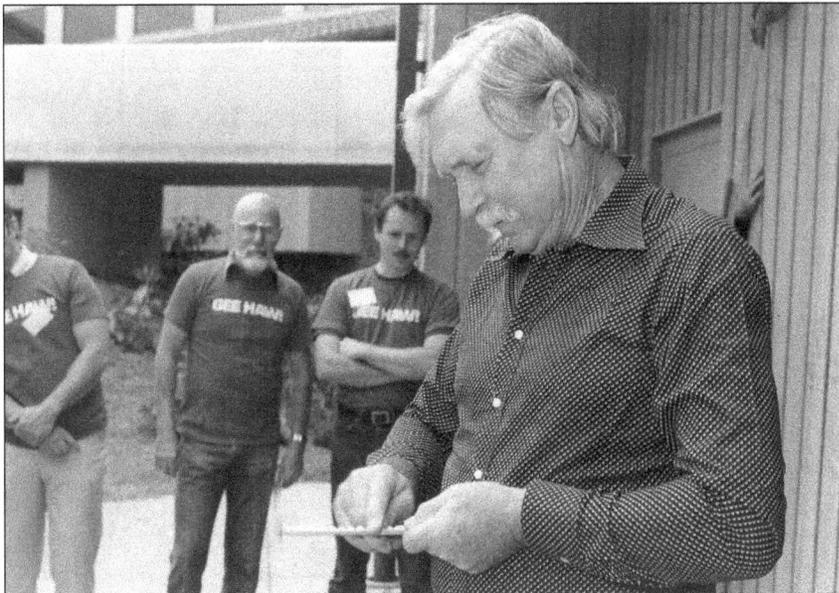

Another annual program launched by the guild was Celebrate Folk Art, which began as a one-day event in May 1985. The program was promoted as "a folk art celebration with living treasures of the guild." It included heritage guild members G.B. Chiltoskey, Elizabeth Edens, Harold Evans, Bill Gordy, Bill Henry, Ethel Hogsed, Elsie and Edsel Martin, Sue McClure, Mrs. E.B. McDonald, Charlotte Tracey, and Hazel Whittington. In the afternoon, there were presentations about traditional Appalachian culture. At left, Harold Garrison of Weaverville, North Carolina, is demonstrating an Appalachian toy called the dancing man. Garrison was a Heritage Crafts Affiliate member of the guild. Below, Bill Gordy is throwing a pot on an electric wheel. Gordy was part of the North Georgia tradition of heritage potters. He operated his family's pottery for 57 years.

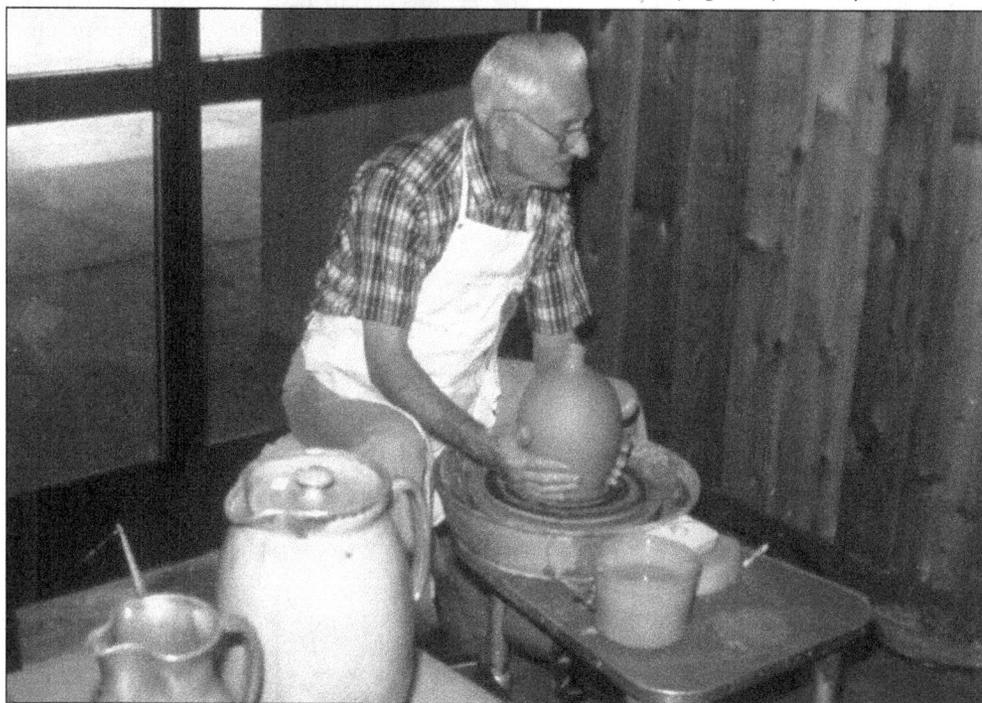

Charlotte Tracy, from Gaffney, South Carolina, learned basketry from her father and grandfather. She joined the guild in 1965 and could remember demonstrating basketry as a child at the Allanstand shop in downtown Asheville, North Carolina. She did white-oak basketry with a distinctive god's-eye shape at the handle.

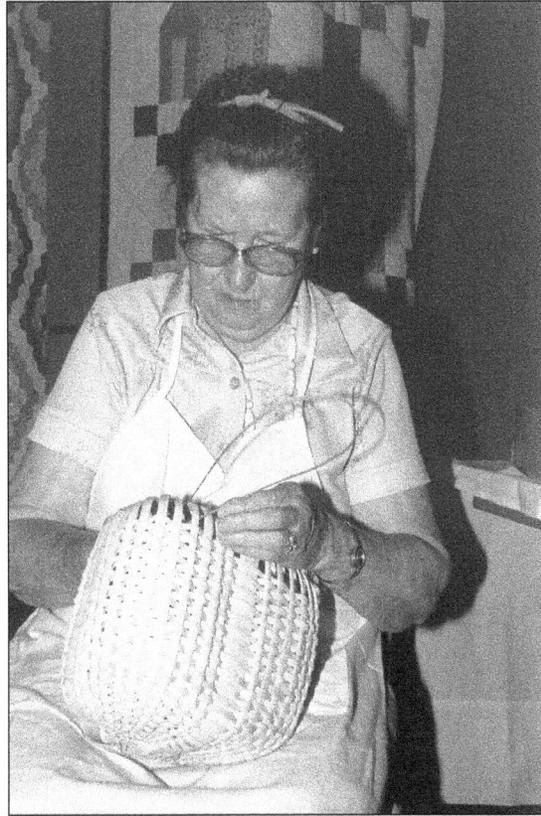

Pricilla Blosser-Rainey managed a sheep farm in Timberville, Virginia. She joined the guild in 1977 with hand-spinning and weaving. She also taught throughout the region and at her River Farm Craft School. Her interest in spinning led to her amassing a collection of unusual spinning wheels. Below, she is working with a distaff and a double-bobbin wheel.

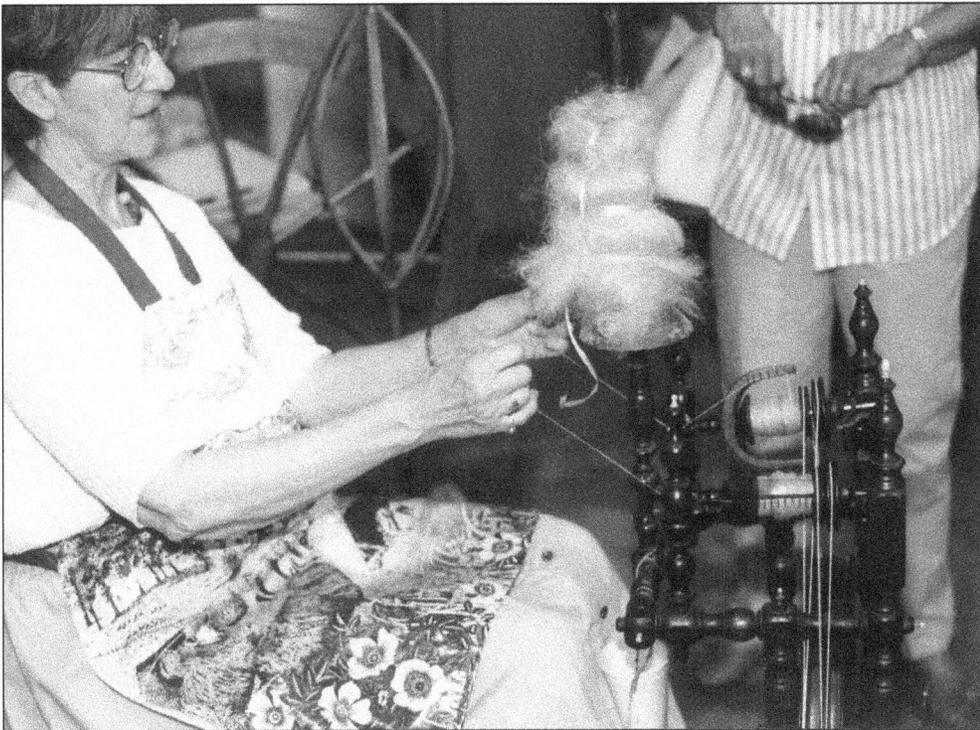

Fiber Day had an early start in 1981 as the finale to a fiber exhibition and went through several iterations before the guild settled on the popular event held every spring (and shown above in 1995). In 1986, a "Sheep to Shawl" program took place. The next year, the idea grew to include the full spectrum of fiber work. Visitors and children are invited to get up close and often lend a hand with projects and materials.

In 1983, the fiber attraction was Quilt Sharing Day with moderator Georgia Bonesteel. The public was invited to bring a quilt to the Folk Art Center. Bonesteel, who had a popular television show at the time, was able to identify patterns and give tips on care and repair. Each quilt was recorded with a photograph. The successful event was repeated in 1985 and 1987.

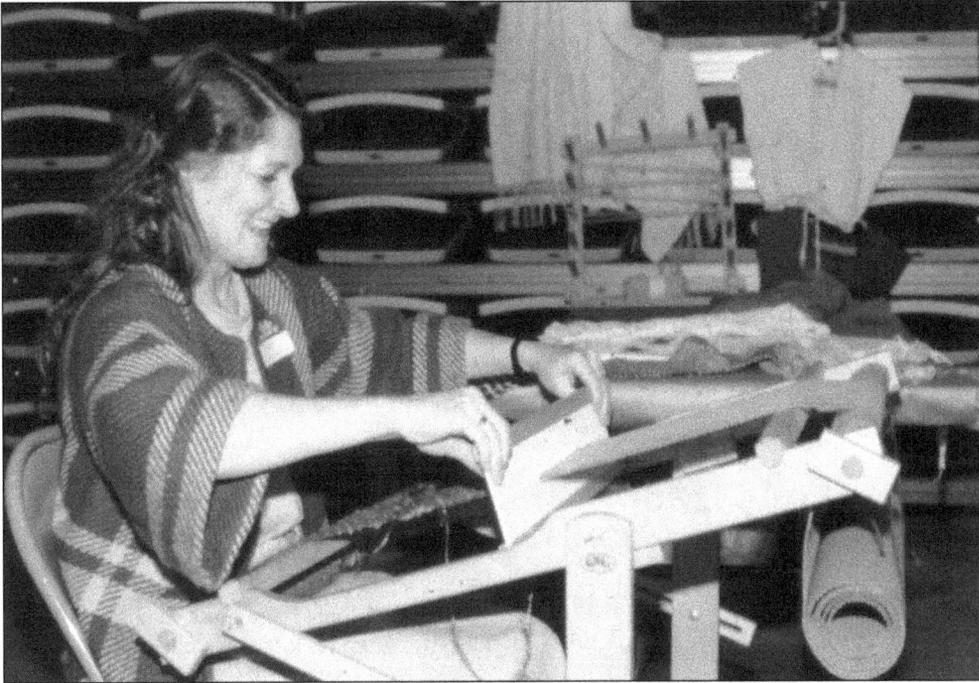

Susanne Leveille is Lucy Morgan's great-niece and had a life centered around crafts. She joined the guild in 1983 and operated Riverwood Handweaving Studio in Dillsboro, North Carolina. Later, she moved to gallery space next door to her father Ralph Morgan's Riverwood Pewter. She is demonstrating on a rigid-heddle loom and is modeling a handwoven jacket.

Dale Liles joined the guild in 1977 as a spinner, dyer, and felt maker. She learned her craft with Persis Grayson after moving to Knoxville, Tennessee, for her husband Jim Liles's teaching job at the University of Tennessee. At the Fiber Day event in 1988, she demonstrated making felt. Jim was also an avid dyer with a special interest in historical reproduction.

Even with a year-round showcase at the Folk Art Center, the semiannual Craftsman's Fairs continued and grew in Asheville, North Carolina. In 1987, the guild celebrated the 40th edition of the Craftsman's Fair. Jimmie Benedict, then the board president, cut the cake for the celebration. She is wearing one of her quilted dresses for the occasion.

At these more modern fairs, the guild no longer supplied tables and pegboard. Curtains and basic lighting were provided to give each artist or center a section in which to design their display. There were over 650 guild members in the 1980s, and the best use of the civic center still only allowed about a third of the artists to gather there.

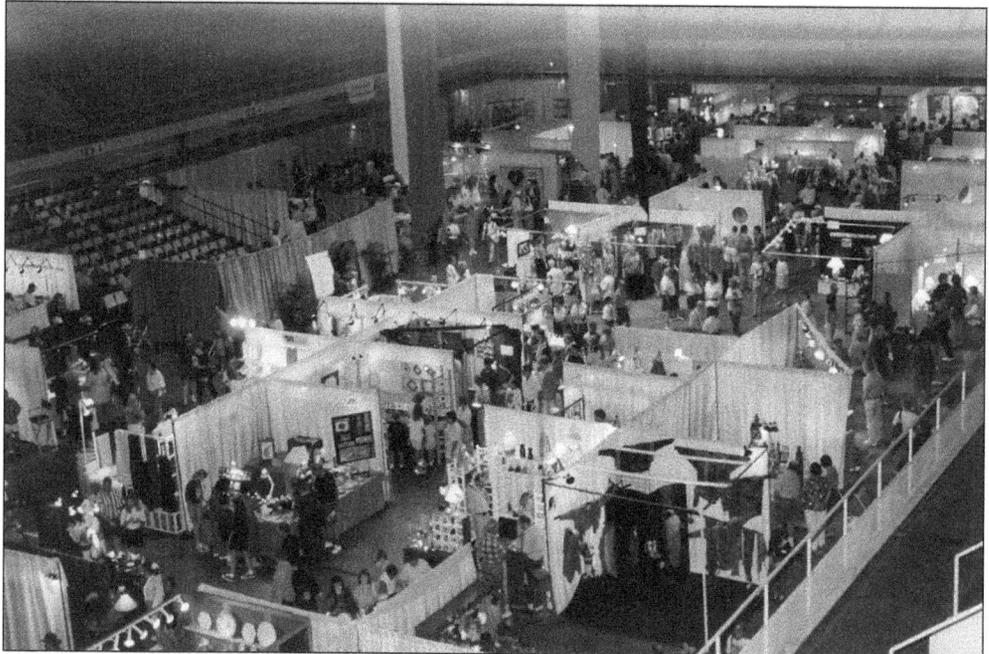

Demonstrations are a part of each year's fair. In 1980, Jim Sams of London, Kentucky, demonstrated wood carving. Sams is a self-taught artist who began by carving decoys and increasingly realistic ducks. His studio borders the Daniel Boone National Forest and provides inspiration for the finely detailed birds and flowers he still carves today. Sams uses native basswood and hickory for his work.

Lee Davis joined the guild in 1976 after moving to Brasstown, North Carolina. He taught pottery at the John C. Campbell Folk School for over 20 years. His functional pottery provides a canvas for the delft blue drawings that decorate the pieces. Davis was also a participant at Clay Day, where he shared his wheel with young visitors.

Stoney Lamar joined the guild in 1983 with wood turning done on an electric lathe. His father, Tracy Lamar, was also a member who made wooden toys in the 1970s and 1980s. Stoney uses the symmetry of lathe work but turns the wood, so there are multiple axes. He has been active with the guild and the American Craft Council.

Juanita Wolfe (left) joined the guild in 1977 and was often accompanied at guild events by her daughter Robin (right). Juanita lived in Cherokee, North Carolina, and began basketry at the age of seven. She taught the craft at Haywood Tech Community College and led workshops throughout the southeast. She also participated in Qualla Arts and Crafts Mutual.

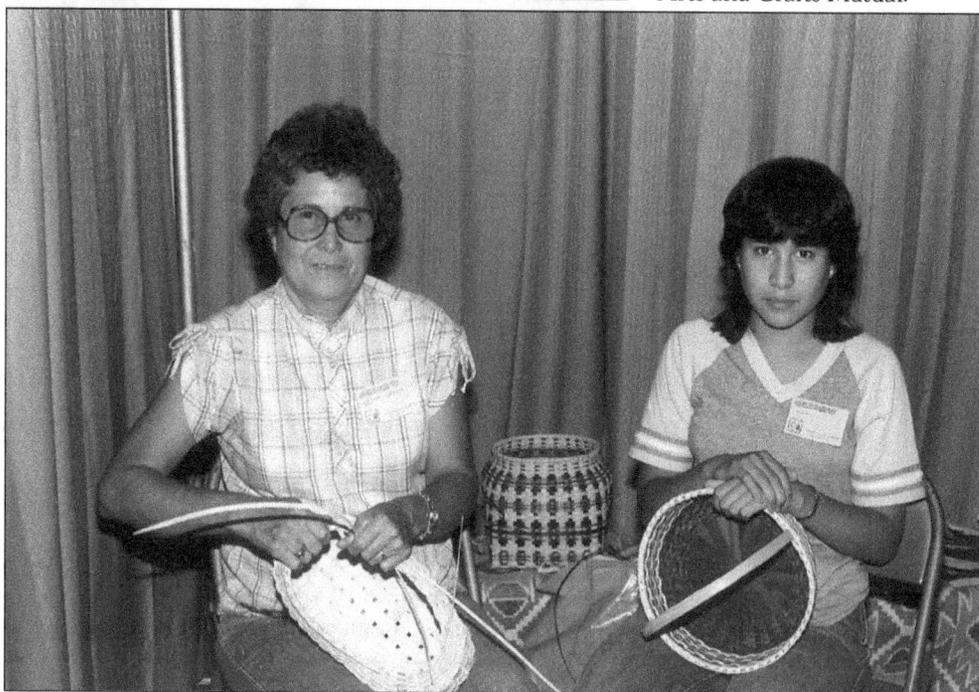

Michael Sherrill is a North Carolina native who joined the guild in 1976. He started doing pottery in high school at age 16 and was a full-time potter five years later. He has played an active role in the guild while developing his craft on a spectrum ranging from functional pieces to the sculptural work he is known for today. In 2018, he had a one-man show at the Mint Museum in Charlotte, North Carolina.

This photograph of Michael Sherrill's booth at the 1981 craft fair is a good example of how booth displays were changing around this time. Artists were investing in pedestals and signage to draw attention to their work. The increasing number of fairs in the region meant that a good display arrangement could be used more than twice a year.

THE POTTER'S HOUSE
Michael Sherrill
Salt-Glazed
Stoneware & Porcelain

Ellen Turner settled in the mountains after a life of travel with a military family. Her art training came from a scattering of classes she took growing up. Her folksy dolls were built on a wire frame, which gave them flexibility, and fully articulated hands allowed them to portray a wide range of activities.

Akira Blount grew up in Wisconsin and joined the guild in 1981 after moving to Tennessee. She learned needlework from her grandmother and made fabric toys for her child. She discovered a talent for soft sculpture and added an element of collage as she included natural materials in her cloth creations.

Barbara Miller joined the guild in 1965 with needlework, dyeing, and weaving. She grew up in Pisgah Forest, North Carolina, and has been active in guild activities on every level while teaching throughout the region. Her interest in Appalachian weaving and the work of Frances Goodrich led to her working on two books about traditional overshot patterns.

Crossnore School (now Crossnore School & Children's Home) is one of the original members that has continued to participate in guild fairs. The weaving still supplies a source of revenue for the boarding school. The manager, Ellie Hjennet (shown here at the spinning wheel), has continued to work with local weavers and is beginning a program of tartan weaving.

In 1990, Clay Day became the second media focus day at the Folk Art Center. Bob Wagar of Asheville, North Carolina, is shown sharing the magic of the potter's wheel with a young visitor. This interaction is key to the success of the guild's event days. Wagar has a university background and has developed his pottery style as it has ranged from contemporary functional to more sculptural forms.

Another opportunity to interact with clay is through raku firing. Gary Clontz organized a raku demonstration, and visitors are invited to glaze pots for the fire. Clontz taught at Haywood Community College for 30 years and was instrumental in the school's development of a well-rounded art curriculum that includes marketing. He arranged for an annual gallery show at the Folk Art Center to be a part of the graduating class's requirements.

Herb Cohen came to the mountains from New York City. He has a university background as a potter and worked for many years at the Mint Museum in Charlotte, North Carolina. He joined the guild in 1974 after moving to Blowing Rock, North Carolina. He is especially known for his precise sgraffito work on pottery, which he is shown demonstrating at the 1991 event.

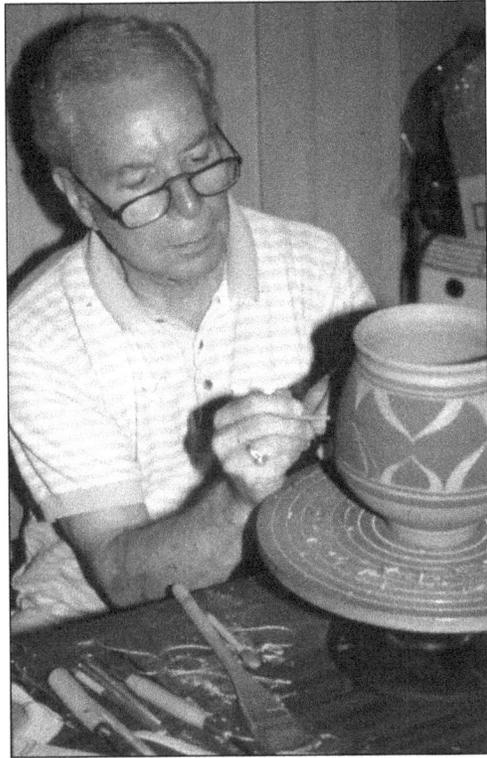

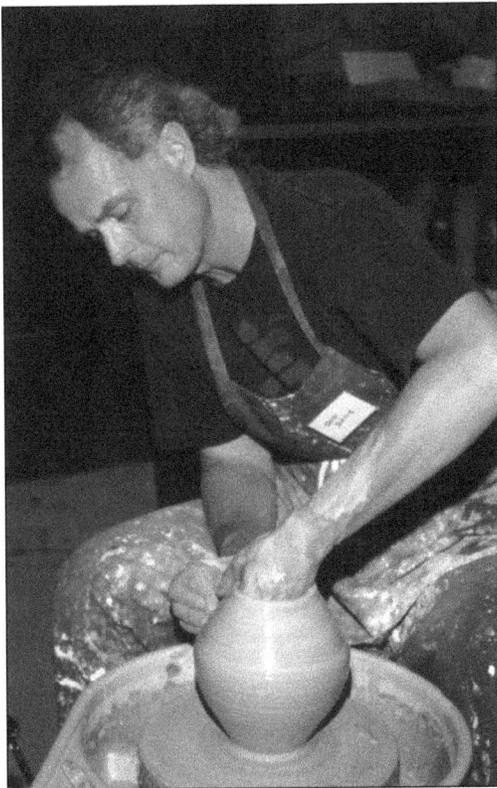

Don Davis joined the guild in 1978 and settled in North Carolina after a life of travel with his military family. He taught ceramics at Haywood Community College and East Tennessee State University. Functionality is important in his work, and he generally uses porcelain so that the glaze colors stand out. He was the first director of the Odyssey Center for the Ceramic Arts in Asheville, North Carolina.

121

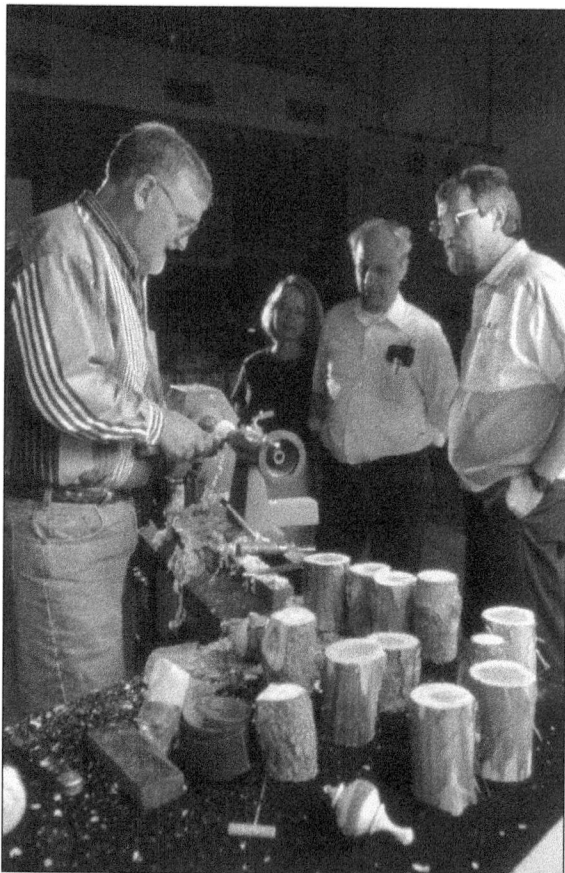

In 1998, Wood Day was initiated. In this image, Ray Huskey has prepared wood sections lined up for his demonstration of electric lathe work. He joined the guild in 1966 with his brother Earl and continued to operate the family's Village Craft Shop after his brother's death in 1997. His 1999 limited-edition birdhouse ornament was a Christmas fundraiser for the guild.

Jimmy White was born and bred in Maynardville, Tennessee. He learned woodworking from his father. He chose to focus his interest on Shaker boxes and wood basketry. He owned a small sawmill so that he could produce the thin woods that he wanted for his craftwork. He brought his spring pole lathe to Wood Day for demonstrations.

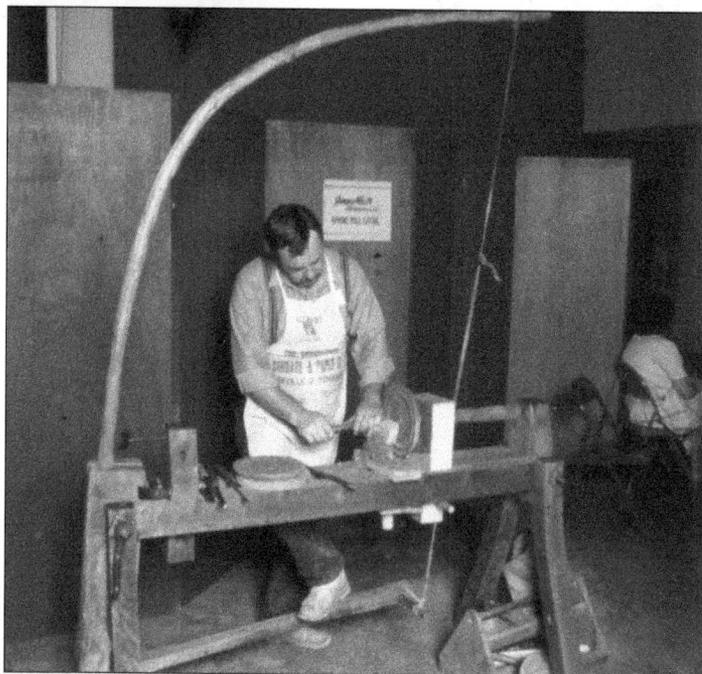

The guild's exhibitions have improved over the years. Andrew Glasgow was the guild's first professional curator who designed and initiated gallery presentations. The 1995 Chair Show was the third of its type and brought chairmakers from around the country to the Folk Art Center. The center also hosts national traveling exhibitions, which are augmented with membership participation.

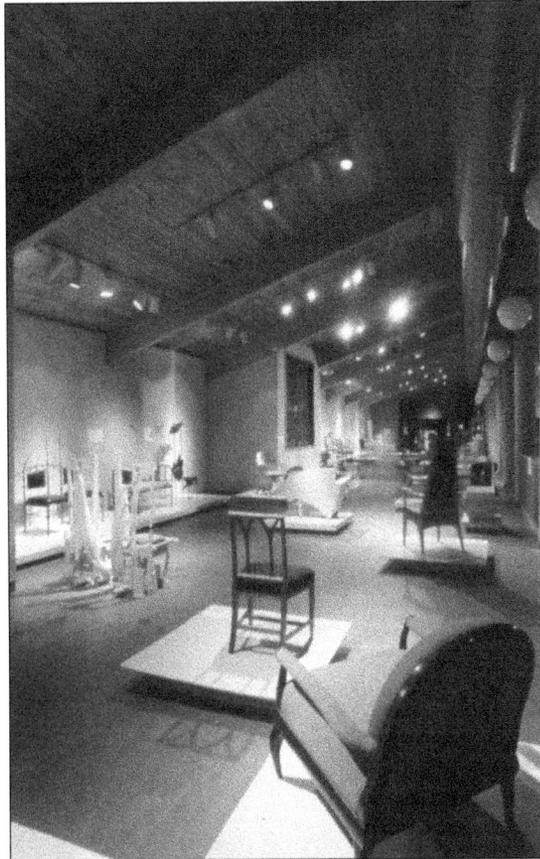

The Members' Exhibition is a biennial event that showcases the work of guild members and is based on a theme. The theme for the 2008 show pictured below was "New Traditions in Cabinetmaking." It was curated by Nikki Josheff.

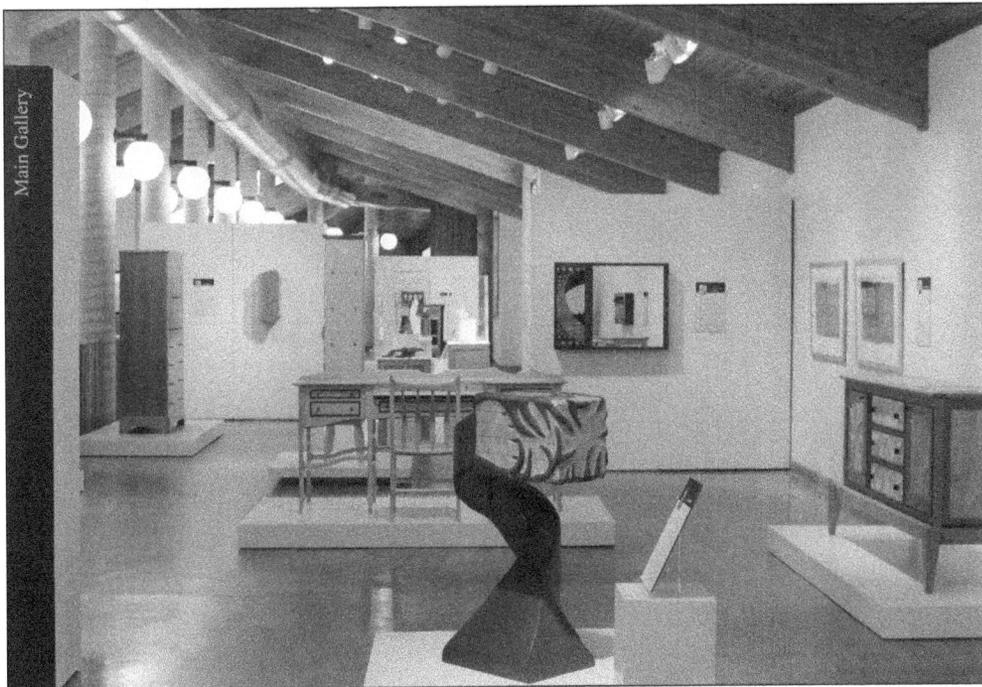

Main Gallery

In 1994, the Pi Beta Phi Fraternity leased the Arrowcraft Shop in Gatlinburg, Tennessee, to the SHCG. For 20 years, it provided an additional display opportunity for members. Demonstrations and heritage events were held on the grounds. In 2014, the historic shop was bought by developers, and the site is now a parking lot.

A sixth shop had a brief tenure in Middlesboro, Kentucky. The NPS Cumberland Gap National Historic Park Visitors' Center provided a sales space and area for demonstrations. Cumberland Crafts opened in 2002 and closed in 2015.

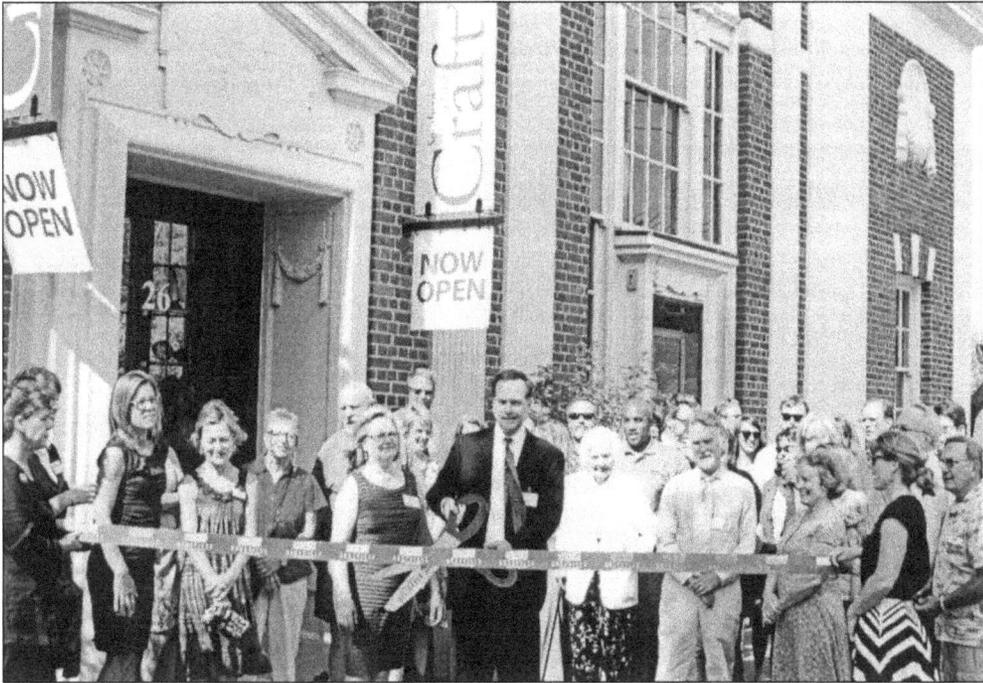

In 2013, the guild was able to purchase a former bank building in Biltmore Village in Asheville, North Carolina. The beautiful old building was updated and stocked. Guild director Tom Bailey and shop manager Joanne Hewatt cut the ribbon on opening day while Asheville mayor Esther Manheimer (third from left) looked on.

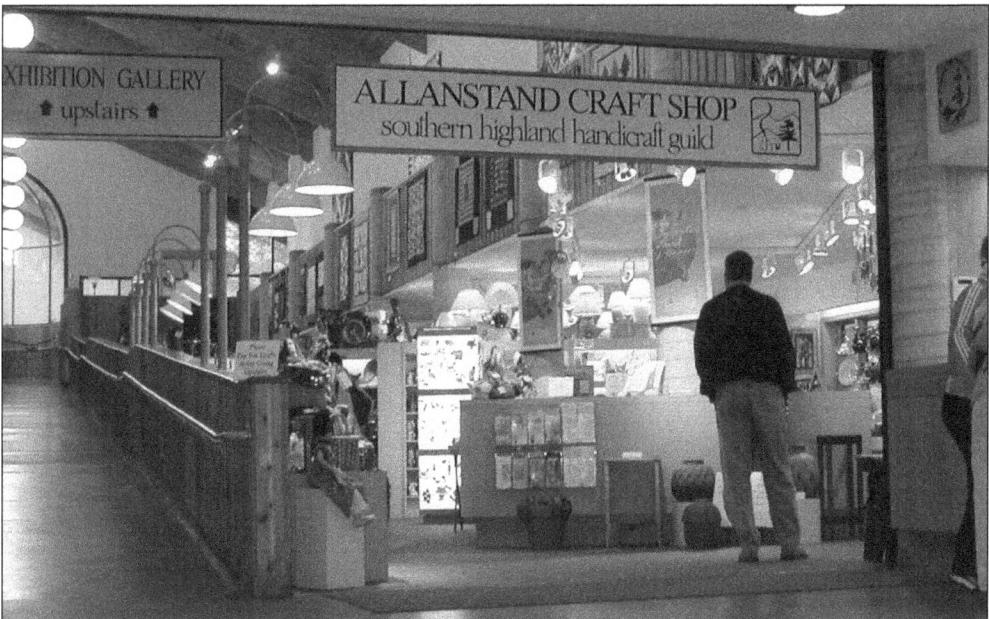

Today, the Allanstand Craft Shop continues to thrive at the Folk Art Center. It is open 362 days of the year and receives over 250,000 thousand visitors annually. Although it is not large enough for every member to display work within it, the crafts vary over each year, and a new second-floor area contains furniture and items previously too large to fit in the shop. Everyone is welcome.

BIBLIOGRAPHY

Alvic, Philis. *Weavers of the Southern Highlands.* Lexington, KY: University Press of Kentucky, 2003.

Barker, Garry G. *The Handcraft Revival in Southern Appalachia, 1930-1990.* Knoxville, TN: University of Tennessee Press, 1991.

Barnwell, Tim. *Hands in Harmony.* New York: W.W. Norton & Co., 2009.

Brunk, Robert S. *May we all remember well, vols. 1 & 2.* Asheville, NC: Robert S. Brunk Auction Services, 1997, 2001.

Bullard, Helen. *Crafts and Craftsmen of the Tennessee Mountains.* Falls Church, VA: Summit Press, 1976.

Campbell, John C. *The Southern Highlander and His Homeland.* Second edition. Lexington, KY: University Press of Kentucky, 1969.

Davis, Don. *Wheel-Thrown Ceramics.* Asheville, NC: Lark Press, 1998.

DuPuy, Edward L. *Artisans of the Appalachians.* Asheville, NC: Miller Printing, 1967.

Eaton, Allen H. *Handicrafts of the Southern Highlands.* New York: Dover Publications, 1973.

Goodrich, Frances L. *Mountain Homespun, new edition.* Knoxville, TN: University of Tennessee, 1989.

Laub, Lindsey K. *Evolution of a Potter, Conversations with Bill Gordy.* Cartersville, GA: Bartow History Center, 1992.

Leftwich, Rodney H. *Pisgah Forest and Nonconnah, the potteries of Walter B. Stephens.* Bradenton, FL: Martin Media Publishing, 2006.

Miller, Barbara, and Deb Schillo. *Frances L. Goodrich's Brown Book of Weaving Drafts* and *Frances L Goodrich's Coverlet and Counterpane Drafts.* Atglen, PA: Schiffer Publishing, 2013 and 2016.

Morgan, Lucy. *Gift from the Hills.* Third edition. Penland, NC: Penland School of Crafts, 2005.

Sloop, Mary T. Martin. *Miracle in the Hills.* New York: McGraw-Hill Book Co., 1953.

About the
Southern Highland
Craft Guild

The Southern Highland Craft Guild continues to represent the best in southern mountain crafts and attracts artists and visitors to the region. All guild members must have a residence in one of the counties described by SHCG policy. A current listing is available on the craft guild website (craftguild.org). Application procedures and forms are also available on the guild's website.

The jury process has two steps: first, pictures of the work are submitted for review, and if the work passes, the objects are requested for review. A committee of members and artists familiar with each specific medium review and recommend applicants for membership.

Today, the SHCG operates four shops in North Carolina:

Folk Art Center's Allanstand Craft Shop
Milepost 382 on the Blue Ridge Parkway
Asheville, North Carolina

Tunnel Road Shop
930 Tunnel Road
Asheville, North Carolina

Biltmore Village Shop
26 Lodge Street
Asheville, North Carolina

Moses Cone Manor Shop
Milepost 294 on the Blue Ridge Parkway
Blowing Rock, North Carolina

Visit us at
arcadiapublishing.com

· ·

www.ingramcontent.com/pod-product-compliance
Lightning Source LLC
Chambersburg PA
CBHW050920150426

42812CB00051B/1916